Webcomics

BLOOMSBURY COMICS STUDIES

Covering major genres, creators, and themes, the Bloomsbury Comics Studies series are accessible, authoritative, and comprehensive introductions to key topics in Comics Studies. Providing historical overviews, guides to key texts, and important critical approaches, books in the series include annotated guides to further reading and online resources, discussion questions, and glossaries of key terms to help students and fans navigate the diverse world of comic books today.

Series Editor Derek Parker Royal

Titles in the series

Superhero Comics, Christopher Gavaler
Autobiographical Comics, Andrew J. Kunka
Children and Young Adult Comics, Gwen Tarbox

Forthcoming titles

Manga, Ronald Stewart and Shige (CJ) Suzuki
Alan Moore, Jackson Ayres

Webcomics

Sean Kleefeld

BLOOMSBURY ACADEMIC
LONDON • NEW YORK • OXFORD • NEW DELHI • SYDNEY

BLOOMSBURY ACADEMIC
Bloomsbury Publishing Plc
50 Bedford Square, London, WC1B 3DP, UK
1385 Broadway, New York, NY 10018, USA

BLOOMSBURY, BLOOMSBURY ACADEMIC, and the Diana logo are
trademarks of Bloomsbury Publishing Plc

First published in Great Britain 2020

Cover design: Eleanor Rose
Cover illustration © Rachel Smith

A catalogue record for this book is available from the British Library.

A catalog record for this book is available from the Library of Congress.

ISBN: HB: 978-1-3500-2818-0
PB: 978-1-3500-2817-3
ePDF: 978-1-3500-2820-3
eBook: 978-1-3500-2819-7

Series: Bloomsbury Comics Studies series

Typeset by Deanta Global Publishing Services, Chennai, India
Printed and bound in Great Britain

To find out more about our authors and books visit www.bloomsbury.com
and sign up for our newsletters.

For Lauriean

CONTENTS

SERIES EDITOR'S PREFACE

The *Bloomsbury Comics Studies Series* reflects both the increasing use of comics within the university classroom and the emergence of the medium as a respected narrative and artistic form. It is a unique line of texts, one that has yet to be addressed within the publishing community. While there is no shortage of scholarly studies devoted to comics and graphic novels, most assume a specialized audience with an often-rarefied rhetoric. While such texts may advance the scholarly discourse, they nonetheless run the risk of alienating students and representing problematic distinctions between "popular" and "literary." The current series is intended as a more democratic approach to comics studies. It reflects the need for more programmatic classroom textbooks devoted to the medium, studies that are not only accessible to general readers but whose depth of knowledge will resonate with specialists in the field. As such, each volume within the *Bloomsbury Comics Studies Series* will serve as a comprehensive introduction to a specific theme, genre, author, or key text.

While the organizational arrangement among the various volumes may differ slightly, each of the books within the series is structured to include an historical overview of its subject matter, a survey of its key texts, a discussion of the topic's social and cultural impact, recommendations for critical and classroom uses, a list of resources for further study, and a glossary reflecting the text's specific focus. In all, the *Bloomsbury Comics Studies Series* is intended as an exploratory bridge between specialist and student. Its content is informed by the growing body of comics scholarship available, and its presentation is both pragmatic and interdisciplinary. The goal of this series, as ideal as it may be, is to satisfy the needs of novices and experts alike, in addition to the many fans and aficionados upon whom the medium popularly rests.

Derek Parker Royal

FIGURES

ACKNOWLEDGMENTS

Thanks to all those who've read and supported my research and writing about webcomics in the past. I think it's an area that still receives far too little attention, so I appreciate my previous editors—most notably Valerie D'Orazio, Alex Zalben, and Tom Akel—over the years for giving me a platform to ramble at length on the topic, even when it wasn't bringing the attention that the latest superhero movie news was. I also want to thank the late Derek Royal for the opportunity with this book to expand on all the ideas that I'd merely touched in those pieces.

Thanks, of course, goes to all the webcomic creators whose work I've enjoyed and particularly those who I've pestered with questions over the years. Even those who I haven't specifically cited in this book have helped inform everything in it, and those creators who have been on the front lines of figuring out the webcomic form deserve far more recognition than they're currently getting. Even after more than two decades of webcomics being a thing, you're all still pioneering great work and I hope you're all able to celebrate that. Kudos especially to Frank Page and David Gallaher, who not only do great webcomics work themselves but have been especially supportive in my writing about the form as a whole.

Finally, I can't thank my wife, Laurian, nearly enough for her patience as I holed myself away every night working on this book—a fount of optimism and encouragement that I probably don't show nearly enough appreciation for.

Introduction

The internet has had a huge impact on society, certainly reaching far beyond its original intentions. It permeates many of the day-to-day activities of the world, with entire industries built up around supporting organizations' perpetual connectedness. Seemingly disparate industries like banking, education, retail, and entertainment are almost unrecognizable from a few decades earlier, thanks to the communications infrastructure and relative ubiquity of the internet.

So it should come as no surprise that the medium of comics has changed radically as well. Comics were, of course, around well before the advent of web technology and, like many other industries, saw drastic changes in operations thanks to the internet. Creators could share their art files with publishers electronically almost instantly, rather than shipping pieces of paper across the country. The shared files could be copied and distributed, which allowed for multiple people (e.g., inkers, letterers, and colorists) to work on the same comic simultaneously. Completed files could be digitally sent to the printers, whose print run could change almost until the actual pages were being printed as retailers send in their last-minute orders electronically. The internet enables just-in-time delivery of almost every aspect of the production process, streamlining how comics are made in innumerable ways. But more importantly for the purposes here, separating the notion of comics as content from their traditional delivery mechanism also means that many of those elements can be eliminated entirely, leading to webcomics.

In *Understanding Comics*, Scott McCloud (1993) spends the entire first chapter trying to define comics. He openly asked for competing definitions welcoming "the great debate" (23) and many have offered challenges or modifications to McCloud's definition. Regardless of whether or not you agree with his simplified "sequential art" definition (itself borrowed from Will Eisner), one thing few people have argued with is that the specific delivery mechanism should not be included in the definition. Comics can

be created on paper, rock, tapestry, glass, plastic, and so on; the medium of comics is distinct from its venue. That is, the content of a comic is separate from its delivery vehicle. To be sure, a comic's form of delivery can indeed impact its content, as will be discussed shortly, but the two are not necessarily tied to one another.

Thus by removing the traditional delivery mechanism for comics—namely, paper—one can begin to separate comics' content as distinct and distribute it via another venue. As alluded to earlier, this distribution is already occurring in the production process, as files get sent from the creator to the publisher to the printer, but in the case of webcomics, the readers themselves are included in that electronic distribution and are, indeed, the primary recipient.

How, then, are webcomics any different than printed comics if their files are all being sent around electronically anyway? Many printed comics are available digitally as well. Newspaper strips are frequently published on their syndicate's website (in many cases, technically before they are printed in the newspapers themselves) and many traditional pamphlet comics are available online via dedicated smartphone apps or a third-party online distributor like comiXology. How might webcomics be defined as unique relative to these other comics that are also shared via the internet?

There are two distinctions to be made with webcomics that separate them from other types of comics that happen to be distributed electronically. The first is authorial intent; did the creator(s) design the comic to be seen on the web in the first place? Many webcomics earn much of their income from the sale of printed copies of their material, as will be discussed in depth later, thus making print the ultimate destination for comics themselves. However, creatively speaking, creators working in this mode still work toward the webcomic format first with print collections a secondary consideration. At its root, the question of whether a creator intends their work to be a webcomic is significant.

At some level, this effectively removes external definitions for webcomics, or even comics, from consideration and places the definition within the rights of the creators themselves. Do they define what they themselves are doing as webcomics? As will be seen shortly, that criteria alone is inexact and inefficient at best, so it should not be used exclusively, or necessarily even primarily, as a consideration, but it should be a consideration nonetheless.

It is also worth pointing out that multiple creators often work on a single project, and they might not all be in agreement about whether a given work is intended for use online or not. For example, Chris Ware's *The Last Saturday* was serialized on *The Guardian*'s website throughout 2014 and 2015, but Ware himself was completely ignorant of its publication online. He had been simply commissioned for the piece from *The Guardian* and never saw the final product after he had turned it in to them. It was only at a panel discussion a year later when a fan asked about it that Ware learned how or where it had been used: "He seemed totally puzzled by the question, and it eventually came out that he never even knew it was published on the internet!! He assumed it was only going into the print edition, and was totally unaware that he had done a webcomic" (Ellis, 2017). In this case, *The Guardian*, who has yet to publish the comic in print, clearly intended it to be used online, despite Ware being completely unaware of this. Since creators and publishers may themselves have conflicting ideas on the matter, as demonstrated in the abovementioned example, that intent cannot be used exclusively as criteria.

It should be noted that, for definitional purposes here, intent still generally trumps initial publication venue. Traditional newspaper comic strips like *Blondie* and *Garfield* see the debut of each installment online technically before they're published. These strips are digitally queued up in advance and begin being served on their websites at midnight. The newspapers they're more commonly associated with, however, typically aren't distributed until an hour or more later, particularly in later time zones. Few people would consider *Beetle Bailey* a webcomic—certainly not originator Mort Walker or any of his successors—and thus using the initial publishing mechanism as a means of differentiating webcomics quickly becomes problematic. Since newspaper strip creators, while certainly acknowledging that their work is available online, still create their strips with newspapers being the primary outlet under consideration, they should not be considered webcomics.

The second factor is the software used in the readers' viewing. Rather than a specific program being the defining characteristic, though, it is the lack of a named application that is more important. It is this second criteria that is necessary to distinguish webcomics from digital comics. Digital comics are also delivered electronically, frequently via the internet, much like webcomics. However, digital

comics are viewed through some proprietary application software, such as Adobe Acrobat in the case of PDFs. Webcomics, by contrast, can be viewed natively in any web browsing software, with the specific rendering being handled by an open-source coding language like HTML.

To a casual reader, this distinction may not always be readily apparent. In the case of comiXology, for example, the comics they host are viewable through most web browsers which may make them seem like webcomics. However, the comic pages are actually served up through proprietary software that happens to be running within the context of a browser window, and is exclusive to that company. This can be more readily noticed if users attempt to save the comics they are viewing. With a webcomic, the "Save As" function in their browser will allow them to save a copy of the web page and all of the associated graphics to their hard drive so they can be viewed later in an offline capacity. The exclusivity of comiXology's platform prevents this, and users are not able to simply save a copy for later use. The "Save As" feature is still available in the browser, but it will not save any of the comic a reader is looking at thanks to the proprietary software in use.

Creators seem to intuitively know this distinction. While they are not necessarily likely to express the differences to others, they will identify their own comic correctly, in part reinforcing the notion of authorial intent. The distinction can be hazy for readers, however, as is evident in a number of prominent comics awards either conflating digital comics and webcomics into a single category or having digital comics nominated in a webcomics category and webcomics nominated in a digital comics category. These distinctions have become clearer to readers as time moves on, but the confusion in earlier comics awards highlights that it took several years for everyone to be able to differentiate one from the other.

An additional difficulty in identifying webcomics is the use of animation. By virtue of the paper delivery methods historically used for comics, animation simply was not a possibility. But with electronic delivery, it has become possible to present static images alongside animated ones with no appreciable difficulty. Referring again to McCloud's (1993) discussion of the definition of comics, he notes that "we all learned to perceive time spatially, for in the world of comics, time and space are one and the same" (100). McCloud argues that time can only be represented spatially

in comics; that is, that adding elements to a comic in which sequences are depicted through time instead of space removes the work from the realm of comics and into the realm of animations. Some comic publishers took to producing animations based off their previously printed works, calling them "motion comics"; however, the progression of the narratives was frequently so driven by the animation that the "comic" portion of the name is no longer accurate. The stories unfolded at a pace set entirely by the animators, and not at a pace set by the viewer, thus making the work much more passive, regardless of how active or involved the original comic may have been.

That is not to say that animation is unable to coexist with webcomics. Some creators have gone to adding short cycle animations peppered throughout their work. A cycle animation is one in which the animation is seamlessly looped and continues indefinitely with no substantive change in the story. Examples might include a running waterfall, a flickering light, a waving flag, or passing clouds. Technically, there is some time that passes during a cycle animation—typically no more than a couple seconds—but since they loop back to the same starting point indefinitely, they ultimately do not progress a comic's narrative at all. Whether the animation runs once or a thousand times, the reader can proceed to the next panel with no change in how much time has passed within the story itself. Thus, cycle animations are generally considered acceptable within webcomics; it is the reader who still controls the pace of the narrative, taking in each panel for as long or as short as they desire.

Similarly, but used less frequently, are sounds. Like animation, sound does have a chronological element to it and its use would suggest the reader no longer has control of the narrative pace. However, when its use is limited in the same way cycle animations are, sound can add another dimension to a webcomic. Typically, this will manifest in the form of ambient noise like crickets chirping, the ongoing hum of machinery in operation, or the never-ending crashing of waves on the shore. Here again, when these sounds are looped properly, they have the net effect of no time passing in the comic. A few seconds of unintelligible chatter in a crowded train station can carry on indefinitely to provide additional atmosphere, but without impacting how much time passes in the comic. The viewer is still left in control of their reading pace.

Despite some of these guidelines that narrow the definition of what might be considered a webcomic, the relatively low barriers to entry (which we will discuss later) mean that a great many people are able to create and publish webcomics. So many that there are literally hundreds of thousands that are posted online. In fact, thanks to social media, many webcomics get posted and shared and re-shared so much that webcomics as a medium is virtually ubiquitous online. Many people likely would say they never read webcomics or have no interest in them; although in point of fact, they probably read webcomics on a regular basis without even realizing it.

One of the benefits of working digitally, as mentioned earlier, is that it is very easy to copy and share files. Even before the advent of social media, an image used in a webcomic could be saved to a local hard drive and then pasted into message boards, emails, or messenger applications for immediate sharing. Additionally, the URL of a webcomic can be sent around as well allowing a reader to easily click directly to a specific installment of comic online. That is essentially how and why the internet was even created—to share files quickly and easily—and people who go online tend to grasp that concept very quickly.

What people do not often realize, however, is that a lot of what they are sharing are even comics in the first place. The notion of comics, in the public sphere, tends to be centered around specific intellectual properties they are at least nominally familiar with, whether those are characters like Snoopy, Batman, and Flash Gordon or regular series like *The Far Side, Tales from the Crypt*, and *One Piece*. Readers are familiar enough with these types of comics that they recognize them as such, and most likely close kin like the *Girl Genius* and *Penny Arcade* webcomics highlighted later in this book. Since those webcomics bear a superficial similarity in terms of overarching structure, they are seen as a form of comics. What is often not recognized as comics, though, are seemingly stand-alone, non-serialized works that utilize existing material as their source. These are frequently simply identified as memes, and are not often viewed as comics in the public consciousness.

It should be noted that not all memes are comics. Meme is simply the broader term for themes and ideas that are quickly and easily shared throughout a culture; these often take a visual form, as individuals might take a photo or a still image from a video and apply a caption to it. Again, with the advent of social media, it

became incredibly easy to share such images with large groups of people very quickly. A subset of memes, however, is presented in comic form, where a series of images are presented together, each bearing its own caption. Often these are still shots taken from video and presented in a question/answer/response format, where the first image presents a (usually famous) person asking a question; the second image presents a different person (also usually famous) answering in an unexpected, often humorous, manner; and the third image showing the first person's reaction. This basic formula, of course, can be expanded or modified in innumerable ways and the use of existing imagery means that people without even rudimentary drawing ability can put together their own memes. Indeed, a quick online search for "meme generator" turns up a number of online tools that allow someone to simply select from a predetermined list of images or image sets, and apply their own dialogue or captions.

These types of memes generally fall well within any definition of comics, but are often not thought of as such, in part because they are seen and treated under the broader umbrella of memes and, in part, because they frequently rely on images appropriated from other media like film and television. Because the images might show Gene Wilder as Willy Wonka from his role in *Charlie and the Chocolate Factory* or LeBron James from a televised basketball game, they're more closely associated with that source material's format than as a comic they have been transformed into. Regardless of any legal issues surrounding the use of appropriated material like that, the transformed works, when created to be shared online, are indeed webcomics. That they might not have a "main" website they're hosted on or appear with any regularity does not preclude them from being considered in the same vein as the other webcomics discussed in this book.

These definitions and clarifications about what will and won't be covered here may seem overly pedantic; however, there has been so little written about webcomics to date that this seems necessary as most readers will be coming to this book without the benefit of having read much else about the topic. As of this writing, there have been a total of six books written about webcomics in any capacity. Four of them are instructional guides for creators, and only two of the six even remained in print beyond 2008. Not only has little been written on the topic but what has been written is difficult to get a hold of.

It could be argued, of course, that a medium like webcomics which is very rooted in the technology of its delivery—the internet—is not ideally suited to be discussed in book form. The webcomics industry is changing so rapidly, thanks in large part to the technology, that traditional book publishing with its historically long lead times will mean any book written about the topic will be inherently out of date as soon as it's published. That could explain why so few have attempted such a volume.

There will be at least some passages in this book that will be noticeably dated as soon as it has been printed. Technology moves at an incredibly fast pace and the immutability of the printed page necessarily means that changes will occur that cannot be reflected here. Indeed, the rate of technological advancements is even accelerating. Futurist Ray Kurzweil (2001) explained, "So we won't experience 100 years of progress in the 21st century—it will be more like 20,000 years of progress (at today's rate). The 'returns,' such as chip speed and cost-effectiveness, also increase exponentially. There's even exponential growth in the rate of exponential growth."

So if changes are occurring so rapidly with technology, why commit such a significant amount of writing to a technology-based medium like webcomics? Certainly any number of changes can take place between when it was written and when it can first be read, so why publish something that will be at least partially inaccurate by the time it is printed? Even the care taken in avoiding particularly time-sensitive subjects, like the specifics of uploading finished comics to the web or the specific software applications used in creating webcomics, it will be impossible to avoid some terminology that may become outdated or referencing long-held standards that fall by the wayside.

In many cases, it makes more sense to discuss different aspects of webcomics independent of one another, in shorter and faster pieces that can be accessed and read online. Should changes occur, the articles could be easily updated or have replacement pieces entirely rewritten. In fact, many such pieces exist online already. Brad Guigar, in addition to his webcomic *Evil Inc.*, has posted a great deal of information about webcomics online in both written and podcast formats. He updates material regularly, not infrequently discussing recent changes in the webcomics and surrounding

industries. That it's online also means that it's searchable, so that it's quick and easy to get to topics that are of particular interest. Wouldn't that approach make more sense to provide accurate and up-to-date information?

The point of this work is somewhat different, though, in that instead of directing readers to short, specific pieces of information, it's intended to provide a broader overview. In discussing the differences between print and online reading, Torheim (2017) explained that longer, comprehensive works like this are better suited to be presented as printed books:

> If the text is long, needs to be read carefully and perhaps involves making notes, then studies show that many people, including young people such as students, still often prefer a printed book, even if it is available as both an e-book and in electronic formats with options for making notes, enabling the user to search for and highlight the text digitally. . . . When we are reading from a screen, only one section can be seen at a time and the available reading surface area is limited. If you read a printed medium such as a book, several text areas are available simultaneously and it feels easier to form an overview.

So while some of the specifics may feel dated very quickly, using the book form is more likely to do a better job of painting an overall picture of the webcomics medium as a whole, and provide the reader with a better understanding than what a series of shorter online posts might.

Further, comic and pop culture news websites also tend to pay only minimal attention to webcomics. When the topic is brought up, it is frequently within the context of print publications as when a creator well known for their print work, like Mark Waid or Warren Ellis, turns their attention to a webcomic project; or when a webcomic creator's work is picked up for publication by a major publisher, as with the case of Noelle Stevenson's *Nimona* or Kate Beaton's *Hark! A Vagrant*. The focus remains on print publication, with webcomics merely being an unusual angle for a particular article or press release. This is, not surprisingly, based on broader traffic trends, and a relatively recent analysis (MacDonald, 2017) found that only 30 percent of the stories on the top six comics news

sites are about comics in any form with "little news about anything other than Marvel or DC" and "very few sites with any reach [that] are publishing news about indies or even Image, Dark Horse and IDW." So that webcomics get so little coverage among comics press is almost to be expected in that type of environment.

All of which serves as context for and a preface to this volume. Webcomics, while ubiquitous among even those who don't profess to read comics of any sort, have been largely neglected in discussions about comics, while those who are discussing them are frequently overlooked by anyone who is not already a practicing webcomic creator. Webcomics, as is suggested by the increasing number of award categories devoted to them as well as the increasing number of webcomics winning awards in other categories, play a significant role in the broader spectrum of comics and deserve further study. They bear marked differences from cousins like newspaper comics and graphic novels, and cannot be fully examined only within the contexts of other forms of comics. While this author hopes to ameliorate that somewhat with this volume, it also means that some of the content may require longer explanations, as there is frequently only minimal material to reference or quote.

To focus the virtually infinite array of genres, topics, themes, styles, processes, technologies, business models, and so on that are utilized by webcomics into something manageable, this book is divided into four main sections. This chapter and the "Historical Overview," Chapter 1, provide a high-level view of webcomics in general. Chapter 2 will look at the "Social and Cultural Impact" of webcomics, particularly with regard to their "Ubiquity," "Technology," Conflicts with Newspaper Strips," "Audience Participation," "Education/Social Causes," "Formats," and "Financing." Chapter 3, "Key Texts," will then examine in greater detail seven specific webcomics: *Girl Genius* by Phil and Kaja Foglio, *Penny Arcade* by Mike Krahulik and Jerry Holkins, *Questionable Content* by Jeph Jacques, *Stand Still. Stay Silent.* by Minna Sundberg, *The Adventures of Gyno-Star* by Rebecca Cohen, *Dumbing of Age* by David M. Willis, and *Empathize This* by Tak et al. These were selected not necessarily as a perfect representation all of the webcomics available, but rather that they are emblematic of a variety of different approaches to webcomics and they will be discussed in terms of the ways they might be created or operate

differently than one another. These elements will certainly be seen in previous sections, but only in relation to specific examples; this section as a whole will discuss the topics with broader view, thus putting the earlier "Key Texts" into a wider context. Finally, Chapter 4, "Critical Uses," will address some additional questions to consider.

1

Historical Overview

It should go without saying that webcomics would not exist without the internet. Indeed, the world wide web itself would not exist without the internet, so in providing a historical overview of webcomics, it makes sense to cover the internet's basic history, leading to the development of the world wide web and, thus, webcomics.

As an initial point of clarification, "internet" and "world wide web" are not synonymous. The internet is essentially the collection of computers and networks that are all interconnected across the globe. It is what allows banks to process transfers electronically, electric companies to remotely see what sectors of the city are with or without power, and a reporter on one side of the country to interview a politician on live television from the other side of the country. It's the infrastructure that lets you communicate with your friends and relatives via email, instant message, voice over IP (VOIP), and pretty much any other method that doesn't involve either standing within earshot of them or handing them a physical object with markings on it. The internet is all of the world's computers connecting with one another in real time, regardless of the platform, the protocol, or the type of data being shared.

The world wide web, by contrast, is only a subset of that. Tim Berners-Lee (1991a) began the very first web page by describing the world wide web itself: "The WorldWideWeb (W3) is a wide-area hypermedia information retrieval initiative aiming to give universal access to a large universe of documents." He went on in a little more detail in his executive summary:

The WWW world consists of documents, and links. Indexes are special documents which, rather than being read, may be

searched. The result of such a search is another ("virtual") document containing links to the documents found. A simple protocol ("HTTP") is used to allow a browser program to request a keyword search by a remote information server.

The web contains documents in many formats. Those documents which are hypertext (real or virtual) contain links to other documents, or places within documents. All documents, whether real, virtual or indexes, look similar to the reader and are contained within the same addressing scheme.

To follow a link, a reader clicks with a mouse (or types in a number if he or she has no mouse). To search and index, a reader gives keywords (or other search criteria). These are the only operations necessary to access the entire world of data. (1991b)

What Berners-Lee is describing is a very precise set of documents available on the internet and how they can connect with one another. He is describing web pages. The references to "hypermedia" and "hypertext" are just saying that web pages can use images, videos, and sounds and link to other web pages. It is precisely that functionality that directly leads to webcomics.

With that distinction out of the way, the origins of the internet trace back to a set of memos written by J. C. R. Licklider of MIT in 1962. In them, he described a "galactic network" (Leiner et al., 1997) of computers connected around the planet that would allow anyone to access any data or programs from anywhere else. He was somewhat evangelical about the idea, and convinced a variety of people at the Defense Advanced Research Projects Agency (DARPA) of the idea's importance. Among others, Licklider spoke with Lawrence G. Roberts, who worked at DARPA and had begun working on having computers transfer packets of information via phone lines, eventually creating the first computer network by connecting a machine in Massachusetts with one in California in 1965 via the phone lines (although the initial connection crashed while transmitting the third letter [Gromov, 1995]).

Roberts soon found other researchers working on similar ideas. His connection had worked but the phone lines were inadequate for scaling up his network of two computers, and it was in incorporating the packet encoding processes developed by Donald Davies (who had also talked with Licklider) and Roger Scantlebury of the National Physics Laboratory (NPL) that broadening the

network might be made possible. Along with other researchers, they began planning a project they called the Advanced Research Projects Agency Network (ARPANET). In 1968, Roberts took their research and presented the plan for ARPANET to leaders at ARPA.

Work proceeded relatively smoothly from there, and DARPA's Bob Kahn organized the first public demonstration of what would become the internet, connecting twenty different computers, during the International Computer Communication Conference in 1972. That year also saw the debut of email, which easily and quickly became the most popular application among early adopters of the internet for the next decade (Leiner et al., 1997). Though perhaps not obvious at the time, email's popularity spoke to what would become one of the biggest allures of the internet; while it was originally conceived and designed to have computers connect with one another and share information, it was the concept of connecting people with other people that held more popular appeal.

Kahn then began working with Vint Cerf on creating a new transmission protocol. What had been in use thus far, Network Control Protocol (NCP), was expressly reliant on ARPANET as something of a central gateway, and provided little in the way of error-checking. If a single packet of information was lost or corrupted for any reason, things would grind to a halt. What Cerf and Kahn began work on was a new protocol that would account for these and other concerns.

The two developed the Transmission Control Protocol and the Internet Protocol (TCP/IP). While this would address a number of technical issues, there were several key components that further helped shape the tone of the internet. Primarily, they developed a protocol that was very deliberately decentralized. Not only would smaller individual networks not be required to route through ARPANET, they could operate independently and still allow information transfers from one system to another, regardless of the operating system. Systems could be built up independently and still communicate.

Getting into the 1980s, personal computers became more common as they grew more affordable and, thus, internet traffic grew as well. People were able to connect directly to larger systems to make library book requests, communicate with one another on Bulletin Board Systems (BBS), and share (mostly text) files with

others. This additional traffic started to push the limits of basic internet management and router capabilities of the time. These were both addressed basically with a combination of management decentralization and setting up a more hierarchical structure of how internet addresses worked.

All of these elements combined essentially laid the framework for much of the internet dynamic on the whole, where everything is a sprawling connection of not-necessarily related links with no real central authority governing any of the content. This can be seen in any number of ways today, from the thousands of independent "hubs" where groups of people can gather to discuss a favorite topic to the very fact that virtually anyone with an internet connection can launch their own webcomic about any subject they want. This is all effectively the result of the internet growing faster than a single group could maintain.

The challenge with the internet, as it existed up through the 1980s, was laid out by the world wide web's founder, Tim Berners-Lee (2001).

> Well, I found it frustrating that in those days, there was different information on different computers, but you had to log on to different computers to get at it. Also, sometimes you had to learn a different program on each computer. . . . Because people at CERN [where Berners-Lee worked] came from universities all over the world, they brought with them all types of computers. Not just Unix, Mac and PC: there were all kinds of big mainframe computer and medium sized computers running all sorts of software.

Berners-Lee, after having developed multiple programs just to convert one system's information into another system's format, sought to design a structure that all of the systems could tap into just as readily.

Berners-Lee began with the notion of hypertext, an idea that was then circulating in various forms. He documented his idea in "Information Management: A Proposal" and went on to develop what would become the three tenets of the web: HyperText Markup Language (HTML, the basic language of the web), Uniform Resource Locator (URL, an addressing system to uniquely identify each document on the entire web), and hypertext transfer protocol

(HTTP, the system of sending files across the web). He then went on to program the first web browser and invited colleagues to view the first web page he posted in 1990, announcing it more broadly to the world in 1991.

Berners-Lee (1998) was keen to have use of the web widely adopted:

> The dream behind the Web is of a common information space in which we communicate by sharing information. Its universality is essential. . . . The first three years were a phase of persuasion, aided by my colleague and first convert Robert Cailliau, to get the Web adopted. We needed Web clients for other platforms (as the NeXT was not ubiquitous) and browsers Erwise, Viola, Cello and Mosaic eventually came on the scene. We needed seed servers to provide incentive and examples, and all over the world inspired people put up all kinds of things.

To that end, he continued to follow the theme of decentralizing the foundations of the web: "It was simply that had the technology been proprietary, and in my total control, it would probably not have taken off. The decision to make the Web an open system was necessary for it to be universal. You can't propose that something be a universal space and at the same time keep control of it" (2002).

This open framework approach led to the final component that brought the web to the public at large. While Berners-Lee had been conscious of and wanted to accommodate a variety of media with his hypertext language, he generally felt that non-text media should just be linked to. His browser did not display graphics at all; linking to images meant the user had to download them first and then view them in a separate graphics program. But leaving the system open for others to play with allowed Marc Andreessen and Eric Brina to start developing their own web browser. They named their browser Mosaic and launched it for free in early 1993.

It was with the introduction of Mosaic that the web really began to take off. In the first place, it allowed for more design to be brought into web pages; features as rudimentary as centered text were not used previously. Coupled with some basic design features, it also was able to display inline graphics. It was not the first browser to be able to do this, but it was the first easy-to-use and popular one.

The ease of use was certainly a contributing factor in the browser's popularity, but almost as important was that Andreessen and Brina developed versions for Unix, PCs, and Macs, so it was available to nearly everyone who worked on a personal computer. "A Free and Simple Computer Link. Enormous stores of data are just a click away," proclaimed a headline in *The New York Times* later that year (Markoff, 1993).

This effectively sets the technological stage for webcomics. However, the idea of being able to read comics online had already begun a decade earlier. As alluded to already, navigating the internet prior to the advent of the web was done nearly entirely through text, with no graphics to speak of. What people had already discovered was that text-only messages do not convey the author's tone, and any number of arguments and disagreements came up simply because one person misinterpreted the intent of another: mistaking jokes for serious accusations, assuming offense when none was intended, and so on.

Eventually, people began discussing using some form of textual notation to indicate humorous intent. Ampersands, asterisks, and percent signs were discussed with some cleverly borrowing from newspaper comics' history showing a string of unusual characters to represent self-censored swearing. After a few days, Scott Fahlman (1982) proposed what would later be called emoticons.

```
19-Sep-82 11:44 Scott E Fahlman :-)
From: Scott E Fahlman <Fahlman at Cmu-20c>

I propose that the following character sequence
for joke markers:

:-)

Read it sideways. Actually, it is probably more
economical to mark
things that are NOT jokes, given current trends.
For this, use

:-(
```

While this certainly is not even a comic, it acts as something of a precursor to them. Providing humor and graphics, however limited, with the available options. T Campbell (2006: 13) compares this to

"cavemen with black ochre crayons . . . creating basic but effective cartoons out of the limited tools at hand." More importantly, it got people thinking about using the internet for purposes beyond data transfers and basic communication.

Embedded graphics were still several years away, but people began uploading cartoons to some of their early internet service provider hosts. One of the earliest (often considered *the* earliest) regular online comics was *T.H.E. Fox* by Joe Ekaitis, which ran weekly from 1986 through 1998. The single panel cartoons originally debuted on CompuServe before Ekaitis began uploading them to Q-link and GEnie. Each comic had to be uploaded manually on each system, so there was no single, comprehensive source for all the strips. Ekaitis (1994) kept the files small—only 160 × 200 pixels—and had to draw the text manually "one pixel at a time" at first because the graphics program he was using, KoalaPainter, did not have native text capabilities. Although his creative process did get streamlined over the years as the technology improved, it always remained labor intensive relative to contemporary webcomics.

Ekaitis was not the only one thinking about posting comics online before the web. Hans Bjordahl had been publishing his comic *Where the Buffalo Roam* in *The Colorado Daily* beginning in 1987. Despite the fact that Bjordahl was attending Boulder University at the time, he seemed largely ignorant of the internet. It was, in fact, his friend Herb Morreale that suggested he post his comics online. Morreale (1992) came to the idea independently of others. He relayed his thought process in his original announcement that *Where the Buffalo Roam* would be posted online soon:

I was sitting around thinking about all the neat things the net had to offer. You know, the usual stuff about "where is this whole things [*sic*] was going to be in 20 years?," and "I wonder if we will ever be able to shop on-line and transfer money directly," and "maybe we will be voting for the president on-line soon." While considering these types of things, I usually end up thinking about having the morning paper pop up in a window for me every day when I sit down with my cup of coffee. Clarinet is now offering the UPI wire in USENET format, so some of the "morning paper" is already available (though at a price). So what's missing? Not just *Dear Abby*, but the Comics!

The web was still a few years off, so pages with integrated graphics that didn't require independent download were not yet a thing, but people were already starting to explore the possibilities of the medium. Many people were exploring the potential of the internet and, certainly in hindsight, hoping to lay claims to having been the first to come up with an idea. Eric Millikin's *Witches & Stitches* comic, for example, is frequently cited as debuting on CompuServe in 1985 when Millikin was still in elementary school; however, there seems to be no surviving evidence of this and, in an interview where he was expressly talking about his early comics-making experience, he talked about selling his homemade comics for a quarter apiece in his fourth-grade class, but made no mention of the internet (Rall, 2006: 65). Conversely, Bjordahl (n.d) does claim that *Where the Buffalo Roam* is "the Internet's first regularly updated comic strip" despite clear proof that strips like *T.H.E. Fox* came earlier. Bjordahl's claim should likely also be taken with a grain of salt, though, as he also claims he posted the "first Internet comic strip to ever use the phrase 'diddle-dee-dee, yabba yabba nincompoop' on its Web site."

When the web launched in 1991, it was hardly the powerhouse that it would later become. In fact, not only was its future uncertain but it had competition with other protocols like Gopher. So creators were not necessarily flocking to the web right away. Ekaitis and Bjordahl, for examples, continued their respective efforts unchanged initially. Others, like Dominic White, launched their strips on protocols because it seemed like a better option for one reason or another. Indeed, White's internet service provider at the time, Seagopher, paid him a commission for his *Slugs!* comic strip, a benefit he was unable to get on the web (Campbell, 2006: 15). It wouldn't be until late 1994 that the web's popularity really began to take off as Gopher's began to decline (Lee, 2008).

The web itself, then, was just an experiment, and so it should come as little surprise that the first regular comic on the web was also an experiment. David Farley (2005) had been posting his *Dr. Fun* comic on USENET for years, and that was after printing them up as "a photocopied 'zine" that he distributed himself. Farley's initial goal was one of experimentation and entertainment. Farley (1993) stated when he first launched *Dr. Fun* on the web, "I'm doing *Doctor Fun* a) for fun b) because I can do what I want with the subject matter c) I can draw cartoons solely for viewing on video,

which allows me more latitude in color and texture than 'reality' d) to encourage other people to do the same." Farley then went on for another 300 words just describing and explaining why the comics were "presented only in a 640x480 24-bit JPEG format" which he arrived at via a seemingly good amount of testing.

Dr. Fun was compared to Gary Larson's *The Far Side* early on, even by Farley (2002) himself: "If you draw any kind of wacky one-panel comic, and anybody laughs at it, then somebody brings up *The Far Side*." Farley was also quick to admit, though, that Jim Unger's *Herman* was probably a bigger influence. That style of irreverent, non-sequitur humor seems perfectly fitting for the first regular comic to appear on the world wide web, as the very nature of hypertext often leads users through a seemingly perpetual cascade of frequently only tangentially related links. What a reader found on *Dr. Fun* on any given day could be just as unexpected as the series of links the same reader might find themselves clicking through that same day.

It should be emphasized that *Dr. Fun* was not the first webcomic of any sort, but rather the first *regular* webcomic. Stafford Huyler actually beat Farley to the punch by about two months, launching *NetBoy* in the summer of 1993. Huyler's schedule was erratic at first as he, too, was simply playing around with the new medium (Campbell, 2006: 20). What is worth noting, though, is that Huyler's focus in the strip was around computers and technical topics like graphic user interfaces (GUI) that were scarcely known outside software developers and over-clocking computers, a subject only tackled by heavy enthusiasts.

This, of course, reflected Huyler's own interests and background. But more significantly, it reflected the interests and backgrounds of people who were already online. The internet, and by extension the web, was largely the domain of those with a deep interest in technology in 1993. The web was populated by a combination of academics and technophiles, looking to see what this new medium had to offer. It is also fitting that the first comics of any sort to appear on the web reflected that. Many of the other early strips, like *Kevin & Kell* and *Helen, Sweetheart of the Internet*, discussed similar topics.

Whatever individual inspirations these strips provided to later webcomic creators, collectively, they helped to define the primary tone and style of later webcomics. While certainly all manner of

genres and topics and styles are currently available, that many feature an odd brand of esoteric humor and/or a strong bent toward technology can be linked fairly directly back to these first comics to appear on the web.

Most of the early webcomics were experimental in the sense that the web itself was largely an experiment, so any content that was uploaded to it would be one as well. The comics themselves were not necessarily experimental; they relied heavily on the forms and standards seen in the newspapers. Indeed, some of the early webcomics were being created and posted from people who had already been doing a comic for their local university paper. One of the first to branch out and actually explore how webcomics might be different than other types of comics was Mike Wean's *Jax & Co.*

Jax & Co. was a relatively straightforward strip conceptually. The titular Jax was an only child whose mother left him home alone frequently, and he used his imagination to make friends with the household appliances. Where Wean began experimenting was in the presentation itself. Rather than showing all of a strip's panels at once, he displayed them one at a time, giving the reader the ability to click through from one to the next. The individual panels for any given strip all remained on the same page, and Wean used Javascript (a relatively unheard-of scripting language in 1994 when *Jax & Co.* launched) to create a unique navigation system for the comic. While using only a simple seventeen-line script, Wean became the first cartoonist to begin to explore the possibilities webcomics afforded beyond just replicating what had already been done in print.

Charley Parker (2018) bills his *Argon Zark!* strip "the first long form webcomic." The accuracy of his claim certainly depends at least in part on how "long form" is defined and, to be fair, he has caveated that with "as far as I can tell" in interviews (Withrow and Barber, 2005: 80), but it stands out among early webcomics for several reasons. It was indeed "long form" in the sense that Parker treated each installment as the page of a graphic novel, rather than as a stand-alone joke or gag. If readers were interested in following along, they had to start at the beginning to understand the story. Also like a graphic novel, the artwork was much more visually robust than just about everything else available at that time, using a much richer color palette and extensive use of Photoshop filters and 3-D modeling. While arguably overdone by contemporary standards, at

the time, Parker was exploring what was possible to achieve online, taking advantage of computer monitors' vibrancy relative to paper. Tying in with the notion of the web being generally dominated by technophiles, *Argon Zark!* focuses on the story of a hacker who invents a Personal Transport Protocol (PTP) that allows uploading and downloading of physical objects via the internet. The story is heavily infused with science fiction, obviously, but much of the language and basic concepts shown in the comic are (extreme) extensions of what real hackers were discussing then. Parker takes the comic format itself a bit further by utilizing new features that were available on the web as he discovered them:

> I was amazed because it just seemed like a natural match to me. There were comics posted [online], but they were mostly scans of newspaper comics that had been posted as GIF files, the way you might tape one up on your refrigerator. Without anything to use as a guide, I figured I'd just have to dive in and make it up as I went along. . . . As new technologies appeared on the Web, like animated GIFs, JavaScript, dynamic HTML, and Flash, I started incorporating them into the strip. (80)

He was also one of the first to take advantage of on-page navigation so that users could simply click through the story one page at a time. While seemingly obvious in retrospect, many comics at the time relied on a single page that linked to all of a comic's installments, and a reader would have to click back to that page and then forward again to the next comic for each update. He later recommended, "It's extremely important to provide your visitors with simple, consistent, easy-to-understand navigation. If they get lost, they'll go away" (89).

After a few years of experimentation, both with the web generally and webcomics in particular, both the creators and the audience reached something of a breakthrough point. Internet usage among the general population of the developed world began taking off in the late 1990s (ICT, 2008). This meant that website traffic for everybody was increasing, just by virtue of an ever-growing potential audience. Simultaneously, enough creators had been online and experimenting that many of the big kinks in getting functional webcomics had been worked out. Creators had begun

adopting navigation techniques similar to Parker had created; they had seen people like Farley experiment with image sizes; they saw how comics like Huyler's could cater to a niche audience instead of trying to play to everyone like newspaper strips. Just as creators were figuring out how webcomics worked, an audience looking for them was coming online.

Although it's hard to find precise numbers of new creators starting webcomics at this time, it certainly seems that there were not enough collectively delivering new content as fast as new readers were coming online. In part because of this lack of content, it was during this period in 1997–98 that webcomics began seeing some names that would become huge success stories: *Goats* by Jonathan Rosenberg, *Bobbins* by John Allison, *Sluggy Freelance* by Pete Abrams, and *PvP* by Scott Kurtz, for examples. These creators were among the first to earn their livings making webcomics. There were few enough creators even attempting to make webcomics that many were able to succeed based at least in part on being in the right place at the right time, and their persistence in staying there.

One of those successes was J. D. Frazer's *User Friendly*, launched in late 1997. Like many early webcomics, it focused heavily on jokes about technology with the strip's primary setting being the offices of an internet service provider. Structurally, it bore some resemblance to Scott Adams's early *Dilbert* strips, and Frazer (n.d.) also adapted some of his readers' submitted experiences to comic storylines asking, "If you have a story or two, send them in! I really much prefer real-life stories, since the best humour has a grain of truth in it. Everything is open to abuse." More importantly, Frazer helped pioneer several webcomics functions that would become staples.

The notion of embedding "Forward" and "Back" links next to the comics themselves had become pretty standardized by the time *User Friendly* debuted. What had not been established yet, however, was a "Random" button that would send users to randomly selected strip from the comic's archives. This would not have made sense for a strip with a serialized story like *Argon Zark!* but for a strip that had little ongoing continuity, it allowed readers to quickly see a broad cross section of strips so readers could validate that they enjoyed the strip as a whole and the creator wasn't just having a particularly good week. In adding this, Frazer

was acknowledging the deliberate approach to mimic the structure of most newspaper comics.

Frazer also became one of the first webcomic creators to push for making a living from their strip. In a 2001 interview, Frazer stated, "Judging from the size of my audience, I knew that I could go one of two ways. I could do it all on my own, and not get very far, or I could turn it into a business and actually get paid for what I like to do" (Coleman, 2001). He started soliciting advertising early on, and he had begun selling T-shirts within the strip's first year. He even went as far as "forcing" readers to see the ads by running them right under the strips themselves, but deliberately delaying the actual strip an additional twenty seconds (Campbell, 2006: 39). With little else on the page, and ad blocking software still several years off, readers couldn't help but see the advertisements.

Frazer was also keen to capitalize on audience interaction. As noted earlier, he encouraged readers to send in their crazy technology stories early on. He set up each comic to include a "USENET-like comment thread" but got his fans to host *User Friendly* message boards (to minimize bandwidth issues to the comic's own site) (39). Finally, he set up a "postcard" system where users could select from a collection of images, greetings, and colors to create individualized e-cards that could be sent anyone with an email address. Not only being a fun point of interactivity for readers, this also acted as an advertisement to the e-card recipient, who may not have seen the strip previously.

User Friendly's audience demographic is likely what led to a problem few, if any cartoonists, had discussed previously: "rippers" and "scrapers." Because the strip was so strongly focused on technology, its audience was unusually tech-savvy. Frazer (2006) describes the comic as having "a hefty reach to a narrow but deep demographic of technology professionals. This includes front-line tech support to CIOs and CTOs; from regional ISPs to the U.S. Air Force; from the minions of Microsoft to the serfs at SuSE/Novell." This meant that they were fairly adept at finding ways to "borrow" the comic for other purposes. Initially, some of his readers took a quick look at his site's code and would embed his comics on their sites using his hosted images. This meant that Frazer would effectively be paying for that site's bandwidth, and wouldn't even gain the benefit of advertising revenue since these "rippers" only grabbed the comic itself, not the ads.

Later, other developers came up with "scrapers" that would automatically go to the *User Friendly* site, download the latest comic, and repost it somewhere else. While Frazer wasn't paying for additional bandwidth in these cases, he was losing money since his work was essentially being syndicated for free, against his wishes. Frazer certainly wasn't the first or only creator that had these types of issues, but he was one of the first to discuss it publicly.

The strips' early FAQ granted readers a relatively broad license with regard to repurposing *User Friendly*: "What I'm doing here is essentially giving you a very limited license to use an image or group of images from *User Friendly*. The spirit of that license is to let you do what you want for personal enjoyment, but you need to acknowledge that the image(s) are my intellectual property" (Frazer, 1999). A few years later, he changed his FAQ to include the following: "I don't like freeloaders, PERIOD. I understand there are people who can't afford to support *UF* with money, and most of them are fine with the ads because of that—and that's great! However, if you refuse to accept either (pay or ads), you fall into the phylum Annelida [i.e., worms and leeches]. You'll be treated as such" (2004). Frazer never seems to have needed to bring down a hard legal hammer on anyone, but he was clearly an early webcomics proponent of protecting his intellectual property and raised awareness of some issues before many other creators considered them.

Gamers were an important early audience for webcomics. As a group, they tended to be more tech-savvy than most and were, thus, more prone to going online, especially as more companies began developing games specifically to be played online. Games such as Ultima Online in 1997 and EverQuest in 1999 helped popularize the genre and encouraged more players to spend time on the internet (Koster, 2017). Whether the audience drove the content, or the content was driven by the type of people coming online, gaming became the focus of a number of webcomics, like *PvP* by Scott Kurtz, *8-Bit Theater* by Brian Clevinger, and *Ctrl+Alt+Del* by Tim Buckley.

Similar to the technology-themed webcomics, these gaming comics often relied on readers being familiar with various aspects of the gaming industry. As evidenced in the examples earlier, even the names of the comics sometimes required at least some minimal gaming knowledge to understand their meaning. With many

creators being gamers themselves, this led to some opportunities in advertising that many had not previously considered. Rather than simply host somewhat generic banner ads that might promote a company's game, creators would begin to develop custom comics using their own characters to advertise these games. Sometimes, these were done as regular installments of the strip where the characters might discuss or review the game; other times, the ads were separate from the strip but still done in the same tone and style the creator was known for. The success of some of these still-early webcomics led others to try to mimic them, creating something of a cycle for generating more webcomics about video games.

A more significant crossover between video games and webcomics, though, comes in the name of Bryan McNett. McNett is a video game developer by trade and doesn't seem to have actually tried his hand at creating his own webcomic. But what he did do was help to launch the webcomics hosting platform/creator community called Big Panda. The idea was novel at the time: creators could host their webcomics with Big Panda, who would sell advertising space for the entire group as a collective, and the profit from that would be shared back with the cartoonists. As hosting services at the time were often seen as prohibitively expensive, particularly for young cartoonists just starting their first comics, this seemed like an excellent alternative. For smaller and lesser-known comics, this could be an especially good deal since they were too small to warrant decent ad revenues on their own and they could gain some additional attention by being seen on the same platform as more popular webcomics.

That was a second significant aspect to Big Panda; it acted as a kind of comics portal where readers could keep up with and/ or discover hundreds of new webcomics. Among some of the more popular initial titles hosted, there were *Sluggy Freelance* by Pete Abrams, *Superosity* by Chris Crosby, and *Bobbins* by John Allison. The titles got ranked—and were subsequently promoted accordingly—based on traffic, which encouraged some (mostly) friendly competition among creators. Creators who had largely worked in isolation before began talking with one another and developing a community. Tim Dawson of *Dragon Tails* later recalled,

Big Panda was an eye-opener for me. As corny as it sounds, I kind of thought webcomics were a wonderfully new idea, that

maybe I had come up with. It was like newspaper comics, but on the internet, for free . . . stumbling across Big Panda was a bit like someone who was used to a one car town stumbling into a major city. (Xerexes, 2007)

Nukees' creator Darren Bleuel elaborated on some of the interactions he had:

That's when I really found out that webcomics (other than my own) existed, and got involved with the community. . . . These were the days before spam made email a chore, and I remember wasting lots of time on long email exchanges with Vince [Suzukawa, creator of *The Class Menagerie*], learning a lot about art and materials and drawing. I had no artistic training when I started *Nukees*, and no artist friends, so this was my first chance ever to actually find out how other artists work.

Those first encounters also led to a little webcartoonist club called "The Hotseat" that was great fun and a very valuable learning experience. A group of about 15-20 of us would read one comic's complete archives from our group each week, and give scathingly honest feedback. The advice I got on *Nukees* was great, but more importantly, it really also helped strengthen this emerging webcomic community. (2007)

The initial problem Big Panda ran into, however, was an economic one. Popular creators like Abrams realized that he could earn more money on his own, even after paying for more expensive site hosting. As more creators realized this and vacated the platform, this left Big Panda with some financial problems as they were not drawing as many visitors, thus decreasing what could be charged for advertising. This was soon followed by technical problems as well as the servers began "garbling descriptions, mixing up ranking order, and going offline longer and longer" (Campbell, 2006: 64). To further compound problems, McNett largely ignored emails and phone calls, leaving everyone confused and angry.

Crosby and Bleuel, as webcartoonists whose strips were on Big Panda, saw these problems firsthand. In one of the few communications McNett sent out, he offered to turn control of Big Panda over to Crosby, but never followed up after Crosby agreed (64). Crosby and Bleuel then went out to help cofound

another webcomics collective named Keenspot, and virtually every creator still on Big Panda followed them. While certainly better in communication and technical service, Keenspot ran into similar financial problems as Big Panda since they began with an almost identical financial model. Crosby had to scramble looking for other revenue streams.

Joey Manley started his own collective in 2002, focusing on more of a subscription model instead of one based on ad revenues. Modern Tales was able to lure known creators like Lea Hernandez and James Kochalka, and Manley began turning a profit within its first two weeks (70). Keenspot also introduced a subscription option on top of their advertising model as well, and both were garnering six-figure revenues by 2004 (71). While this didn't yet translate to a living wage for the individual cartoonists, it did prove that webcomics were a viable source of income. Other collectives like Comics Sherpa—run by Universal Press Syndicate, indicating the attention online comics were now attracting—and Slipshine came online with variations on the model, all with the hope of figuring out the best way to make money from webcomics.

As some were working on monetizing this new medium, others were more interested in exploring the form. While some early creators like Wean and Parker did play with ways of presenting their comics, the basic structures they used were familiar. Their comics presented a series of panels that were intended to appear in the context of a single monitor with buttons to click forward to the next "page" as a reader might turn the pages of a book. In his book *Reinventing Comics*, Scott McCloud introduced the phrase "infinite canvas" (2000: 200) to explain the formal possibilities webcomics had that were functionally impossible in print: "In a digital environment there's no reason a 500 panel story can't be told vertically—or horizontally like a great graphic skyline. We could indulge our left-to-right and up-to-down habits from beginning to end in a giant descending staircase—or pack it all into a slowly revolving cube" (223). McCloud (2004) went on to theorize other potential ideas for how comics could work online, and experimented with some of them over the next few years. *Zot! Online: Hearts & Minds* in 2000 and *The Right Number* in 2003 both play with variations of his infinite canvas idea.

Other cartoonists, whether following the notions in McCloud's book or exploring on their own, began playing with their forms

as well. Cat Garza toyed with a variety of ideas in *Magic Inkwell*, but many of his strips were expressly experiments with the formal structure and lacked any narrative; while they were interesting, they didn't capture a large audience. By contrast, demian 5's *When I Am King* did capture readers' attention with the wordless misadventures of an Egyptian king traveling through the desert, and the comic was written up in *The Comics Journal*, *Wired*, *The Independent*, and *Salon*. His strip had fewer formal experiments than Garza's, but what he did use was done expressly to serve the story's narrative. That demian 5 was based out of Switzerland also pointed to many people how webcomics were beginning to see experimentation all around the world.

This sort of attention was reflected with webcomics beginning to see awards and more formal accolades. In 2000, Scott Maddix and Mark Mekkes got together with the intent of creating an award specifically for webcomics. Called the Web Cartoonists' Choice Awards, they were set up as a form of peer recognition; only creators currently working on webcomics could vote. They only lasted through 2008, presumably due to problems that committee member Lewis Powell (2007) had previously cited, such as "making people aware of [the awards], getting people to care about them" and "communication, participation of the people involved."

Fortunately, though, other existing awards groups began seeing the relevance of webcomics and started to include special categories for them. Among the first webcomics to win these were Pete Abram's *Sluggy Freelance* which won an Eagle Award in 2001, Jason Little's *Bee* which won an Ignatz Award in 2002, Brian Fies's *Mom's Cancer* which won an Eisner Award in 2005, and James Kochalka's *American Elf* which won a Harvey Award in 2006. Despite this recognition, though, it would seem as if the various judges were not always clear on what a webcomic even was. Many of the categories initially conflated webcomics and digital comics as a single category, and even after a distinction started being made, some webcomics won digital comic awards and some digital comics won webcomic awards.

Almost as soon as the web became broadly available, people started looking for new content to publish online; hence, the rise of webcomics is essentially synonymous with the rise of the web. Not surprisingly, many people beyond cartoonists wanted to share their ideas and some chose to use the web as a way to do more

free-form writing, elaborating on whatever thoughts they might have regardless of the topic. This form of online journaling came to be known as blogging (from "weblog" coined by Jorn Barger in 1997, shortened to "blog" by Peter Merholz, and first used as a verb by Evan Williams [Baker, 2008]) and the early practitioners hard-coded their pages in HTML, just like any other web page. This meant the practice was largely limited to those who could write HTML code initially.

The practice took off in 1999 when a variety of platforms became available that allowed users to write content in a manner closer to a typical word processing program and post it without having to look at the code. Open Diary launched in late 1998, followed by LiveJournal, DiaryLand, and Blogger in 1999. On top of making the process to create content easier, they also provided hosting services and many people took advantage, including cartoonists. While the platforms were initially designed for writing, they did allow for including images, and comic creators soon realized that they could take advantage of blogging tools to help manage their own websites. While this might have been a bit limiting for creators deliberately trying to experiment with new webcomic forms, it worked fairly well for those just hoping to replicate the regularity of newspaper strips or comic books.

One of the platforms that became especially popular with cartoonists was WordPress, first released in 2003 by Mike Little and Matt Mullenweg. It is and was designed as more than a blogging platform, being described on their website as "an elegant, well-architected personal publishing system" that "provides the opportunity for anyone to create and share, from handcrafted personal anecdotes to world-changing movements." A key factor in WordPress' success (as of this writing, it is used on 32 percent of all websites) is that it is built with a great deal of flexibility ("Democratize Publishing," n.d.). Of particular interest to webcomic creators was the way Tyler Martin (2010) developed a very specialized theme for webcomics.

In 2005, Martin built a WordPress theme—essentially a page layout template—that utilized a lot of the best practices that had been accepted for webcomics. Other creators were able to take this ComicPress theme, apply their own color scheme and graphics, and almost immediately take advantage of all the basic functionality of standard webcomic: forward and back buttons, first and last comic

buttons, an archive page, and so on. Creators no longer had to try to become user interface designers on top of cartoonists. The theme proved very popular and, in 2008, it was expanded by John Bintz to include a WordPress plugin that helped creators to "automate many of the tasks in managing a comic" (2010).

This was certainly popular with creators, and it has been widely adopted as the standard for nonexperimental webcomics. While designed with a creator's perspective in mind, this has also been something of a boon for readers. With many of the best practice features built into the template, they no longer need worry that a creator has remembered to add "standard" functionality and, in fact, because they're based on a template, the functions show up in roughly the same place from comic to comic, and the reader is not required to hunt for those features. Further, that templated setup also means that when creators might try to over-stylize their buttons or links, the placement is familiar enough that readers have little difficulty in understanding what might otherwise be confusing navigation symbols or highly illegible fonts.

Reducing barriers to readership like this goes back to the creators' benefit, as people discovering the comic for the first time are less likely to turn away in frustration because of reasons unrelated to the comic itself. Greater readership, in turn, meant that a creator had a greater likelihood of generating living wages from their work. A few creators were beginning to earn a living from the comics, but their results were varied enough that it was difficult to tell what worked best and whether any of their success was repeatable. Some of the collectives, too, were making money, but generally not enough to support the creators in those collectives. A few years into the new century, Shaenon Garrity reflected,

> Money is the big missing piece in the webcomics puzzle. And, to jarringly jump metaphors, I don't think a magic bullet is coming along anytime soon. My best-case hope is that subscriptions and BitPass will become more commonplace and accepted. I think the real secret disappointment of 2004 was that, after two years of slow but steady growth, Modern Tales revenues plateaued. (Zabel et al., 2004)

BitPass, founded in 2002, was an attempt to get a working model for micropayments. The goal with micropayments in general, and with

webcomics in particular, was to reduce the barriers for payment processing online to enough of a degree that it would be viable to ask users for very small payments, often a dollar or less. The prevailing thought was that most readers would be unwilling to pay much for online-only content and that prices for webcomics would have to be exceptionally low. The subscription model worked for collectives because of the volume of titles that were available from a single collective could warrant somewhat higher prices; but for a single title, the cost would have to be much lower to draw in an audience, yet still high enough to cover processing charges. BitPass could not get their model to work ultimately, and they closed in 2007. Other micropayment companies of the time saw similar fates.

But cartoonists still felt their work was valuable, and that they should be able to find a way to draw their comics without having to support themselves via a job working in retail or laying out uninteresting advertising flyers at a small agency. Though it wasn't called this right away, some creators started playing with the notion of crowdfunding. *Something Positive* creator Randy Milholland (2003), in a fit of frustration with his day job, posted under his strip, "I work in Medicaid billing—so I bill poor people. ANYWAY, a ex-roommate has suggested I try to see if I can get enough donation to mach [*sic*] a year's salary (about 3 or so bucks per reader) and if I do, that I quit my job for a year and focus on comics." He wound up getting over $22,000 and other creators took notice. Jonathan Rosenberg raised $10,000 for *Goats*, Pete Abrams raised enough for a year's salary to work on *Sluggy Freelance*, and Michael Jantze raised over $60,000 for *The Norm* (Campbell, 2006: 142–43).

While these were primarily not necessarily donation drives, and many creators tried to offer something beyond their regular comic to contributors, there were by and large no real contractual obligations on the creators' part. The payment processes differed from creator to creator, and there was no real systemic way for them to keep track of everything. It was entirely reliant on the bookkeeping skills of the creators themselves (or the creator's spouse in at least Jantze's case). It was easy for readers to be skeptical of creators' claims, and there was little recourse beyond emailing the creator and hoping for a response if any problems arose. This wasn't unique to webcomics, of course, but issues like these across various creative industries helped to inspire the creation of formal crowdfunding platforms.

The basic idea behind crowdfunding platforms is that a creator solicits funds from a large variety small donors instead of a smaller number of large venture capital donors, not unlike the abovementioned examples. However, it is the platform that provides greater stability and accountability, allowing for a more organized and uniform method of tracking funds and a project's development. Often, social media platforms are tied in as well in order to make sharing information about the specific campaign easier. Most importantly, they handle the processing of payments, in some cases withholding disbursement of the money collected until a campaign is over. This is all done for a small fee, of course, so the platform itself can remain solvent and continue. Michael Sullivan coined the term "crowdfunding" in 2006, not long after Jeff Howe first came up with the term "crowdsourcing."

Crowdfunding platforms were not entirely new when Sullivan came up with the name. ArtistShare (2016) was founded in 2001 and bills itself as "the Internet's first 'fan-funding' platform." ArtistShare, however, was primarily focused on the music industry; it wasn't until Indiegogo launched in 2008 that a viable platform for cartoonists emerged. Like creators in a variety of fields, Danae Ringelmann, Slava Rubin, and Eric Schell had trouble funding their works—in their cases, plays, and films. But they recognized early on that such a platform would be of great benefit to a wide variety of creative endeavors. Rubin noted in an interview,

> Typically whatever your campaign is about is really about getting people involved; we like to say "do it with others." It's about creating a story or creating a campaign that others can be a part of . . . what we are now and what we are for the future is we're all about allowing anybody to raise money for any idea. ("Wake Me Up," 2010)

Kickstarter, however, was when the idea of crowdfunding really took off for webcomics. One of their main differentiators was that, unlike most other platforms at the time, they only charged people's accounts if a campaign successfully met its stated goal. Therefore, if a creator calculated that it would take at least $10,000 to fund their project, but they could only raise $9,000, the people who contributed would not have given their money to a project that couldn't be completed. This made the platform more appealing to

potential contributors and, by extension, to creators. Then, when Rich Burlew raised over $1 million to republish *The Order of the Stick*, many other webcomic creators took serious notice.

It was really Burlew's project (covered in greater detail in the Financing section) that opened many creators' eyes to the possibility and practicalities of crowdfunding webcomics. Putting a comic on the web in and of itself had long been proven relatively easy to do. The challenge had been making a living at it. While some creators had managed this as early as the late 1990s, their successes had largely been seen as aberrations. It was once these formal crowdfunding platforms became widely available that creators saw a practical way to create comics and earn a living doing so.

Although it should be noted that it still was not easy to achieve that, it was simply seen as viable. Some creators found the logistics of delivering on their campaigns in a timely fashion difficult. It became something of a given that any given Kickstarter project would likely ship at least two or three months later than was originally promised, and more than a few creators made note of unexpected costs that quickly ate up all of their funds. In perhaps the most alarming instance, John Campbell (2014) succumbed to the stress of dealing with cost overruns associated with fulfilling the rewards from their *Pictures for Sad Children* campaign, and they just began burning the books they already had printed (going so far as to post video of their doing so to prove it) after posting a 4,500-word screed against capitalism, and then deleting all traces of the webcomic from their site.

While Campbell's experience was by far an extreme, it was a number of creators dealing with those types of issues that led to a new type of collective. Whereas most previous collectives focused on attracting readership and, sometimes, sharing in ad revenues, others began to emerge that acted as more of a partner to share resources of all sorts. One of the more successful to date has been Hiveworks, founded in 2011. From a reader's outside perspective, it largely looks like any other collective: something of curated hub for a variety of webcomics. However, they go further by offering a variety of services webcomic creators might need help with, such as editing, book design, merchandise fulfillment, crowdfunding logistics, and online content management.

In Hiveworks case, at least, they started organically. Cofounder Isabelle Melançon (2018) recalled, "The intent was not initially to

create a business inspired by other existing platforms, it was just to help out friends." Their friends-helping-friends model proved successful on several levels, and they began commissioning entirely original webcomics beginning in 2013 with *Blindsprings* by Kadi Fedoruk: "In the end, we are pretty much a studio and publisher— we chose those terms because we feel like a space for folks to work at and receive assistance in the form of the services we have."

This speaks to where webcomics have risen. Where the original webcomics were completely independent works from the ground-up as creators worked in relative isolation, they developed communities, and started a variety of business models. A great deal of experimentation took place, both creatively and fiscally. What is noteworthy, though, is that webcomics as a whole became successful enough that industries have grown up around them to better support creators who just want to tell their stories. From platforms and basic payment processing to fully functional support groups that offer a set of à la carte services that compliment whatever an individual creator's strengths might be.

While there are still few successful organizations of this last type, that they have taken a solid foothold in the business around webcomics points to a level of maturity webcomics have reached as an industry. No doubt there will continue to be changes to the industry as technology changes, and as more creators experiment with new ideas. New business ventures will arise and will impact both the internet at large and webcomics specifically. New comics will debut and capture widespread attention. While experimentation will undoubtedly continue thanks to webcomics' continued low barriers to entry, there is a substantial foundation for the industry that will continue strengthening as more webcomics find more ways to success.

2

Social and Cultural Impact

Ubiquity

In early 2018, the internet reached a noteworthy milestone. The number of people who had access to the internet relative to the entire planet became a majority; that is, the number of people in the world who had access to the internet is higher than the number that did not have internet access. That includes everyone from major metropolitan commercial centers to poor remote villages that don't have running water or electricity. Out of everyone in the whole world, more than 50 percent of the world population could access the internet. This was led primarily by North America and Europe, which saw 95 percent and 85 percent of their respective populations with internet access. While Asia had over 2,000,000,000 people with access, this only represented half of the continent's population ("Internet," 2018).

Beginning in 1997, the rate of global adoption grew at a fairly steady 2–3 percent every year. Thanks to satellite and cellular services that are increasingly able to reach remote areas, there have not been any obvious hindrances that might slow that rate down. So-called "developing world" countries began getting internet access later, and had a slower initial adoption rate, but the 2–3 percent annual increase globally was largely driven by these countries' 2–3 percent rate starting around 2006 ("ICT," 2008).

Suffice it to say that the world wide web is increasingly becoming more accurately named. While the original point of the internet was to be able to connect remote computers (and, by extension, people) with one another, connecting intercontinentally was rare at first. As more and more countries were able (or felt obliged) to adopt the

technological infrastructures of the internet, more people were able to see what was being made available.

The technology being used has advanced as well. Cellular phones were commercially introduced in 1983, which encouraged a mass of individuals to begin considering wireless technologies for long distance communications. When they began getting combined with personal digital assistants in the late 1990s, the public began to see the devices more as pocket-sized computers than as phones with some additional features. Smart phone popularity skyrocketed with the introduction of Apple's iPhone in 2007 which added a much smoother web browsing experience with a more natural user interface. In 2017, the number of mobile phone subscriptions surpassed the world population and the penetration rate even among developing nations hit 98.7 percent (2017).

Clearly, not everyone with access to a mobile phone is using it to go online, however. Just having access is not necessarily indicative of having a connection fast or robust enough to adequately handle many of the graphics and videos available online. Cellular coverage maps show virtually complete availability throughout Europe, North America, India, and Southeast Asia, with large areas spreading out from population centers like Moscow, Sydney, Johannesburg, and Rio de Janeiro. Of those people not yet using the internet, only a third live in an uncovered area; two-thirds are restricted by factors such as affordability and literacy (George and Hatt, 2017).

So while global internet access is not, strictly speaking, ubiquitous yet, worldwide coverage is impressive and nearly everyone interested in connecting to the internet can do so nearly any place they are likely to find themselves. This means that webcomics, regardless of where they are created, can be both uploaded from anywhere and read from anywhere. And, while language barriers can still pose issues when it comes to understanding them, this gives webcomics a far greater potential reach than printed comics whose very physicality means that they would need to be manually transported to a location in order to be read, a process that, while technically doable, is functionally and cost-prohibitively impractical in many cases.

This, however, really only speaks to the ubiquity of the internet itself. That was the promise of the medium: to be able to connect with anyone, anywhere on the planet. That communication can be done

via the written word, audio, video, and so on. How do webcomics elevate themselves beyond many other forms of communication when it comes to finding themselves ubiquitous online?

Richard Dawkins (1976) famously coined the term "meme" in his book *The Selfish Gene*. He defined it in terms of a genetic replicators: "Fundamental units of natural selection, the basic things that survive or fail to survive, that form lineages of identical copies with occasional random mutations" (253). Memes, as Dawkins saw it, were basic ideas that could be easily passed from individual to individual.

> Examples of memes are tunes, ideas, catch-phrases, clothes fashions, ways of making pots or of building arches. Just as genes propagate themselves in the gene pool by leaping from body to body via sperms or eggs, so memes propagate themselves in the meme pool by leaping from brain to brain via a process which, in the broad sense can be called imitation. If a scientist hears, or reads about, a good idea, he passes it on to his colleagues and students. He mentions it in his articles and his lectures. If the idea catches on, it can be said to propagate itself, spreading from brain to brain. (192)

The term has since largely been appropriated by the internet, with its definition narrowed considerably to refer specifically to an image that is shared, usually via social media. Dawkins, in a 2013 interview, seemed relatively accepting of the alteration, stating,

> The meaning is not that far away from the original. . . . In the original introduction to the word meme in the last chapter of *The Selfish Gene*, I did actually use the metaphor of a virus. So when anybody talks about something going viral on the internet, that is exactly what a meme is and it looks as though the word has been appropriated for a subset of that. (Solon, 2013)

Also like a virus, an internet meme can be passed along unchanged or be modified before getting sent to the next person. With the preponderance of image editing software and online meme generators, customizing an existing meme is a relatively simple process even for those untrained in image editing.

One of the reasons internet memes are disseminated much more rapidly and much more often than the original memes Dawkins was discussing is inherent to the very structure of the web. Images do not need to be passed around in the traditional sense, but rather can be stored in more centralized locations which masses of people can access:

> On the Web, information is no longer distributed by sending copies of files to different recipients. The information is rather stored in one particular location, the "server," where everyone can consult it. "Consultation" means that a temporary copy of the file is downloaded to the RAM memory of the user's computer, so that it can be viewed on the screen. That copy is erased as soon the user moves on to other documents. There is no need to store a permanent copy since the original will always be available. (Heylighen, 1996)

For example, an internet meme stays centrally located on Twitter's servers not just when it is shared on Twitter but users who simply retweet the original are pointing to the exact same file without even having to copy the original.

Further, opting to save a copy and repost it, perhaps through a different social media channel or with some alterations and/or additional commentary, the nature of computers ensures that no image fidelity is lost in the process. Analog image replication processes, from photography to mimeography to manual replication, will result in some distortion and/or degradation from the original. Digital replication, however, allows for exact duplicates, further allowing a single image to be passed along to a wider audience without any change in its readability; both the first copy and the thousandth copy look exactly the same as the original. Both of these factor into internet memes having a much greater longevity than analog ones.

As already suggested, social media plays an important role in the sharing of memes online. Prior to that, they would primarily be passed along via email or posted on message boards; the former requiring the originator to have a deliberate selection of individuals to share a meme with, and the latter generally being somewhat self-limiting as many message boards are organized by specialized topics of interest. Social media allowed a person to share a meme

to a general audience of anybody they know and have connected with, whether that is via family, work, school, shared interests, or any other manner.

All social media platforms' success hinges at least partially on broad adoption. Not having a sufficiently large base with which a person can connect with others defeats the purpose of participating in the first place. Why bother sharing a meme if no one is going to see it? It is not surprising, then, that early platforms like Six Degrees and Friendster, from a time when broad internet adoption in general was still fairly nascent, were not able to sustain themselves long enough to grow a large enough user base to remain viable. When Facebook and Twitter publicly launched later in 2006, they were still only able to capture a little over 10 percent of all US internet users. It would take another three years to get that number of internet users using social media over 50 percent and two years after that for those platforms to attract 50 percent of all adults (Perrin, 2015).

One final component that needs to be examined before getting to the ubiquity of webcomics specifically is the rise of search engines. The first internet search engines predate the world wide web by several years, but were limited in scope to specific databases. The earliest web search engines were broader in scope, but had to be indexed manually. The first automated index of web files was a program named Archie, but it was limited to only looking at file names. It wasn't until 1993 that search engine programs began looking at and indexing the content of a page automatically, but this quickly became the standard. Additional algorithms have also looked at refining results based on things like popularity and authority, but it is examining content itself that lies at the root model of nearly all web search engines.

It is these later algorithms that become particularly significant. Earlier search engines, as suggested previously, focused on the text elements of a document. This meant that unless an image file was created with specific search terms in the file name itself, it would be invisible to search engines. Being able to examine the metadata of image files, the context in which they are posted, and even some automated analysis of the actual image itself (i.e., whether the image is line art or a photo, whether the image displays some recognizable object, etc.) allows individuals to search the web for specific images, beyond just the pages that might specifically reference that image.

Searches can be made for a particular character or artist or even just a broad topic, and hundreds of image results can pop up, allowing people to track down often very specific images despite using imprecise or vague terms.

So far, the components have all been discussed in relatively broad terms, referring to memes or images, and not necessarily webcomics. Certainly, webcomics are composed of images, so a connection of some sort should not be surprising, but the question that arises is this: How do these components help lead to the relative ubiquity of webcomics in particular?

To understand this, it helps to have an understanding of how webcomics are typically built. Regardless of how a webcomic might be formatted—whether it is three panels arranged horizontally like a newspaper strip or a six-panel grid arranged vertically like a pamphlet comic book or some other format entirely—most webcomic creators set up each installment or page of their comic as a single image file. The file format can vary, of course, as can the file size and image dimensions. From the computer's perspective, however, the smallest unit of a webcomic is not an individual panel but an entire page, the portion that a reader will see as a single update. The webcomic page is what the computer uses as a discrete unit.

There are multiple reasons for this. Possibly most noticeable from a creator's perspective is that it cuts down on their workload. If the smallest unit they saved their files as was the individual panel, that would mean they would need to upload three or more image files (depending on how many panels they used on the page) for every update instead of one file for each update. Additionally, depending on the software they use for updating the website itself, they might have to place the multiple panel images on the page separately, instead of letting the software simply choose and display the latest file. (There is no doubt that automated scripts could be written so that a multiple image file format could be handled without manual intervention every time, but given the other benefits the single file format has, this is unlikely to be given much attention by a developer.)

Another benefit is that page layouts can be modified to fit the needs of the narrative. If panels were the smallest unit to be dealt with, creators would have to follow a pretty structured grid system in order for the pages to appear properly online. Computers, by

their nature, are ordered and regular, so trying to create unique, customized layouts on every page—particularly if irregular panel shapes were utilized—would be difficult, if not impossible, for web browsers to render properly with any consistency. This would not only be frustrating for readers but could potentially hamper legibility. By having the image files contain an entire page, as opposed to a single panel, creators can play with a wide variety of page layouts without spending extra time ensuring that a page will display properly across all platforms and devices. The only concern would be whether or not the image loads at all, and not whether all the images load and are displayed with the correct organization.

This leads to the benefits of the single image format with regard to search engines and social media. While perhaps not the foremost concern for a creator, using the whole page as a single image benefits them by expanding how many people might come across their webcomic.

Think first of how a comic might be shared in an environment of printed material. A newspaper strip might be cut out, perhaps photocopied and shared by handing individuals one of the copies. Comics that come from less disposable format like a book might just be photocopied in order to preserve the original. But it's noteworthy here that the page is generally the smallest shareable unit. Readers generally do not pass along individual panels, but focus on a single, complete installment. In the case of a gag comic, this would be the setup, response, and punch line. Missing any of those components removes the context and relevancy. For pamphlet comics, the page might be a fight sequence or a character's soliloquy. Here again, not having the full page removes any of the individual panels from their context and relevancy.

It should not be surprising, then, that the same is done with webcomics. Before getting to search engines and social media specifically, though, imagine trying to share in the same manner as in print, but just using email. In the case of a gag strip, a reader would be interested in sharing the setup, response, and punch line of a webcomic, the same as they might with a newspaper strip. In the case of a more dramatic story, the reader might again want to share a character's speech or a fight scene. If a webcomic were structured so that each panel was a separate file, the reader would need to copy or save each image individually, paste or attach all of the files to an email, and organize them in such a way that the

recipient would not have any difficulty reading the full sequence. This would essentially duplicate the efforts the creator would have had to go through to organize the image files in the first place. If the webcomic were created as a single file for each page, however, that single file could be copied/attached to an email more quickly and with no concern about the recipient having difficulty reorganizing the files into a cohesive narrative.

The same holds true for social media. Social media sites organize and display shared image files differently from one another and, sometimes, even differently between the desktop and mobile environments of the same service. If users only have to post a single image file, with no concern about reading order or visual organization, they are more likely to share an image in the first place because, again, they are using the individual installment as the discrete, shareable unit, not an individual panel.

Ideally, a creator would share not the image files themselves, but links to the page as it appears on their own site. While initially, this desire would stem from the additional ad revenue generated by more site traffic, the rise of ad blockers has decreased advertisements' financial significance considerably. (See the "Financing" section for more details.) But even without the revenue from advertising, getting additional readers to the webcomic site itself brings them into the fold of the webcomic environment, where the creators have more direct control over the messaging that is seen, and can direct people toward any aspects of the site they deem most important.

Not every social media outlet makes sharing in this manner an ideal experience for their users, however. Preview images, if they're shown, might be truncated or reduced so that the image isn't readable on the social media platform itself. Sharing the image directly, generally, is a better reading experience as the images are frequently displayed larger, and the reader does not have to leave the platform they're already in. Social media platforms do this intentionally, of course, for exactly the same reason webcomic creators would prefer people link to their site instead of reposting an image: it keeps the users in that environment where the social media company has more control over the messaging. Social media companies would prefer keeping users on their platform longer and making external linking a less than ideal experience decreases the likelihood users will use that option (Cooper, 2016).

Whether webcomic creators have thought about why social media companies do this is largely irrelevant, but they do recognize that this happens. *Scary Go Round* creator John Allison noted, "I think the biggest change is the way in which people use the web. For so many people, Facebook *is* [emphasis in the original] their Internet. The time they spent goofing off at work, perhaps reading webcomics, is now spent on social media" (Dale, 2015). While they generally have little power to alter social media platforms to work more in their favor, many have responded to by embedding relevant information in the image file itself. Along with the comic, many creators also add, if nothing else, the URL of their comic. Others might add their byline and the comic's title as well. But in seeing that their files were often passed along without attribution, much less a link, creators thought to at least do what they could to mitigate these lost opportunities by adding relevant details for finding their comic in the comic images. That way, a person seeing one of the images just randomly shared without any context beyond the page itself can still find their way over to the webcomic site itself.

The same basic principle can be applied to search engines as well. When running a search on a specific webcomic, typically, the first result pointing to the webcomic site itself will be the comic's home page. This serves both the users and the creators well, as they both recognize the home page as a place to get a summary or overview of the comic. Frequently, the creator will display on the home page their latest installment so readers can get a good sense of the comic's current style and tone, with links to more in-depth details like character descriptions, information about the creators themselves, or additional projects they work on. This all serves as a decent introduction to their webcomic, which a person searching for that comic in particular might be interested in.

However, people looking for a specific instance of a webcomic—perhaps featuring certain characters or covering an unusual topic—might use a variety of search terms that do not include specific references to the webcomic or the creators by name. They are not necessarily looking for that webcomic in particular, but perhaps just something that fits certain broad criteria. Ideally for them, then, they would be directed to a page deep within the webcomic's site that directly relates to the search terms they used. Additionally, if the user is looking for an image to use (perhaps in a student paper

or a background graphic for a slide presentation at work) and is unconcerned about its context to a longer webcomic, they might only run an image search; while this still allows for a user to go back to the webcomic site itself, they generally by default remove much of the context and present the user with just the images themselves.

In these latter cases, the webcomic is presented, at least as far as the creators are concerned, in a less than ideal scenario. The user is not interested in the comic per se, just that single image; and they will be happy to take it out of context. This, then, gets back to the creators using the page as the smallest unit of the comic, instead of the panel. By using an entire page as a single image file, search engines tie their results to at least some form of context—the several panels constituting a single installment—increasing the likelihood that someone will get some sense of the comic, even if that is not what they were initially interested in. Here again, even when these images might get shared via a presentation at work or school, far removed from the context of reading webcomics, anyone seeing these can still be directed back to the site via some of the information embedded in the image itself.

While this type of sharing is frequently thought of in terms of a regular webcomic with a dedicated website (the reason why the abovementioned description is presented the way it is), it applies equally to webcomics that are not presented in a regular fashion by people who might consider themselves webcomic creators. As mentioned in the Introduction, memes are often presented online in the form of webcomics. By using a series of captioned images, often still shots taken from some form of video, many people create jokes and present ideas that can, and are in fact often designed to, be read isolated from the broader narrative context of an ongoing webcomic title. While they don't always have a "home" URL they might be associated with, they can still be shared via social media and found on those platforms via search engines.

It is worth reiterating here that an image can be a meme without being a comic, just as an image can be a comic without being a meme. The notion of memes speaks to a concise idea's predilection to being shared, irrespective of its actual content. Thus a single image can, and often is, presented as a meme, but a lack of temporality in the image would prevent it from being a comic. Likewise, a webcomic might be posted on a creator's site, but without getting any appreciable

sharing traction, it fails to become a meme. For the purposes here, any image in question must be read as a comic (arguably using McCloud's "sequential art" definition from the Introduction) and also as a meme (using Dawkins's description from earlier in this section), and these criteria both need to be applied independently.

These types of memes have become relatively popular in part for that reason of context. There's generally no need to be aware of what other comics the creator might have put together, and there frequently isn't even a need to be aware of the context of the original source images; the characters' expressions as presented are often all the context that is needed. (Although some of the cleverer sequences take advantage of the original context to provide an additional layer of meaning, playing off subtexts present in the source and/or metatextual information.) Thus these memes can be shared among wide groups, regardless of viewers' familiarity with even the individuals portrayed, much less the image sources.

What further encourages these types of comics to be shared is the ease with which they can be imitated, either by mimicry or by remixing. Image retouching software is readily available in many configurations and packages, which gives almost every user with a computer the ability to mix and match elements digitally, regardless of their artistic skill. The creativity involved in replicating meme comics helps to develop an online cultural capital; Limor Shifman (2013) goes so far as to state, "User-driven imitation and remix have become highly valued pillars of contemporary participatory culture."

Users can significantly change the meaning or context of a circulating meme by copying and pasting a new element to the image. Replacing the faces of characters in the images, even if crudely executed, can still convey a significantly different point than the original. Simply labeling the figures differently, making the images a visual metaphor, in fact borrows from standard editorial cartoon practices that go back generations. In some cases, the original images were uploaded to a site specifically for creating memes, and thus can be recreated with hundreds of variations by other visitors to the same site. A simple online search for "meme generator" returns tens of millions of results, with the first twenty pointing to entirely original and unrelated sites, and one of those is a results list on the Google Play store for Android phones. While the quality and usability of these of course vary, that they are all

readily accessible speaks to the ease with which people can create their own meme comics.

Another reason these types of memes propagate so widely goes back to the very notion of comics themselves. First, the visual nature of comics is inherently eye-catching; research has shown that a Tweet with an embedded image receives 150 percent more retweets than those without (Cooper, 2016). Similarly, Facebook posts with images see over twice as much engagement than those without (Pinantoan, 2015). People's eyes are naturally drawn to an image over just text since the image "reads" quicker. This also speaks to why users seem to have a preference over audio; it's much easier and quicker to get a sense of a comic's content at a glance, compared to having to listen to at least a portion of an audio file in real time before even having a basic sense of its content. They are also more likely to recall the same information when it's presented visually instead of audibly (Nelson, Reed, and Walling, 1976).

None of this is to say that comics are inherently a better medium, simply that they are more conducive to sharing and being shared online. While many people might not recognize them as webcomics—whether because they are not overtly tied to a specific title and/or creator or because they might use photo references instead of an illustration style more commonly associated with comics—they wind up being distributed in wide circulation thanks to both social media and search engines. The widespread use of both, coupled with the ubiquity of internet access among worldwide population centers means that webcomics, in some form, are virtually as ever-present as the internet itself and are read, in some capacity, by nearly everyone as a result, even if they do not identify as webcomic readers.

Technology

It should go without saying that webcomics rely on digital technologies much more than other forms of comics. While contemporary professional print publishing certainly is very reliant on many of those same technologies, it has a centuries-long history of analog production. Webcomics, by definition, are only possible at all thanks to the technology that powers both the internet and

the world wide web and, as such, they are completely dependent on them at all times.

One of the challenges webcomic creators face is the ongoing changes in technology. Again, while this is certainly true of many industries broadly speaking, the changes for webcomics can be both more impactful and difficult to acclimate to. In part, this stems from many creators being single-person operations whose skillset veers heavily toward art and storytelling, with minimal formalized background in either web technologies or creative software. With substantial updates coming from them with little warning, and without a dedicated resource to help them with things, this can leave many creators at a disadvantage.

One of the earlier technological challenges webcomic creators faced was an issue with bandwidth. The first commercially available modem—which predates the world wide web by decades—was the Bell 103, which was introduced in 1962 and had a speed of 300 bits per second (bps). This remained the standard speed for modems until the 1980s when 1,200 and 2,400 bps models were introduced. On that type of setup, a small, black-and-white GIF of the sort used in Hans Bjordhal's early *Where the Buffalo Roam* comic would take a minimum of two minutes to download under ideal conditions. While some early adopters of the internet would be willing to wait that long just to experience having a comic delivered in that manner, it hardly makes for ideal reading conditions.

Modem speeds of course continued to improve, and a 14,400 bps model was available in early 1992, not long after the world wide web was launched. While this increase in speed was certainly welcome, it was still slow enough that download times were still a significant consideration for creators. That same *Where the Buffalo Roam* comic would take 20 seconds to download. For the era, that was not an unreasonable amount of time to wait. However, creators needed to be careful not to make their image files too large, as they risked losing potential readers. For every additional kilobyte an image file had, that meant another half second the reader would have to wait to download it; a mere 10 kb meant another five seconds.

Creators had to spend at least some of their creative time trying to compress their images as much as possible. They would limit the color options in GIFs, altering the overall palette, or used such heavy compression in JPGs that the images became distorted. The image

dimensions were often reduced to such a degree that text would sometimes become hard to read. Creators had to experiment in striking a balance between maintaining basic legibility and keeping the file size small. The web was still a nascent environment, and few could afford to give visitors any reason to leave; forcing users to wait an extended period for everything to download absolutely qualified as an excuse for a potential reader to move on.

As transmission technologies improved, this became less of a concern. However, older webcomics, particularly those that have finished and are no longer updated regularly, still show evidence of bandwidth concerns in their smaller image files. As internet speeds and monitor resolutions continue to increase, though, seeing even larger image files taking advantage of both is to be expected.

Monitor changes, in fact, have been another issue that webcomic creators have had to deal with. The earliest home computers used cathode-ray tube (CRT) monitors, many in fact hooking directly in to television sets, although by the time the world wide web debuted, computer manufacturers had switched to relying on VGA monitors dedicated to computer devices. These provided sharper images and more accurate colors than televisions of the time. However, like televisions, they began appearing in an array of sizes and, unlike televisions, with a variety of resolution settings.

Both the size and the resolution are significant because they impact how much of a web page (and any comic that might be on it) can be seen without having to scroll around. A resolution of 1024 × 768 pixels was not uncommon for desktop machines in the 1990s, and creators tailoring their work to fit in that size screen might have felt secure that most of their readers could see and navigate the site comfortably. The problem with that assumption, however, was that approach did not work well in two notable circumstances: with larger, higher-resolution monitors and with laptops.

Laptops of the time typically used liquid crystal display (LCD) monitors, which were more expensive to produce than comparably sized CRTs. In order to keep costs affordable, most laptop screens were considerably smaller than desktops, with resolutions between 60 percent and 80 percent of average desktop sizes. Therefore, building a webcomic site based off the larger resolution meant anyone viewing the same comic on a laptop would see at least some of the imagery cut off. A reader could use their mouse to move around the page and see the whole comic, but this could become

frustrating and annoying very quickly, as it disrupted the reading flow of the comic.

Higher-resolution desktop monitors could also be problematic, although for different reasons. Early web page designs frequently had to work with very limited layout capabilities. HTML was not originally designed to accommodate anything resembling design; an image could only be aligned to the left, right, or center of the page. This meant that, on larger monitors, there could be huge stretches of unused space on either or both sides of a comic when viewed on larger monitors. While this did allow readers to see the entire strip without having to scroll, the large empty spaces did tend to be visually uncomfortable.

The increasing proliferation of sizes and even aspect ratios for monitors continued to make things challenging. Before launching a webcomic, a creator would almost have to study the trends in current monitor resolutions in order to cater to the broadest audience possible. However, as this might not be reflective of the webcomic's specific audience, it would often be advisable to review the comic's own unique user statistics to see if any adjustments might improve the experience.

Further complicating things were the advent of smart phones, with screen sizes radically smaller than even the original laptops. Additionally, while most phones will automatically reorient the screen depending on whether a person is holding it vertically or horizontally, the default orientation for most people is vertical as opposed to the horizontal format of most desktops and laptops. The extremes that creators had to take under consideration grew even further apart.

Arguably, a creator could ignore these issues and still produce a webcomic; it might just be difficult (or even impossible) to read on some devices. A technological challenge they can't ignore, however, is the ongoing evolution of the hardware and software they use in creating the comic in the first place. The first part of this problem stems from computer manufacturers creating their hardware using a policy of planned obsolescence, the practice of deliberately building products with a limited lifespan so that customers are forced to purchase new ones on a relatively regular basis. Two obvious examples here might be smart phones and laptops, whose rechargeable batteries will degrade over a period of a few years, eventually becoming unusable; but if the unit itself is completely

sealed and the battery cannot be replaced by itself, the user is left with little choice but to purchase an entirely new unit.

This notion of planned obsolescence is not limited to battery life, however. A SquareTrade study in 2009 found that roughly one-third of all laptops fail in the first three years, mostly due to hardware that has worn out (Sands and Tseng, 2009). Many goods are built with deliberately inferior materials that are prone to break, particularly parts that are critical to the device's basic operation. Software can be an issue, too, though. In 2017, Apple admitted that it had been slowing down the speed of users' phones shortly before the release of newer models (Clover, 2017). While they claimed it was to extend battery life as those wore down, that it always happened to be timed to coincide with the release of a new product seems more than a little suspect. But regardless of the reason, virtually all electronic devices that might be used in conjunction with creating a webcomics—from the computers themselves to drawing tablets to monitors to scanners to modems to routers—will need to be periodically replaced (repairs are generally impractical financially) causing both a disruption in a creator's workflow and an ongoing need to ensure their income can cover such costs as a basic necessity of their webcomics business.

Another related potential issue stems from actual damage. While it's uncommon for a desktop device to fail because it fell off a table, many creators work from laptops. This allows them to operate in a more mobile manner, as they take their laptop to work or conventions in order to maximize their time. Others prefer taking their equipment to a coffee shop, than having to work in their home studio, in order to work in a more energetic area. This travel back and forth certainly adds a physical wear and tear on a user's laptop, as well as exposing it to a much greater possibility of being dropped. Not to mention other possible sources of damage, like a still-full, but stray, cup of coffee. Accidents of any sort can damage a creator's expensive equipment, rendering further development of their webcomic impossible until a replacement is made. While traditional tools are certainly prone to damage, as well, and their breakage can halt comic production just as readily as a computer, their replacement can be orders of magnitude smaller, relative to a computer or laptop.

Obtaining a new computer does allow for a small benefit in that the user is, by default, upgraded to a functionally better system.

Although the rate of improvements has slowed somewhat in the years around the time of this writing, Moore's Law of computer capacity doubling every 18–24 months has remained surprisingly accurate since Gordon Moore's initial observation in 1965. For the typical consumer, this means that every phone or laptop they get is twice as fast as the one it's replacing. This, however, is not inexpensive and, in an industry whose creators' livelihood are entirely dependent on these pricey tools remaining fully functional all the time, these upkeep costs can arise at particularly inopportune times and/or be prohibitively expensive.

But being able to replace hardware like this is only a portion of the challenge. While the newer processors can generally run faster, suggesting that creators can be more efficient while they're working, it's also not uncommon that the older software that was used previously can become error-prone or might not work at all. Software often takes advantage of shortcuts inherent in processor architecture to make their programs run smoother or faster than they otherwise might. Trying to utilize the same shortcuts using newer processors and/or processing architecture might well slow the software down, or even prevent it from running altogether. Thus, trying to work on a new computer might well mean that updated software needs to be purchased at the same time.

Even if a creator's hardware continues to run smoothly and does not require replacing, they can still be the victims of this game of leapfrog. As new processors are released, software developers try to take advantage of the faster speeds by rewriting their program code to better utilize the new hardware. Where this can become a problem is that, if updates are automatically pushed out to existing users as might be the case with Adobe's Creative Cloud software, they could be left running software that is no longer tailored toward the system they have, but the newer ones that are becoming available. This can lead to updates not being able to install or, worse, install but not run.

The Adobe example raises another technological concern creators have to deal with. While the company was founded in 1982, it was not until the last two years of the decade that they began making serious forays into the image editing software market they would later become known for. Their two primary products, Illustrator and Photoshop, were very popular and became the de facto standards for computer image manipulation by the mid-

1990s. By 2005, Adobe had bought out many of its main rivals underscoring "consolidation in a crowded market and customers' desires to deal with fewer vendors" (Graham, 2005).

Having all but a monopoly on image editing software, Adobe switched from perpetual licenses to a subscription model in 2013. Now, instead of paying for the software once and being able to install it on subsequent devices as they were upgraded or replaced, users were being forced into ongoing subscription contracts. *Forbes* writer Adrian Kingsley-Hughes (2013) explained,

> At the core of the protest ultimately is the fact that some people dislike the notion of a monthly bill in order to be able to use a piece of software. They see it as another monthly payment, along with their rent and car payment. These people would rather buy the software outright, and then run it for as long as possible. Many of these users are running old—some very old—versions of Creative Suite, and don't feel the need to pay for an upgrade.

The drastic change in Adobe's business model had a direct impact on webcomic creators' operations as many rely on their software to create the comics.

A similar problem can be found in hardware. Storage solutions, particularly for early webcomics of the 1990s, were still largely limited to some iteration of floppy disks. Whether the more traditional type of floppy or larger capacity devices like SyQuest or Zip drives, they worked by storing data on a magnetically encoded disk. These were largely replaced by digital optical devices like CDs and DVDs, which were in turn largely replaced by flash drives. In each case, the devices used to read these storage options became obsolete and were no longer supported. Creators storing their works might find themselves in the unenviable position of no longer being able to access their original source files, unless they would periodically upgrade their storage system entirely and transfer older files to a more contemporary format. While not always an expensive prospect, it can be a time-consuming one, assuming the lone creator has the wherewithal to recognize the technology shift and its implications before it's too late. Considering that access to old files is typically not a top-of-mind concern for creators perpetually working toward their next deadline, this likely fails to happen more often than it should.

Another ongoing concern is the very language of the internet itself. The web is largely based on the Hypertext Markup Language (HTML) which is, in essence, a way of adding some notations to a text document that can use "tags" to define different aspects of how the document should be read and interpreted by a browser, such as whether a portion of text should link to another document or where a new paragraph should begin. The original draft of the language included only eighteen tags, although some early browsers expanded that capability informally before they were later adopted by the World Wide Web Consortium (W3C). It was still discrete and straightforward enough that the language could largely be learned over a weekend, and easily updated by anyone using a simple text editor.

With time, not surprisingly, the possibilities on the web expanded. JavaScript was introduced in 1995 and formally adopted in 1997, while Cascading Style Sheets (CSS) was introduced in 1996 and formally adopted in 1998. Javascript allowed for website content to be more dynamic and interactive, while CSS afforded a great deal more flexibility when it came to page design and layouts. Additional coding languages like Active Server Pages (ASP) and PHP: Hypertext Preprocessor (PHP) would later be developed that could interact with backend databases and provide even more functionality. These expanded capabilities, however, meant creating websites that even had "standard" baseline requirements were increasingly difficult to code by oneself.

Increasingly advanced software tools certainly helped make things easier, as did a proliferation of templates, but the less a cartoonist knew about web design and development, the greater the disadvantage they put themselves at. Users were becoming accustomed to certain standards on the web, and were comparing webcomic sites with not only other webcomic sites but everything else they might find online. Jakob Nielsen's (2000) Law of the Internet User Experience states, "Users spend most of their time on other sites. This means that users prefer your site to work the same way as all the other sites they already know." Accordingly, it has become increasingly imperative that even a website for a simple webcomic needs to utilize many of the same tools that are being developed by large corporations with dozens of designers, programmers, and other professionals.

Fortunately, these services are readily available in a variety of forms. Beyond the obvious notion of hiring freelancers to help, these types of assistance can often be had as ad hoc add-ons from hosting providers or webcomic collectives. There are enough tools and templates, as suggested earlier, that a creator with a little design sense and a willingness to learn some basic coding can put together a reasonable enough site, but it's considerably more challenging now than it would have been in the early 1990s, and it promises to become more complex as the web continues to evolve.

Another challenge that comes to many webcomic creators is social media. While this may seem somewhat counterintuitive given that they've already displayed their comfort level with presenting work on the web, that's not always the case. However digitally native someone might be, that doesn't necessarily speak to how comfortable they are with social media. Social media is, after all, named social for a reason and any problems or issues that a creator might have in interacting with and relating to other individuals can certainly carry over online.

However, webcomic creators who try to ignore social media run much the same risk that companies do. It's not impossible to be successful without using social media these days, of course, but it can be much more difficult. And that level of difficulty will likely increase.

A 2015 study of 20,000 consumers found that social media influenced their buying habits in 26 percent of all purchases. Not just online, but offline as well. And two-thirds of that influence was very direct in that those purchases were made as the result of a person specifically recommending it (Bughin, 2015).

Now, that is a study of consumers—over a quarter of all purchases came from suggestions on social media. If that kind of influence can be had to get individuals to part with their hard-earned money, it stands to reason that there's also a noticeable impact in getting people to check out a freely available webcomic. The cost to the individual is simply a little time. This would not necessarily lead to immediate sales, of course, but the greater number of people who look at a comic, the greater number of them will hang around long enough to become regular readers.

That same study found that, to no surprise, a large chunk of the referrals—upward of 45 percent—came from a very small percentage—about 5 percent—of users. This speaks to the notion

of "true fans" discussed in Chapter 4. If a creator can engage well with a fairly small number of fans and they become so-called true fans, they can help amplify the creator's signal pretty dramatically by becoming evangelists.

However, that's still dependent on the creator starting that engagement in the first place. It doesn't seem to matter which social media platforms are in use; the key seems to be for the creator to meet their audience wherever they are. Which is another challenge in and of itself: just keeping up with the latest social media trends in general to understand where a webcomic's potential audience is spending their time. While some basic self-promotion (i.e., announcing and linking to the latest installment) is obviously necessary, the benefits of using social media really come when the creator actively engages with the readers. Not only responding to questions and comments, but offering up other thoughts and ideas that might not be directly related to the comic.

By engaging readers as a multifaceted individual beyond their comic, creators have a greater chance to connect with them. So instead of relying exclusively on the comic, social media is a way to open up more avenues to convert casual readers into more active fans, and those active fans can become true fans, who feel a bond with the creator even if the work itself is not their absolute favorite, and can help spread word of the creator's work.

Conflicts with Newspaper Strips

One curious phenomenon that took place as webcomics started becoming known and, in some cases, even popular was that some newspaper strip cartoonists seemed to display a fair amount of animosity toward any webcomic creators that found any success. In the days when the notion of whether webcomics could provide more than a handful of creators with a sustainable living was still open to debate, it is somewhat understandable that others might look on the medium with some level of confusion, but the disdain seemed to come almost exclusively from newspaper cartoonists. Graphic novelists and creators working in other adjacent fields also openly admitted to some of that confusion, but seemed more than happy to see whether or not webcomics could find a business model that was successful for them.

Interestingly, this animosity didn't start until webcomics had been around for a while. In a 2004 roundtable discussion with *Speed Bump*'s Dave Coverly, *Frazz*'s Jef Mallett, *Rhymes with Orange*'s Hilary Price and *Pearls Before Swine*'s Stephan Pastis, the notion of webcomics was completely ignored even when they were specifically asked about the impact of the internet. They discussed the ability to hear more quickly and interact directly with readers, and the ability to reach audiences whose local paper might not carry their strip via their own comics being posted online, and their only concern was that if the syndicates put their strips online for free, newspapers might use that as an excuse to drop it. There was no animosity shown toward webcomics; it just seemed like the very notion of them was so completely foreign that it was never even considered. Coverly seemed to sum up their collective unease and confusion: "I think the whole industry is in a big transition right now, and no one has absolutely any idea where it's going to go or how anyone is going to make any money" (Heintjes, 2005: 47). Clearly, this came from ignorance as webcomics like *Something Positive*, *Diesel Sweeties*, *PvP*, and others had been earning their creators a solid living by that point.

Pastis's ignorance is particularly curious here, though, as his strip was essentially launched as a webcomic by his syndicate as a test to see readers' reactions before they tried selling it to newspapers: "I'm not saying I'm the first web-to-print [comic strip] but I was the first time a syndicate experimented with web-to-print for the purpose of seeing if it would make it. . . . So they put [*Pearls Before Swine*] up on comics.com in November 2000, and it did OK" (Heintjes, 2009: 48). Pastis frequently cites his tenure on the web before his transition to print when retelling how he got his syndication deal, often talking about watching the traffic numbers and getting direct and immediate feedback from readers. The strip ran in this fashion for over a year before getting sold to newspapers, but he seems to consider *Pearls* during that period as a newspaper-comic-in-development and not a webcomic.

Webcomics did seem to catch many newspaper strip creators' attention not long after that roundtable discussion, though. Around that time, some newspapers, who had been seeing declining revenues, were trying to get comics for free or reduced prices from the syndicates. The syndicates flatly refused, and several months

later, the *LA Times* became the subject of others' headlines for dropping Jim Davis's popular *Garfield* within a few days of Chris Browne's *Raising Duncan* being entirely dropped by his syndicate. *The Atlanta Journal-Constitution* cut *Brenda Starr* and *Judge Parker*. *The Dallas Morning News* dropped a dozen strips to save half a page. *The Salt Lake Tribune* reduced its comics section from three pages to two. These items in fairly quick succession spoke directly to the fears expressed by Mallett and others in that roundtable: "It will be really sad if newspapers say, 'Well, the hell with it—readers can get all comic strips online, so we're just going to use that page for something else'" (Heintjes, 2005: 47). While this was certainly very concerning for newspaper cartoonists, *PvP* creator Scott Kurtz stepped in and essentially gave them something very specific to use as an outlet for their fear and anger.

Kurtz had created *PvP* in 1998 and had enjoyed a fair amount of success with it, even getting it picked up for print publication by Image Comics in 2003. Coincidentally, that was also the year that Universal Press Syndicate approached him about putting the strip in newspapers. Kurtz was very firm that he would not relinquish any of his legal ownership of the property. While this was part and parcel of Image's contracts, Universal insisted they were not interested unless Kurtz turned over all of his rights to them. Kurtz walked away from the deal.

The following year, though, upon hearing of the attempted negotiations between newspapers and syndicates and with the idea that someone might be interested in reading *PvP* in newspapers, Kurtz (2004a) began attempting to syndicate *PvP* for free. He announced, "In the coming months, I'll be putting into effect, a program in which papers can receive *PvP* for free. That's right, free. They don't have to pay me a cent for it. I will provide for the papers, a comic strip with a larger established audience then any new syndicated feature, a year's worth of strips in advance, and I won't charge them a cent for it." Kurtz continued,

> The exposure and prestige of *PvP* appearing in daily papers would more than pay for itself in a months' time. In exchange, I can offer the papers a comics feature that's tried and tested, funny and best of all, free. They have nothing to lose or risk financially. They can see, in advance, a years' worth of strips so they don't

risk me flaking out on them. Most of all, I can provide them with yet another bargaining chip against the very syndicates. This is the perfect climate to take this step.

Newspaper strip cartoonists, already anxious about their own futures, took this as a direct attack against them. *Non-Sequitur* creator Wiley Miller was perhaps the most vocal, stating, "Kurtz is apparently as ignorant about newspapers, particularly editors, as he is about syndicates and syndication. It doesn't matter if he offers them his strip for free. Hell, he could offer to PAY newspapers to run his strip. . . . He's in for a rude awakening" (2004b). Miller even went so far as to mock Kurtz specifically in his December 14, 2004, strip, depicting him as a badly dressed juvenile who was insisting his website traffic ensured his celebrity status. Webcomic creators were generally dismissive of the attacks against them. *Penny Arcade* writer Jerry Holkins (2004) sarcastically responded, "We are desperate for the legitimacy that print supposedly offers! We too long to chide whipper-snappers and wear comfortable adult diapers."

As time wore on, more and more newspaper cartoonists saw their prospects wither while more and more webcartoonists began making a living online. *Dinette Set* creator Julie Larson was explicit in laying blame:

> The culprit is the Internet. *The Dinette Set* is available 24-7, with that day's strip available for free all over the Internet. The free-for-all is killing any chance for a cartoonist to make a modest income. . . . I used to get $375 [from *The Seattle Post-Intelligencer*] for four *Dinette Set* Sunday cartoons. Now that they're strictly an online paper, they only pay $40. . . . To add insult to injury, even my own syndicate, bound to sell and promote *Dinette Set*, gives my product away for free on their website. (Tarter, 2009)

Ultimately, Kurtz's attempt at self-syndication in newspapers was unsuccessful—newspapers refused his requirement to include his URL, citing that readers might get upset with the paper for something they found on Kurtz's site. Kurtz eventually halted the experience out of frustration in dealing with the level of customization each paper wanted: "There's no point in giving the strip away for free if there is no benefit to me . . . Some papers

would run the URL, but only wanted certain gags from *PvP*. Some only wanted technology gags, some only wanted relationship gags. Some wanted storylines, others wanted NO storylines . . . gags only" (Gardner, 2006). Kurtz had no problems with the financial end of things, but found the newspaper editors too much of a hassle to make it worth his time.

Despite this, newspaper creators like Miller continued to insist that webcomics simply weren't viable and, even if they were, it could only be for an isolated few and was "irrelevant to anyone else" (2008). Writers Brian and Greg Walker and artist Robert "Chance" Browne took a shot at the notion in their September 18, 2009, *Hi and Lois*, which featured Chip's nameless friend being thrilled that he sold three whole T-shirts based on his webcomic. Even as late as 2012, Pastis was calling into question webcomic creators' truthfulness when it came to their earnings:

> Many of those guys, from *Penny Arcade* to *Cyanide and Happiness* to *The Perry Bible Fellowship*—which are all excellent—claim to make a living, but how do you know? I can tell you that even if someone does a strip and it's fairly popular online, the money is not online. I question a lot of claims about the money being made, and the question remains that if things continue to go that route for newspapers, and you have to make money online, how do you do it? (Smith, 2012)

It didn't help that even some of the more progressive newspaper cartoonists had trouble stepping away from the century-old syndication model they were accustomed to. Larson attempted self-syndication in 2010, but returned to a more traditional syndicate after only a few months: "Syndicates are there for a reason. They take care of a lot of time consuming tasks and I have full faith that UFS [United Features Syndicate] is a strong, hardworking professional syndicate and makes things happen" (Gardner, 2010). Rina Piccolo, who had been working on *Six Chix* and *Tina's Groove* for newspapers, started a webcomic called *Velia, Dear* but couldn't make the economics work after two years.

This all overshadowed those newspaper cartoonists who were successful in developing their own webcomics. Michael Jantze terminated his King Features contract for *The Norm* in 2004 to move the strip online. Greg Cravens, who began working on the

syndicated *The Buckets* when Scott Stantis left, started his own online strip *Hubris!* in 2010. *Garfield* creator Jim Davis embraced the webcomic parody, *Garfield Minus Garfield*, and promoted webcomics as the funniest strips he was seeing ("Q&A-ing," 2008). Even Universal Press Syndicate began running webcomics on their site alongside the strips they traditionally syndicated.

Cravens (2016) attributed a good chunk of the disconnect to generational differences, as well as a basic misunderstanding of how things changed. He used the National Cartoonist Society (NCS) as an example. To qualify for membership, prospective members had to show that a significant portion of their income came from cartooning:

> If the syndicate sent you money, it was for your cartooning, even if the syndicate got a lot of that money from T-shirts or stuffed toys or product licensing. Webcartoonists (Or, Cartoonists Nowadays, if you prefer) make income from selling ad space on their cartooning sites, and T-shirts, and hats, and with convention appearances, and a lot of other things. Is that income from cartooning? Of course it is, in the same way that the money that came to cartoonists from newspaper sales was generated by ad income and Sunday supplements and all the rest. But it didn't FEEL that way.

Newspaper cartoonists, particularly older ones born solidly during the baby boom (roughly 1946–64), viewed themselves exclusively as artists and looked down on webcartoonists who also handled their own business affairs; they weren't artists, just businesspeople with a little artistic talent: "There were dark rumblings about how things were getting tough, and how these kids and their computers were running amok. Some of them even wanted to join the NCS, and all they were doing were scrawling junk and putting it on the computer! How could that ever qualify them as peers of Charles Schulz, Rube Goldberg, or Al Capp?" (2016).

Miller repeatedly claimed he was not dismissive of the internet, but continued to insist that it be treated exactly the same as print: "What the internet lacks is a clear marketplace for professional work similar to what we've had in newspapers and magazines, where the medium pays for our work" (Gardner, 2008). The point he is dancing around is that he dislikes one of the internet's most

distinguishing features and arguably one of its greatest benefits: a lack of gatekeepers. Editorial cartoonist Ted Rall (2009) was more explicit in his disgust of webcomics, railing against both the medium as a whole and Kurtz in particular, exclaiming,

> Look at webcartoons like *PvP* and *Penny Arcade*, by all accounts the most successful webcomics around . . . it's terrible. Incompetently written. Awful characterization. Plastic, cold artwork . . . now that there's no gatekeeper, all the shit is everywhere. It used to be off the page. Now it's damned near impossible for readers to distinguish what's good because it's surrounded by crap.

Robert Khoo (2010), the business manager for *Penny Arcade* at the time, expressed some level of confusion over the antipathy print cartoonists displayed toward webcomics:

> For those who oppose webcomics . . . I guess I have to ask: Is your goal . . . not to get your work to your audience? There's no denying that the medium of choice has changed, and we'd all be idiots to think that the Internet is the last bastion of content delivery. . . . But in the meantime, the Internet is it.

His point being that the internet is the prime delivery method for content in the early twenty-first century, and not actively trying to take full advantage of that seems to be a path to guaranteed failure. Creators should instead focus on making quality comics, and getting them in front as many readers as possible which, in this case, is on the web: "Go to them. Make it as effortless as you can for your audience to access your content."

What is also interesting in this debate is that everyone seems to recognize that webcomics are not in competition with newspaper comics; they inhabit completely different spaces and target very different audiences. It was one element even Miller conceded, stating, "The point is, there is no such thing as 'web vs. print' cartoons as they are two entirely different mediums, just as comic strips are a different market from comic books or magazine gag cartoons. . . . Cartoons done on the internet have nothing to do, nor have any affect [*sic*], on syndicated comics" (Gardner, 2008). Spike Trotman (2013a), who created *Templar, AZ* before going on to become

the publisher of Iron Circus Comics, more poignantly noted that newspaper cartoonists' greatest competition are strips like *Calvin & Hobbes*, *For Better or For Worse*, *Cul de Sac*, and *Peanuts*—that is, comics that continue to be rerun in syndication despite ending a decade or more earlier: "If you want to be a newspaper cartoonist, you're competing against dead people. And probably losing."

What many of the newspaper cartoonists seem to miss is that, while the point of newspaper comics is to generally appeal to as wide an audience as possible, the point of webcomics is to appeal much more strongly to a select group. Many newspaper comics don't seem terribly witty or relevant precisely because they're trying to be all things to all people. Davis has been very clear on this point:

> It's a conscious effort to include everyone as readers. . . . I don't use rhyming gags, plays on words, colloquialisms, in an effort to make *Garfield* apply to virtually any society where he may appear. In an effort to keep the gags broad, the humor general and applicable to everyone, I deal mainly with eating and sleeping. That applies to everyone, anywhere. (Shapiro, 1982)

The narrowcasting of webcomics means that those creators are free to have a specific voice that might not be interesting or funny to everyone. A webcomic creator only needs a relative few number of really dedicated fans, compared to the huge number of casual fans that are more typical of newspaper strips. The measurements of success are entirely different because the business model is entirely different. Webcartoonists don't have to share their profits with loads of middlemen, like syndicates, editors, and agents so they don't have to generate as many sales to earn the same amount of money. Kurtz tried explaining to a group of newspaper cartoonists this way: "We're helming it directly in lieu of a syndicate doing it for us. This could mean more work for us, or it means we hire our own vendors and assistants and publishers. It also means we can make a living with a smaller audience since we retain the majority of our profits" (Gardner, 2008).

Why, then, do some newspaper creators refuse to listen to webcartoonists while others work to embrace the idea that old models are increasingly not working? Cravens saw his father's career prospects change because of societal factors. The notion of working at one company until he retired with a gold watch and

a pension vanished in favor of being replaced with newcomers because they could be hired more cheaply. Witnessing that sort of career obsolescence is part of what drove Cravens (2016) to tackle webcomics. "I still draw a newspaper comic strip (*The Buckets*) for which newspaper income is declining and web income is, slowly, increasing. But in a panic that I'd be left behind, sweatily poking a gnarled finger on whatever will replace the iPad and swearing 'Gol-darn' and 'Dagnabbit,' I started a webcomic (hubriscomics. com) so I'd HAVE to learn to keep up." That sort of willingness to dive in, even if it is driven by fear, speaks to a lot of what ultimately separates traditional newspaper cartoonists from webcartoonists.

Kurtz has admitted that his emotions can get the better of him when discussing these topics, and he's inadvertently agitated more than a few newspaper cartoonists in the process. But in one of those discussions, he managed to pinpoint out where much of the conflict stems from.

And whenever those of us on the web EXPLAIN how we're making a LIVING, people tend to ignore, dismiss or discount us. Even if we offer to provide tax returns. Some people just don't want to accept that, yes, we're making as legitimate and stable a living as the rest of the cartooning world. Leading some on the web side to speculate that our traditional-model brothers are just scared of what's ahead of them if things keep changing the way they are. (Gardner, 2008)

Interestingly, among all the responses Kurtz received for all his messages on that particular thread, it was this one that went almost entirely ignored.

A few years later, Khoo (2010) went on to further examine the fear of those cartoonists who were antagonistic toward the web. He explains how it's their fear of change that is keeping them arrested, over-riding their fear of obsolescence:

I know why they are fighting. It's fear. It's those who see that pyramid and don't even want to try to get to the base. It's those who aren't nimble, flexible or dynamic enough to deal with change. It's generational. It's old-time cartoonists that aren't willing to learn how to do things a different way, so instead of facing the truth of an industry shift, they grasp wildly at thin air

and make bold, unsubstantiated claims hoping—no, praying—that what they type is the truth and the truth is nothing but snake oil and copper bracelets.

The vitriol seems to have diminished as of this writing, probably for several reasons. The pool of newspaper cartoonists has only decreased since these fights began. Increasingly, those creators who are retiring or passing on are not being replaced; newspapers seem content to rerun older work. Those that are left seem to have tired of retreading the same arguments, in which both sides claim the other isn't listening. On the webcomics side, the number of creatively and commercially successful webcartoonists has been growing. And while some of the older webcartoonists like Kurtz may have sought some form of validation from members of the NCS, younger ones seem less concerned about such formal acknowledgments and find validation in their own success. Increasingly, they likely did not grow up with parents reading newspapers and, thus, had little exposure to the comics in them; having always got their content online, they are more likely to look at other webcomics for inspiration and not newspaper strips.

Audience Participation

Historically, comic creators worked in relative isolation. They would sit alone in their studio, writing and drawing their next comic, and it might not get published until weeks or even months later. If a reader wanted to respond to it in some way, their only option was generally to write to whoever published it and hope the letter was forwarded on to the creators. This, too, could take weeks or months, meaning that it could take a minimum of three months between when a creator put pen to paper and when they heard whether someone liked it or not.

Charles Schulz somewhat famously added Franklin to his cast in *Peanuts* at the suggestion of former schoolteacher Harriet Glickman, who wrote to several cartoonists suggesting they add people of color to their strips. What's frequently noted in the story is that, despite a brief hesitation over concern that he might be too patronizing, Schulz was still relatively quick to take up the suggestion. But "relatively quick" still meant that while Glickman had first written

shortly after Martin Luther King, Jr.'s assassination in April 1968, Franklin didn't debut until the very last day of July—a period of nearly four months (Florido, 2015).

Of course, advancements in technology made the speed of communication much more rapid. Scott Adams was one cartoonist who recognized the internet's potential to enable a more open line of dialogue between a creator and their audience, and in 1993, he began including his email address with every *Dilbert* strip he did, specifically to get faster and better responses from his readers: "My business training told me I needed to open a direct channel to my customers and modify my product based on their feedback" (Gallo, 2013). The following year, he started an email newsletter; the first one being largely a series of frequently asked questions to address many of the 15,000 messages he had received. He further encouraged interactions by including his email and promoting the newsletter specifically in his books (Adams, 1994).

In 1995, he became the first syndicated cartoonist to put his strip online for free in an attempt to increase his readership (Gallo, 2013). Interestingly, though, he didn't purchase the dilbert.com domain until 1997. This also helped steer the direction of *Dilbert*, as readers responded not only with positive feedback but personal stories that Adams could utilize in his strip. *Narbonic* creator Shaenon Garrity noted, "For years now, much of the material in the strip has been based on personal stories Adams gets from readers via his website and email. Instantaneous feedback is one of the features of webcomics that many of us under-utilize, but *Dilbert* makes full use of Adams' ability to summon a steady stream of input from his fanbase" (Zabel et al., 2004).

The idea of steady communications with a comics reader was hardly new. Many editors and publishers had long realized the importance of interacting with their readership, even if they did not have the technological means to do so quickly. Not only did it provide them with direct feedback on their work, providing context to sometimes enigmatic and oblique sales figures, but if the communication was positive, it could help cement a relationship with readers. Cynically, this would help to deepen a casual reader's interest, making them a more devout fan willing to spend more money, and it could also bring first-time readers into the fold, providing them with a sense of community and belonging. William Gaines, publisher of EC Comics, and Stan Lee, publisher of Marvel

Comics, both excelled at creating a sense of identity among their fans.

EC, for example, encouraged readers to join their official EC Fan-Addict Club for 50 cents. Fans were sent items like a formal-looking certificate, an identification card, and a shoulder patch as well as a subscription to their newsletter. This EC Fan-Addict Club Bulletin was key as it contained "chitchat about the writers, artists, and editors . . . trial balloons on ideas for new comics . . . members' requests for back numbers and in general [tried] to foster in the membership a sense of identification with this particular publishing company and its staff" (Warshow, 1954: 596). It largely worked and many of the fans continued talking and writing about their favorite EC Comics even after the company stopped publishing them. John Benson noted,

> There was a group of EC and comics fans (and of course there was an overlap) who wanted to still be fans but who had nothing to be fans of except [Harvey] Kurtzman's stuff. This group was quite productive as far as fanzines went. These fanzines had lots of stuff about comics, especially where the old EC artists could be found in the current comics on the stands. This was really a continuation of EC fandom. (Schelly, 1999: 19–20)

It is this sort of devotion and loyalty that creators and publishers want to establish with their readers. It encourages them to come back to the material repeatedly, spend more money on the material, and evangelize it to others who might not be familiar with it. This is, in effect, the ideal reader, as they not only spend their own money to support the work but encourage others to do so as well. A relatively small number of devoted fans like this can be enough to sustain a webcomics' ongoing viability.

The basic notion behind what people like Gaines and Adams were doing is connecting with their readers as individuals. The comics they produced had to speak to readers at some level in the first place to capture their attention, of course, but setting up those more direct lines of communication allowed readers to see the creators as real people who they have a (usually) distant relationship with:

> The best webcomics seem to have developed in a sort of conversation, a day-by-day process of stimulus-response between

reader and creator. The creator often begins with a firm idea of who the characters are and where things will go, but learns from his or her readers—either their input or their visceral responses—how to implement those ideas in the way that affects them most. (Campbell, 2006: 17)

That familiarity helps to breed loyalty; and whether that's done more cynically or simply out of a genuine and sincere attempt to connect with individual readers, the result is, generally, an increasing readership.

Sheldon creator Dave Kellett identified three basic concepts for connecting with an audience: be accessible, be entertaining, and be kind (Guigar et al., 2011b: 106). These guidelines apply regardless of what channel(s) a creator is using, and whether their interactions with readers are individualized or as a broad group. All three are important and, while they definitely need to reflect the personality of the creator, they can all be tailored to suit both the creator and their audience. If you look back through their work, you'll see that while their styles and tones and venues are all different, Kellett is doing the same thing that Adams was doing in the 1990s and what Gaines was doing in the 1950s.

Being accessible is simply giving readers an open opportunity to contact a creator. Whether they want to express their enjoyment of the latest strip, or point out a typo, or ask an entirely unrelated question, there needs to be some relatively easy means of communication. This proved a little more challenging for creators before the internet, obviously, but it's an easy advantage webcomics have over their printed counterparts. If a reader is looking at the comic's site already, it's easy to add links to the creator's email, social media accounts, discussion boards, or any other means of contact they might have at their disposal. The reader can reach out to the creator with a single click. Any and all platforms that a creator feels comfortable using should be made available, as the idea is to meet with the reader on the terms they're most comfortable with to give them a more comfortable and enjoyable interaction.

Kellett expands on this idea:

Whenever you blog, or respond to your readers' forum posts or emails, you're not only giving them more entertainment value, you're giving them a more immediate, more personal attachment

to the Webcomic . . . through you. Because, let's be honest, when people are reading your Webcomic, they're really reading you. So give them more of what they came for. . . . It adds value to their experience. (106)

It's worth emphasizing, too, that just because a platform is broadly available does not necessarily mean a creator should use it. In the first place, the demographics of their readership might be such that there's little to no interest in that platform among them. This would mean a fair amount of effort on the creator's part to set up and maintain their presence there for only minimal benefit. Additionally, a platform that a creator is uncomfortable with or has difficulty using (for any reason) might make for less than pleasant interactions with readers. Since the goal is to create a positive connection with readers, an environment that works against that is probably better left unused. Better that a reader has only three good options to choose from than five options but two of which lead to bad experiences.

It also makes sense to include some contact information embedded in comic images themselves. As discussed elsewhere in the book, it isn't difficult for readers to remove the webcomic from its native site environment in order to share it with others. By including a website URL and/or email address in the image itself, this increases the likelihood a reader stumbling across the image can still find the creator regardless of where they come into contact with the image. Interestingly, despite this approach largely being pioneered by Adams in *Dilbert*, many newspaper strip artists do not include any means of contact at all; and most of those that do only provide a website URL, instead of including an email or any social media accounts. While there certainly is not a great deal of room in newspaper comics to include all of a person's options, something more than a single URL seems like it should be obvious, especially since the idea started in a newspaper strip.

Interestingly, it is a webcartoonist's experience trying to syndicate his strip in newspapers that sheds possible light on this apparent oversight. Scott Kurtz tried syndicating his *PvP* strip by himself in 2004, and found many editors deliberately stripping his contact information off his artwork: "The papers would not run my URL, which was the only requirement for getting my strip free of charge. Their reasoning was that some newspaper reader might follow the

URL back to my site, read something they didn't like, and send the paper a letter" (Gardner, 2006). This speaks to newspaper editors acting as gatekeepers, trying to limit access to any content over which they have no control. While national syndicates are large enough they can enforce policies of leaving a cartoonist's artwork intact, that still so few newspaper strips include a URL besides the syndicate's own suggests that they're discouraging the practice of including a method of contacting the creator.

Kellett's second notion of being entertaining might seem overly self-evident; the point of most comics in general is to be entertaining, after all. But what Kellett goes on to explain is that all of the ancillary material should be entertaining as well. Blog posts, emails, social media comments, and the like all reflect back on the creator as an individual person and, in the mind of many readers, webcomics and the creator themselves are so intertwined as to be a single package. A webcomic is so much a part of the creator's own voice that readers look to everything else they create as part of the same parcel of entertainment. To be a fan of a webcomic is to be a fan of its creator, and vice versa.

As such, it's not uncommon for readers to follow a creator on social media as much for additional content as for just finding on when the next comic has been posted. The webcomic drives readers to the creator's other material and, more importantly, the other material drives readers to the webcomic. They all should reflect on the creator's/webcomic's overall brand identity. Kellett implores creators that readers "already have to deal with their mom's illness or their late rent check or their failing relationship. They don't come to your site to hear about your troubles on top of all that." He further suggests that if creators still have to bring up their problems (possibly to explain an extended hiatus or other extenuating circumstances that might impact the comic itself), they should make that as entertaining as possible: "Take a page from every stand-up comedian who ever lived, and turn your misery into laughter" (Guigar et al. 2011b: 107).

Evil, Inc.'s Brad Guigar, however, cautions to avoid using self-deprecating humor: "In our pursuit to be interesting on the Web, many of us mistake self-deprecating humor for humility. For example, 'My ability to draw women is only outdone by my ability to draw flies' is a much more intriguing sentence than, 'I'm trying to improve my figure drawing'" (113). The problem with that

approach, Guigar explains, is that, if it's used too often, readers' opinions will start to be shaped by the creator's own negativity and they will come to begin believing it. It can then cause them to start noticing possible flaws in the webcomic itself, and ultimately stop reading the strip entirely which is, of course, the opposite effect than the creator intended!

That directly leads to one of the reasons behind Kellett's third suggestion of being kind. Not only does the notion of a webcomic and its creator being conflated in the minds of readers apply strongly here, but the type of interactions that a creator encourages by example will lead to the types of interactions that readers will assume are acceptable among the overall readership. That is, readers will model their behavior in/around the webcomic based on the behavior of the creator. Kellett explains,

> See, there's a slow filtering process that happens with a webcomic readership. And after a few years of filtering out this type or that type of reader, you inevitably end up with a reader that reflects your basic personality. . . . The readership you build up over time will be a reflection of the work and the words and sentiments you put out there. (108–09)

Not to mention that being unkind is just generally bad for business. Even in a large, corporate-owned retail store, speaking to a low-level employee who responds in a negative or abrasive tone will cause a customer to take on a more negative opinion of the store as a whole. Despite the one employee being far from representative of the entire organization, people will often take that negative interaction and apply it unilaterally. This effect is even more pronounced with smaller organizations and, in the case of webcomics in which there is often only a single individual (i.e., the creator) handling all aspects of the webcomic and everything associated with it, the impact can be catastrophic. Again, to be a fan of a webcomic is to be a fan of its creator, and vice versa. A negative opinion of one will almost certainly lead to a negative opinion of the other.

As alluded to earlier, this can then impact the community that builds up around a webcomic. Whether that's on the comic site itself, another dedicated location for fans, or simply on social media platforms, regular readers of the webcomic will start connecting with one another to form an online community, one that is built up

around and reflective of both the creator and the strip. Communities start over a common interest—in this case, enthusiasm for a webcomic. There is a high degree of likelihood that many fans came to appreciate it for the same, or at least similar, reasons. It is, therefore, a reasonable assumption that these fans also share similar traits among themselves that allow them to appreciate the same form of entertainment. Those commonalities then form the basis of those customs and mores, which are inherent in a majority of the group members anyway. The archetypical fan begins to emerge.

As new members are introduced into the fan community, they observe the actions and behaviors of existing fans, themselves basing their behaviors and attitudes on those of the creator. While each fan is an individual and has their own attitudes and mannerisms, commonalities can be seen by the new member across many of the existing fans. Everything could be under consideration: from "is it acceptable to consider a creator's political views when reviewing their work" to "is it okay to call a creator by their first name?"

During this learning process, a new fan will also observe how fans act and react to other fans. They will learn who others consider the most respected and who has the most authority within the group. Interestingly, these are often those individuals who are themselves most closely aligned with the group's archetype. Because these individuals have a larger than average number of those most highly valued traits among the group, they are generally afforded the most respect within it. It should be noted that they demonstrate those traits through active participation and accruing cultural capital (often through their public interactions with the creator) accordingly.

Online user studies suggest the extent to which people watch and learn the norms of a group. Jakob Nielsen (2006) noted that "in most online communities, 90% of users are lurkers who never contribute, 9% of users contribute a little, and 1% of users account for almost all the action." This points to the notion that a vast majority of people (99 percent) are spending most of their time with the group simply observing how the most active 1 percent behaves. Some of those lurking users are almost certainly either looking for a specific piece of information or seeing if the group is one worth joining—neither are likely to consider themselves members of the group and, in that respect, don't really factor into our notion of a comic's fandom. But the overwhelmingly lopsidedness of the

equation, even accounting for those nonmembers, shows just how significant the impact of those archetypical members can be, and how much they can contribute to the overall group dynamic.

Both social identity theory and self-categorization theory have a fundamental assumption that says people have a strong desire to establish and maintain a generally positive self-image. It is for that reason that they join communities like a fan grouping in the first place and why they enhance their existing characteristics to more closely match a group's archetype. The valued traits of the archetype are, by definition, highly valued but still seen as an achievable ideal to aspire to. As the archetype is often built on the direct examples of the creator and, to a lesser extent, some of the prominent individuals in their fan community, the ideal is actually considered attainable and can be established a realistic life goal. This very real possibility of becoming more like the archetype is able to provide a continual stream of small ego-boosts for an individual as they achieve a series of goals in making themselves more like the archetype.

However, even following the broader practices of the group in general, and the archetype in particular, some readers could still respond very negatively toward the comic. Beyond just reviewers and critics who try to assess and critique the strip for others, there are readers who seem to go out of their way to find the strip's fan community and insist their criticisms be heard by that audience. This might be because the strip touches on an unusually sensitive topic for them, it could be that they are simply looking to cause trouble for its own sake, or it could be that they didn't intend to respond negatively but their communication skills might not be very well honed. There are certainly a myriad of reasons why anyone might react to any strip the way they do, but those reactions can conflict with the norms established by the larger community.

Guigar (2013a: 124) made an excellent comparison about handling those types of people:

> Look at it this way, if someone walks into my house and insults my wife, he gets escorted out of the house. He can have a polite argument, but the minute he crosses the line, he's out. And I decide where that line is. My house; my rules. Following the analogy, of course, if I spend all my time throwing people out of

my house for minor infractions, nobody is going to come to my parties any more. Your site is the house your webcomic lives in. Being a good host means laying out the doormat—not behaving like one.

Guigar, Kellett, and *Starslip Crisis* creator Kris Straub all have gone out of their way to encourage creators to handle these types of people with kindness. They still need to be dealt with in a firm manner, but being kind in the process is almost unilaterally the best policy. Not only does it help to prevent an issue from escalating, particularly in those cases where the negative comments stem from a misunderstanding or poor wording, but it provides a sense of stability and reasonableness for any other readers who might be witness to the conversation. Straub cautioned,

> The last thing you want is for people to see your site as a place to unload all their negativity. That's why it's so important to rise above it and kill that movement with kindness . . . if new readers see that your blog is full of arguments and insults, it's a turn-off and they'll probably have a dim opinion of you and your work, regardless of how good it is. (Guigar et al., 2011b: 113)

The whole point of creating a webcomic is to share it with readers, regardless of whether that's in order to make money or to connect with other people at an emotional level. Readership is clearly important for creators, but it winds up being important for readers as well as they connect with one another just as readily as the creator and their work. The specific venue is almost unimportant; they can post comments right next to the latest webcomic installment or on a dedicated forum or on a social media platform run by an entirely independent third party. What matters to readers—after the ongoing viability of the webcomic itself—is to be able to share with others the joy and excitement they get from reading the comic.

Whether they realize it or not, they want to foster a community around the webcomic. They want to be part of the club that is the webcomic's fans; they want to talk about what they like (and dislike) most about the comic with people who hold similar opinions, including the creator themselves. It's almost necessary for a creator to interact with their readers, and how, when, and where they do

that influences how readers perceive the comic. But so long as the creator realizes this early on, and is at least somewhat prepared for dealing with readers and fans, they can parlay that interest into a deeper and more reliable connection that can help weather any potential problems that might occur during the strip's run.

While the internet has indeed made a huge impact on the ability for diverse fans to get together, it hasn't actually changed the fundamentals of their behavior. Comic fans were arguing about whether Superman was stronger than Captain Marvel as early as the 1940s; kids would trade comics during the Great Depression so that they could all share the same enjoyment from the same stories and talk about how great they were with one another; George Herriman's *Krazy Kat* strips were so popular in the 1910s and 1920s that a Washington, D.C., speakeasy illegally began appropriating the title character's name and likeness to attract customers.

The ability for communication throughout the world has improved dramatically over the past century and promises to continue doing so. There are more means than ever to get in touch with other people, and form communities with them so that everyone within can share the same pleasures of the same comics. But, as has always been the case, miscommunications do occur and, with more venues possible for communication, that also means more venues possible for miscommunication. But that should not take away from the very positive idea of people reaching out to share their passions with others. It connects individuals in a positive and self-affirming way. Fans are out there, not so that they have someone to tell what they thought about the latest strip, but so that they have someone to share their life with. Perhaps not as deeply or intimately as a spouse or significant other, but sharing an aspect of their life that makes up part of their very self-identity and reinforces all their best traits.

There have been and will always continue to be disagreements within fandoms as a whole. With hundreds of thousands of webcomic fans in the world, it would be impossible to get them to all agree on anything. But precisely because there are hundreds of thousands of fans, it's easy, even necessary, for them to break into smaller groups that are more closely knit around individual titles or creators. That's really the key to fandom: to find those people who enjoy the same types of things in webcomics and enjoy time with them.

Education/Social Causes

Creators often have more than one reason for making the comics they do. Frequently, they feel they have a story that needs to be told and they don't see anyone else telling it. Often, they have some sort of commentary on the state of the world that they wish to express, be it directly or through layers of metaphors. Sometimes, they just like drawing funny little pictures. While perhaps a little more rare, some creators come to comics deliberately because of the nature of the medium itself; combining words and pictures in a way that can help facilitate a reader's comprehension and absorption of the material. The comics are a means to convey basic information and, frequently, a deliberate point of view the creator wishes the reader to adopt.

Graphic novelist Will Eisner (1985: 141) called these "attitudinal instruction comics." He wrote, "The relationship or the identification evoked by the acting out or dramatization in a sequence of pictures is in itself instructional. People learn by imitation and the reader in this instance can easily supply the intermediate or connecting action from his or her own experience." Eisner's primary example here was a series of "Job Scene" booklets designed to inform grade school students about vocational opportunities in a variety of trades, but the approach can be taken for a nearly infinite array of ideas. While this is certainly a viable approach for comics produced in any manner, the web affords readers the opportunity for learning and engagement on issues they might otherwise not encounter. However, as Damian Duffy (2017: 208) laments, "The potential for comics as digital interactive online pedagogical texts is an area of inquiry that remains relatively unexplored."

The types of individuals most people interact with on a day-to-day basis tend to be very similar in their background and upbringing. Humans have a "tendency to seek out and associate with people who are similar to us in any number of ways—religiously, politically, economically and, yes, racially, too. The polite term for this phenomenon is 'sorting,' and it affects everything from political polarization to income inequality to the racial differences in friend networks." This has resulted in, for example, the average white American in 2014 having a circle of friends that is 91 percent white (Ingraham, 2014). With a group so devoid of racial diversity, it's unlikely that this theoretical average white American will ever

get to have a meaningful discussion about race that brings in any
nonwhite perspectives.

Some creators have recognized this and have elected to use
webcomics as a means to help share their own thoughts and
experiences in the hopes that they will draw a reader base larger
than their own circle and provide some insights or enlightenment
about lives like their own. With potentially sensitive topics, a
person might not feel comfortable asking awkward, difficult or
embarrassing questions to the people they do know, and a medium
like comics allows readers to explore an understanding of different
perspectives, but from the relative safety of anonymity. While this
perhaps doesn't allow them to ask specific questions, many comics'
ongoing serial nature means that a reader can engage with the
material over a longer period and, if the comic is reasonably well
crafted, they will eventually learn the answers to their questions.

Carlisle Robinson focuses their *caro doodles* webcomic on the
practical issues they face as a deaf, trans masculine, genderqueer
person in large part to teach people about both issues they face
in a generally ableist, heteronormative culture: "There's a lot of
oppression in the binary system, recognizing only male, only female.
But really there's fluidity within that spectrum and there are people
that don't fit . . . comics can also educate people. When there's
oppression within the system, comics can talk about it" ("Carlisle,"
2015). Robinson's comics frequently use autobiographical snippets
to showcase how everyday concerns can become problematic
for people outside of what society considers "normal." How the
simple act of going to a public restroom requires an analysis of how
they're presenting that day, or how they might feel the need for a
friend to escort them for safety reasons, or how ordering food at a
restaurant requires written instructions, but that using a phone for
that purpose can look to other patrons like the person is simply
killing time on social media and not paying attention. Showcasing
short vignettes like these can alert readers to issues and concerns
they likely had not previously considered.

The types of creators making webcomics to highlight social issues
are at least as numerous as the issues themselves. Keith Knight's *K
Chronicles* looks at Blackness in America, Lunatiny's *Anonymous
Asexual* focuses on asexuality, Elaine M. Will's *Look Straight
Ahead* tries to show how a mental breakdown can manifest out of
depression, Olivia Dinnall's *Bi-Assed* explores what it means to be

biracial and bisexual, Jessica and Lianna Oddi's *The Disabled Life* highlights what living in a wheelchair is like, Brennan Lee Mulligan and Molly Ostertag's *Strong Female Protagonist* not surprisingly has a strong feminist message. In *Bounce!*, Chuck Collins uses the backdrop of a bouncer working at a bar to cover just about everything: "It's only political because I dealt with that on a nightly basis with over privileged bar patrons. Racists, misogynists, homophobes, xenophobes . . . the list goes on" (Lopez 2017). For every aspect of life that might be considered out of the ordinary, particularly those that are not discussed much in public, there is a cartoonist trying to tell their story with webcomics.

One of the reasons for the seeming explosion of comics dealing with such issues as webcomics became viable is the lack of gatekeepers. Traditional editors and publishers look at any submissions and have to judge whether or not it will sell enough to be profitable. They might look at works like those listed earlier and consider the potential audience too small or the topic too sensitive. Cynically, they might also simply be bigots and reject creators for superficial reasons. Regardless of their thinking, though, they can and do control whose work is published, which makes getting these stories out difficult at best. The publishing and editing arms of print comics is still dominated by white men and, whether they do so intentionally or not, they often keep any voice that might even just seem like a minority out. In comparing her webcomic *Alone* to traditional comics, Olivia Stephens commented, "Mainstream romance can be pretty pale, sometimes, so it's always great to hear from Black and Latino readers who appreciate my story" (Broadnax, 2015). Since webcomics have no gatekeepers to stifle stories they don't superficially see themselves reflected in, creators are all free to post webcomics on whatever topic they might choose.

Another benefit of having comics like these online is the almost innate community aspect of the web. Even if a comic following the same ideas and themes is printed, the number of people who are able to read and interact with each other on the basis of that comic is fairly limited. Particularly in less urban areas, there often simply is not a large enough population to use those comics as a means of connecting with one another. On the web, however, geography and physical barriers are eliminated and people from anywhere in the world can meet online and develop a community centered around

a webcomics' themes. With under-represented groups, this can be extremely important.

One of the things webcomics like these can do is act as a form of establishment for readers, a justification that they are not the only ones experiencing the challenges of not being considered "normal." Just knowing that they are not living in isolation can boost their confidence and self-esteem. Christian Beranek, the writer of *Validation*, noted that many of the responses she and artist Kelci Crawford receive are uplifting in that manner: "We both get messages from readers now, saying how much they appreciate *Validation* being out there. It helps them with the things they're experiencing in real life as trans people" (Dueben, 2014). The communities that then build up around these shared experiences can lead to knowledge sharing, so not only do readers no longer feel isolated but they are able to learn strategies and tactics for dealing with the challenges people in their group routinely face. And, in the event that no one in that community has relayed their specific solutions, they can still help by providing suggestions based on what experiences they do have, with the benefit of having some personal insights into the general concerns of the group.

Webcomics that build that community especially well can be rewarded financially too. Sophie Labelle (2015), creator of *Assigned Male*, has attracted a large enough following that are willing to donate via her Patreon campaign that she's able to earn a living from her comic. This is likely in part because *Assigned Male* is aimed more precisely at the transgender community, and is not especially intended to enlighten anyone else. Labelle has recognized this, saying,

> There's not a lot of media that targets trans people themselves. Usually when a book is published about a trans character, it's never for trans people, it's for a cause or to educate non-trans people, it's never because we're just part of society. So the fact that I could just reach that audience and create stuff first and foremost for them allowed me to find a market. (Falck, 2018)

Of course, the additional visibility of being online works both ways. By specifically talking about issues and concerns they have as a marginalized community, they can also attract attention of those

who continue to try to suppress those voices; this often manifests as hate speech. *The Immortal Nerd*'s Hanna-Pirita Lehkonen noted, "Most of the ignorance I've encountered is because I'm a feminist and I get a lot of hate because of that. I have even gotten rape and death threats just because I am a feminist and I have made feminist comics journalism" (Jankowski, 2015).

Obviously, were she to keep her comics to herself, she could avoid such responses; indeed, even publishing them traditionally in her home in Finland would not open her up to such a wide group, but putting them on the world wide web means that misogynists from all over the world can react to her.

Labelle, who's had to cancel personal appearances and relocate entirely after being on the receiving end of death threats, spoke to why she continues to post her comics on the web. Her story was picked up by local news and helped draw support for Bill C-16, written to enshrine protection for gender identity and expression in the Canadian Human Rights Act and Criminal Code. Labelle (2017) was glad that her experiences could "help push for more inclusive protections for trans people." She and others like her are actively working in their own way to show how they're marginalized and discriminated against, often in the hopes that just making their challenges more visible that it can bring about change by getting those in power to empathize. Or at least getting the constituents of those in power to empathize. Bill C-16 was passed into law only a few weeks after Labelle had been forced to move (Hartman, 2017).

In some cases, too, the very act of making these types of comics can be somewhat cathartic for the creators. Kylie Wu seemed to almost accidentally fall into creating her *Trans Girl Next Door* webcomic: "The fact that I didn't know about my gender identity for so long, and the way I kind of found out about it, they were all just so funny and interesting to me, so I kind of just went, 'You guys wouldn't believe what had happened!' to the internet." But what she found as she continued working on it was that she was reaching an audience, connecting with them in a significant way, and helping herself work through her own issues:

> People send me messages and tell me my comics have helped them a lot, which is literally the best thing in the world. However, they don't realize that making these comics and putting them out

there has also been a very therapeutic thing for me too. I wasn't expecting this therapeutic experience for myself. . . . I don't feel so alone anymore, and there are people out there who get my sense of humor. (Petkus, 2014)

Regardless of why and how a creator first developed a webcomic, though, by no means does that necessitate they will continue to follow in that same mode. Wu later added that her goals with her webcomic expanded to raise awareness of the transgender community, "I want people to look at my silly drawings and get disarmed by them. The next thing they know, 'Woop, Bam,' they understand us and support us" (2014). Not all creators are that subtle, or coercive, however.

A more dramatic shift occurred in *Sinfest* when creator Tatsuya Ishida switched his focus after a decade from, as one reviewer described, "jiggly pimps-n-hoes humor" (Garrity, 2012) to a more overtly radical feminist message. The change in direction was fairly abrupt and unannounced, surprising many readers. Ishida has been notoriously silent on how and why he opted to change directions, so his motivations have been the subject of much speculation, often among readers he alienated. It's easy to find discussion threads with titles like "What the hell has happened to *Sinfest*" (Yoshimickster, 2014) and "What's going on with *Sinfest*" (Eishtmo, 2013) where these former readers tend to be very vocal in stating that they stopped reading the strip explicitly because of Ishida's feminist message. Ishida (2017) himself seems unconcerned, stating in a short message on his Patreon page: "Over the years [*Sinfest*] has gone through many changes, to the delight of some and dismay of others. I hope to continue polarizing audiences for many years to come."

If Ishida's goal was to educate readers about feminism, that seems to have not worked. His audience largely switched from people who cared little about feminism to those who already supported radical feminism. Thus, whatever feminist message he hopes to convey is primarily going to readers who already agreed with it; the readers who might benefit from learning more about feminism actively left. As noted earlier, however, Ishida (2018) has remained silent on his rationale, apparently preferring the comic speak for itself, so education and awareness might not be what he hopes to accomplish with *Sinfest*. He later started a new *Sinfest*

forum "to foster an environment that's friendly to radical feminists and people who support radical feminism" so community building may be a larger goal. The message of social justice through radical feminism is still the strip's raison d'etre, but it's a message of safety and inclusion rather than one of outreach and education.

It is worth noting this distinction in order to better examine other webcomics and determine whether their voice is directed toward any particular reader. Creators like Ishida and Labelle have set their sights on a primary audience of already like-minded individuals, whereas creators like Wu and Robinson are looking more to reaching an audience who might not currently understand their perspective. This has a notable impact on the style and tone of their work, and how open a webcomic is to different types of new readers. Existing fans would do well to keep those things in mind when recommending comics to others, as trying to build support for a cause might be hampered by sending readers to a comic that is instead designed to be a haven for a specific community. The potential reader would not only be likely to reject the message but could become even more entrenched in their opposing beliefs or, perhaps worse, start attacking the community that they may have even been ignorant of in the first place. Part of Ishida's reason for starting a new *Sinfest* forum was to broadly cull those who chose to verbally attack that community.

Of course, not every webcomic that is intended to inform readers is necessarily discussing potentially divisive topics. Some are strictly educational, trying to supplement materials that might be more formally taught in school, or covering topics that are entirely neglected in typical classroom settings. History tends to be a favorite subject, in part due to the inherent narrative quality built in to the topic, but science, math, and even philosophy are represented as well.

History is a prime subject for a number of reasons. In addition to history itself being already built in a narrative format, there is a wealth of subgenres that individuals can get excited about. In many cases, a creator has become fascinated by a story that might be too small or esoteric for a typical history class and uses webcomics as a platform to both explore the subject themselves and share the story with others. Jane Irwin, for example, spent two years working on *Clockwork Game*, telling the story of a chess-playing automaton that was built in the late 1700s. While a fascinating story, it's hardly

consequential in the vast stretch of history that school systems
have only a scant few years to cover, so it's never brought up in
classrooms, but Irwin has made sure the story is available for
anyone who's interested.

Any historical topic, no matter how inconsequential, can
just as easily be covered. There are no limits on time or space,
so creators can go into as much or as little detail as they feel is
appropriate. Without any gatekeepers, there are no concerns about
making sure it's commercially viable enough to make everyone a
profit. The only limitations are the creators' interest and drive in
relaying the story. Lucas Adams creates self-contained vignettes
at *Modern Farmer* about things like the 1830s Mulberry Craze
and the Pleasant Valley Sheep War. While covering a wide variety
of topics in *The Oatmeal*, Matthew Inman sometimes delves into
history with stand-alone stories focusing on outstanding figures
like Nikola Tesla and Bartolomé de las Casa. His comics are deeply
infused with sarcastic humor, often in the form of adding absurd
analogies and injecting his very blunt opinions, but still stick with
factual information.

Other creators prefer to slide further over to historical fiction;
they might study parts of history in great deal but want to tell their
own story in that setting. Or perhaps they themselves are concerned
that a more strictly historical account would be uninteresting to
others, so they slide a little further away from the historical
record. Interestingly, some of these creators are even more overtly
fascinated by the history and use the fictional elements to try to
make their topics more engaging and fun for readers. Kate Beaton,
whose *Hark! A Vagrant* plays very fast and loose with all of
history for the sake of comedy, actually earned a Bachelor of Arts
in History and Anthropology from Mount Allison University. *The
Thrilling Adventures of Lovelace and Babbage* by Sydney Padua
is also pretty far removed from the actual lives of Ada Lovelace
and Charles Babbage, but is so heavily footnoted that it remains
fairly educational. Lora Innes's (n.d.) *The Dreamer* is rather less
farcical still but very informed by her passion for history, which she
explains at length on her comics' About page

> Many [fans of *The Dreamer*] have chosen to major in history
> thanks to an interest first sparked here. A few are even pursuing
> their masters degrees. Real historians participate in the comments

and have fostered an interest in learning just through their thoughtful contributions.

When I launched the webcomic in 2007, I thought that the historical subject would be a liability to finding an audience. I hoped people would read the comic despite the history. Instead, history lovers across the internet connected here. . . .

So if you're the kind of person who would bake cupcakes for Nathan Hale's birthday, road trip to a historic site on purpose, or dress up in period garb on a hot summer's day, welcome home.

The Dreamer is based on years of research. The blog is rich with articles about the history behind the fiction, photoblogs from road trips historical places and guest-blogs from actual historians.

Beyond history, though, a great many other subjects are taught. Inman, in fact, focuses many more of his comics on science-related topics. He's created comics on NASA's InSight mission on Mars, the ocular biology of the Mantis Shrimp, the chemical effects of coffee on the human brain, and the reproductive process of angler fish to name a few topics. Here again, while he keeps the comics scientifically accurate, he adds a great deal of humor to them, making the information more memorable. Although responding to a specific article, Inman's (2012) approach can be broadly summed up this way: "If you want to read pedantically-impenetrable articles about early 20th century engineers, go read Wikipedia or stroll down to the US Patent Office. If you want to read a funny letter to a geek hero who has been dead for nearly seventy years, read *The Oatmeal.*"

Other creators focus on more specific areas. Katie McKissick's *Beatrice the Biologist* tends to focus on cellular biology while Rosemary Mosco's *Bird and Moon* centers around animals and nature; both use jokes and gags to explain things like how antidepressants work or how ornithologists named the Ring-necked Duck. Jorge Muniz (2018) summarizes medical conditions seriously, but with anthropomorphized cartoon depictions of cells, organs, pathogens, and so on. His *Medcomic* is accurate enough that it is "utilized by university professors all around the world to engage students in the classroom." Frequently, webcomics like these are drawn by fairly expert individuals, giving them a fair amount of credibility and authority on the subject matter; for examples,

McKissick was a biology teacher, Mosco is a naturalist and science writer, and Muniz has a Master's in Medical Sciences.

In some cases, though, a single individual might not be talented and knowledgeable enough to create a comic on a specific topic. It's not unheard of for a cartoonist to team up with a subject matter expert to create a well-informed webcomic. The European Research Council went so far as to hire artists to work with their researchers to create a series of *ERCcOMICS* to explain the achievements of ERC funded research projects. Different comics focused on everything from the processes involved in the formation and evolution of cosmic dust to neuroimaging modality based on ultrasound. But the ERC recognized the significance of webcomics in communicating ideas, and found that to be a more approachable and effective form of informing their audience about what they were working on.

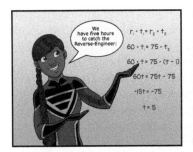

FIGURE 1 *Jim McClain integrates core math concepts into his* Solution Squad *comics. Art by Rose McClain.*
Source: Solution Squad *by Jim McClain.*

The creators with a greater knowledge and background in education take the additional step of making classroom materials and lesson plans available alongside their comics. Jim McClain spent much of his formal career teaching middle-grade mathematics, and created *Solution Squad* to aid in those efforts (Figures 1 and 2). While he originally intended to direct the comic toward fans of the superhero genre, which *Solution Squad* is a part of, he found that his additional efforts in reaching out to other teachers much more successful, in part because of his knowledge of how students learn at that age and how educational systems are structured.

Applying the superhero theme in his comics on top of previously abstract math concepts makes it easier for students to connect the ideas to real-world applications. Adding narrative dramatic tension to, for example, the classic two-trains-speeding-toward-each-other story problem gives readers a greater level of interest in the calculations being discussed and, therefore, a greater likelihood of

FIGURE 2 *Jim McClain integrates core math concepts into his* Solution Squad *comics. Art by Rose McClain.*
Source: *Solution Squad* by Jim McClain.

recalling them later. Certainly, the additional time or even knowledge necessary to develop lesson plans and other ancillary material is not something every creator has, but those like McClain can use their expertise to facilitate not just individual, self-directed learning, but broader classroom instruction. (An example of one of McClain's *Solution Squad* lesson plans can be found in the Appendix.)

What remains fascinating is that topics that would not seem to easily lend themselves to a comic format have been picked up and adapted for webcomics. The typical abstractions in mathematics, as suggested earlier, can be reworked into story problems to show practical applications. Somewhat similarly, philosophy can be taken from the abstract to the concrete using practical scenarios. Corey Mohler's *Existential Comics* anachronistically throws the great philosophers together in practical, if highly illogical, scenarios to play out how their different ideas affect their decision making. How would Jean-Paul Sartre, Soren Kierkegaard, Simone de Beauvoir, and Albert Camus get along if they tried to form a punk rock band? What would a Dungeons & Dragons campaign look like if it were played by Rudolf Carnap, Gottlob Frege, Bertrand Russell, Willard Van Quine, and Ludwig Wittgenstein? Here again, using abstract philosophies in visualized, real-world scenarios can help readers understand and connect with concepts that can often be difficult to understand. This is certainly not an easy effort, of course, which also partially explains why math and philosophy webcomics are perhaps more rare than ones that are more concrete like history, but that they exist at all speaks to the breadth of interest and usefulness of webcomics, and how and why creators might embrace them over more traditional print comics.

Interestingly, many webcomics are also able to be used to teach languages, despite not being created with the intention of doing so. What some creators are able to do, either on their own or with the assistance of fans, is release their webcomics in multiple languages. These are typically written in whatever the creator's native language is, then translated and relettered for the benefit of audiences who might not share the creator's native language. This has the added benefit of providing two stories that are identical in every way, except the language used, meaning that readers can refer back and forth between them to determine how words and phrases translate to one another. Comics have the added benefit, too, of providing visual context so that as a reader becomes more adept, but still perhaps not expert, at a new language, they can use the imagery to help infer the text's meaning.

Theoretically, using modern translation algorithms built into some browsers would allow a reader to take the same basic approach with any page of text on the web; however, at least as of this writing, the translation software can produce less than ideal results, and runs into significant problems when it comes to typographic errors and/or hurriedly written, poorly formed sentence structures, both of which abound even on professional websites. The benefit webcomics have is that the translations are done manually and often afforded extra care to ensure colloquialisms like slang and idioms are given appropriate equivalents.

Gilles Roussel, under the pen name Boulet, has been running his *Bouletcorp* comics on the web after establishing a career in print. He initially posted his diary-style comics only in French, beginning in 2004 and, after a few years, their popularity led to some of his fellow Frenchmen offering to provide English translations. Roussel (n.d.) explained why that didn't work in his English FAQ:

> I had a lot of people trying to translate, and each time, English or American people told me it was still awkward. French people tend to be overconfident with their level in English or at least, with their ability to translate a comic. It's not just about being accurate, it's also about making it sound good, you have to feel it, and that's almost impossible if you are not English or American.

He switched to trying translations himself, not being able to afford a professional, but asks for native English speakers for recommendations to make it sound more natural.

Starting his English version well after his original French version had been running for a while, it naturally lags behind when it comes to the newest comics. But Roussel maintains separate sites for each, as well as having a Korean version hosted elsewhere, so readers don't accidentally slip between them. But with all three languages available, they can act as a digital Rosetta Stone for readers interested and willing to study the comics themselves.

Alexandre Arlène takes a more technology-based approach with *À Poudlard* by switching between French and English just by hovering the cursor over the comic. Readers can instantly switch between languages in the exact same space, so having to glance back and forth between two different versions is not necessary. The translations are provided by Cécile Leducq, so there is some delay

between when the French and English versions are available but, here again, a devoted reader could aid themselves in learning a new language by studying the direct translations of identical content.

John Baird used existing webcomics in a somewhat different manner to help teach language and, later, creative writing. His Create a Comic Project started when he was teaching English as a Second Language in the Republic of China. He took existing webcomics, with the creators' permission, and removed the speech and text from them. Baird's students then used the now-wordless comics to practice the words and phrases they had been learning, posting them back online. Taking this project back to the United States, Baird has used variations of the idea to assist in teaching vocabulary to younger students and as prompts for free-form associative writing exercises in slightly older students.

Whether used in a formal classroom setting to achieve specific academic goals or more broadly directed to inform a general population about social issues, comics have the ability to connect with readers in a way that many other media cannot. Webcomics in particular are very effective to these ends as their global reach means there's no geographic restrictions between a creator and a potential reader; a creator's lessons can be seen and understood regardless of where either the "teacher" or the "student" are located. The extremely low costs and lack of gatekeepers associated with making webcomics also means that no topic is too small or inconsequential to be studied, as long as one creator is interested enough to make a webcomic about it.

Formats

Webcomics tend to be displayed in one of two formats: they resemble either the size and shape of a newspaper strip or a printed comic book page. These formats are indeed lifted from those two sources, and they help readers to identify at an instant what to expect from the webcomic. However, these are by far not the only possibilities and can even hinder how webcomics are read on some devices.

While originally covering a wide range of styles and genres, newspaper strips began switching over primarily to comedic gag strips in the early 1950s. While there are a number of reasons for

this, many place a large chunk of the blame on television. Robert Harvey (1998: 115–19) explained,

> Television, which could be seen coast-to-coast by the mid-50s, displaced radio and the daily newspaper as the nation's source of entertainment in the home. . . . Why would people read a story strip that takes two or three months to tell its tale when they can see an entire adventure in an hour on television? Editors stopped buying story strips; syndicates stopped buying them. They all bought gag strips instead.

Further, Charles Schulz and Mort Walker had recently started *Peanuts* and *Beetle Bailey* respectively and their immense popularity provided a model other creators could follow. "By the end of the decade," Harvey notes, "story strips were virtually swept off the comics pages by a deluge of their chortling brethren" (115).

This meant that, by the time webcomics were beginning to take off, readers had had nearly a half century of becoming accustomed to newspapers presenting a fairly standard format for gag-type strips: three or four square-ish panels arranged horizontally, with the initial panels containing a setup and the final one containing a punch line. There were certainly exceptions and slight variations on that format, but it was common enough that when readers see that format, they almost instinctively prepare themselves for a bit of humor.

Ted Rall directly questioned *Ozy and Millie* creator Dana Simpson on why she originally chose the newspaper strip format for that strip, and why she continued to adhere to it. Simpson responded honestly by saying, "Because I'm used to it. I really don't have a better reason than that. . . . I'm a fundamentally lazy person. I don't have any grand ambition to create museum-quality works of stunning visual composition, though I think the world of cartoonists who do. I just have stories to tell and stuff to rant about" (Rall, 2006: 25). Whether webcartoonists mimic that format because they're expressly trying to set reader expectations or simply because "that's just how it's done" is irrelevant because the reader expectations are guided either way.

Comic books also used to cover a wide range of styles and genres but, for different reasons, were similarly curtailed. The Senate

Subcommittee on Juvenile Delinquency in 1954 put a spotlight on many of the more gruesome stories in comic books, particularly those from publisher EC Comics, and the self-regulating Comics Magazine Association of America was created to essentially censor such stories. Later, in 1972, comic book retailer Phil Seuling came up with the notion of a direct market for comics that would bypass the traditional distribution network used by newsstands and drug stores, which were experiencing declining sales. This direct market buoyed the burgeoning comic specialty shops and many regular comics readers switched to making their purchases there.

This had a cascading effect on the types of stories often told in comic books. The readers who went to dedicated comic shops were primarily fans of the then-popular superhero genre. As fewer comics were now being sold through newsstands and drug stores, those venues cut back and eventually eliminated ordering them entirely. So while superhero sales remained consistent, sales on other genres fell noticeably. Publishers naturally responded, and focused primarily on superhero and superhero-adjacent adventure stories over the ensuing years. Again, by the time webcomics started garnering attention, readers had had a few decades to become accustomed to seeing a 6.5 × 10.25 inch page as the default format for adventure stories.

This format also serves creators well if they have the intention of printing collected editions of their strip. Since it closely matches what is already available via traditional print publishers, those dimensions had long been adopted as a defacto standard. Cartoonists would find it easy to work with printers who already have these standards set up and readily available, and even many print-on-demand companies offer it as one of their regular sizes to choose from. It can be generally assumed that if a webcomic is designed in this format, the creators intend (or at least hope) they can move the story into a printed book form in order to earn some money from it, without having to spend an inordinate amount of time configuring new page layouts.

Conversely, the newspaper strip format is less widespread and a little more difficult to configure, especially for print-on-demand printers. Historically, comic strips were reformatted to fit a traditional paperback book size. This required someone to reconfigure the panel layout of every strip from appearing side by side to having them stacked. (Walt Kelly famously did this work

himself on early *Pogo* collections, "reconfigur[ing] the material, adding in new panels and extending others to create a rhythm of storytelling more befitting book format" [Thompson, 2011: 9].) A horizontal book format more in line with the horizontal nature of comic strips didn't come about until Jim Davis encouraged his publisher's hand with a *Garfield* collection (Davis, 2004: 62) but the relative unique uses of this format means that it's not widely available for many self-publishers. For many webcartoonists, this can mean some additional formatting work when preparing their strip for a printed collection.

Interestingly, while the taller format makes production easier for creators when it comes to print, it's the more horizontal format that tends to display better online for readers. Most screens are configured to be wider than they are tall and, particularly on smaller monitors, this means that an entire installment of a newspaper-style webcomic can be read on the screen without having to scroll at all. Comic book-style webcomics, however, often need to be read by scrolling around the page, disorienting the reader by visually moving the spot where they stopped. This can interrupt the reading flow, and make for a more disjointed feel for the story.

The introduction of tablet devices, popularized with the debut of the iPad in 2010, did allow readers to more readily hold their screens vertically to more closely match the format of these comic book-formatted webcomics. While smart phones also have this capability, their screen sizes are diminutive enough that a webcomic's lettering often became impossibly small to read. They did, however, frequently come very close to duplicating the dimensions of newspaper-style webcomics and gave readers an even greater opportunity to read those types of strips at their leisure, regardless of where they were.

This has led to some additional creativity on the part of cartoonists. Several have structured their page layouts so that each installment is roughly half the size of a typical printed comic book page. This returns the online strip to a horizontal format more suitable for most screens but they can be easily stacked on top of one another, so they combine to form a full comic book page. This only requires a modicum of additional layout work for the creator and, thus, often works as an excellent "compromise" solution.

Another interesting option, albeit one that's rarely used, is to design the pages for a taller print layout, but then limit what is presented as an online installment according to whatever makes the

most sense from a natural storytelling perspective. That is, if a story beat happens to fall two-thirds of the way through a page, then only that two-thirds of the page are presented to the web reader. The next update then might consist of the remaining third of that first page as well as the entirety of the subsequent page. This means that how much story is shown to the reader can vary from day to day and, in some cases, might fit well within typical monitor proportions, while in other cases, might not. This approach can work from the perspective of providing complete narrative chunks of the overall story without trying to artificially alter a story's natural pacing, but this can prove slightly more difficult and time-consuming to prepare for both online and print venues.

Taking this notion of presenting different layouts for web versus print to the extreme, some creators have turned to using completely distinct layouts. An artist might draw and lay out their pages as if they were being created for a traditional comic book, but then take all the individual panels and stack them vertically for web usage. This tends to be done in cases where the expectation is that most readers will view the strip on their phones. An exceptionally vertical format is actually preferred there (if something needs to take up more than a single screen) as readers are able to easily scroll through with the simple swipe of their thumb. While this can still be read readily enough on any desktop device as well, this tends not to be as ideal a format, however; comic panels that are optimized for phones tend to display almost uncomfortably oversized on larger desktop monitors.

Of course, this all assumes that a creator intends to have their webcomic show up in print format at some point. Whether they simply have not thought that far ahead or are actively experimenting with what is capable on the web, creators can easily move beyond those two basic formats if they choose. As detailed in Chapter 1, "Historical Overview," a number of creators have explored variations of the web's infinite canvas, in which the ability to scroll infinitely (for all practical purposes) horizontally or vertically is utilized specifically as a feature, with comics featuring very extended panels and/or sequences. The vertical comics referenced in the previous paragraph can be seen in this manner.

Less frequently seen are webcomics that spend time exploring 3-D space. Comics that were created using 3-D software were hardly new, even within webcomics. Former *American Splendor*

artist Joe Zabel, for example, created several comics for the web that were developed using 3-D software, most famous probably being the 2000 continuation of his traditionally drawn, 1996 print series *The Trespassers*. In 2005, he explained, "I've traded in pen and ink for Poser and Photoshop, two incredibly versatile new tools. . . . I've always been trying to create a realistic effect. Using actual photographs and a 3D program that creates a photo-like image is bringing me much closer to the realistic effect I've been aiming at all along" (Withrow and Barber, 2005: 134). These comics were, however, essentially set up in a print format, just using the computer program to manipulate the precise angle shown in each panel. Other artists with a little more technical savvy were able to explore other options.

French artist Gabriel de Laubier, while not launching any comics of his own, played with the notion of creating webcomics that, at first glance, looked like typical newspaper strips, but had in fact been created in 3-D, allowing the reader to spin the entire strip around and look at it from different perspectives. He recreated *Peanuts* and *Calvin & Hobbes* strips mostly to show how a historically flat comic could be interpreted in a 3-D environment.

André Bergs pushed things a little further by creating comics that were not only built in a 3-D environment but automatically changed perspective with the reader's (often subtle and unintentional) hand movements as they were viewing the panels on a tablet or phone. The comic would be directly tied to the device's internal gyroscope, and the panel perspectives would shift as the device moved, as if the reader were looking through a window instead of at a screen. Unlike de Laubier's fully 3-D environments that could be viewed from literally angle, Bergs limited how far in any direction a viewer could go, almost certainly to ensure some measure of readability. (De Laubier's recreations could be seen from the back or at extreme angles, but the dialogue balloons became illegible.) Bergs also incorporated color and some loop animations for an even more dramatic effect.

These experiments, as of this writing, largely remain experiments, however. They require a unique combination of skills to execute at all and, because of the additional programming involved, take considerably longer to make than an otherwise comparable comic. Further, arguably both de Laubier's and Bergs's works might be more properly defined as digital comics, not webcomics, as they're not

natively viewable in many browsers. However, it should be noted as well that at least some early browsers did not natively support the JPG file format, now almost ubiquitously used for webcomics, so future browsers may support more comics such as de Laubier's and Bergs's without additional browser extensions. Regardless, they've both presented their works through the web and have no doubt sparked more ideas within others on the possibilities of different formats.

As noted in Chapter 1, "Historical Overview," Scott McCloud sparked many creators to explore different formats arising from the notion of the infinite canvas. McCloud (2000) devoted an entire chapter of *Reinventing Comics* to explaining the infinite canvas, and how and why comics might be able to take advantage of new design opportunities that are afforded on the web. He noted,

> In a digital environment, comics can take virtually any size and shape as the temporal map—comics' conceptual DNA—grows in its new dish. . . . But while no one in five hundred years has figured out a way for images to go beyond the edge of the page, digital technologies are pushing their limits on a daily basis. (223–4)

McCloud went on to suggest a variety of examples:

> Navigating through a series of panels embedded in each previous panel may create a sense of diving deeper into a story. A series of panels turned at right angles may keep the reader off-guard, never knowing what to expect around the next corner. Giving pictorial shape to while stories may provide a unifying identity. Most important, the ability of creators to subdivide their work as before is undiminished, but now the "page"—what Will Eisner calls the "meta panel"—can take whatever size and shape a given scene warrants no matter how strange or how simple those sizes and shapes may be. (227–8)

McCloud later created his webcomic *The Right Number* as a way to explore that first example.

McCloud's piece, however, essentially relied on a single panel transition concept: each panel contains a small preview of the next centered in the image, and the reader zooms in to see it. The

transition from one panel to the next is identical every time. Other creators have played with the concept more elaborately. Brendan Cahill, for example, used a variety of transitions in *Outside the Box*. In some cases, elements within a panel were revealed one at a time, a process that would need to take multiple panels in print. In another sequence, the panels would overlay on top of a map that kept highlighting where the character was in his apartment as each new panel would display. In other cases, panels would come up over a larger image suggesting a concentration in focus on a particular part of a larger scene.

Cahill seemed to enjoy exploring his options, although acknowledged that some might not ultimately make sense for webcomics: "Webcomics opens the doors to animation, sound, 'free' color (meaning it doesn't cost more to do a piece in color than in black and white, as it does in the print world), nonlinearity, and a host of other tricks. Many of these doors should arguably stay closed, but it does give the creator freedom to play with them" (Withrow and Barber, 2005: 124). Others individually played with similar notions and, a decade later, Mark Waid had those types of features embedded into his Thrillbent line of webcomics, in an attempt to make them more broadly accessible to creators whose skills may have more exclusively resided in comic storytelling and not web development.

The challenge, it would seem, that creators face in exploring many of the options afforded by webcomics is a technical one. The principle skill cartoonists generally have is the ability to put together words and images to convey a message. However, many of the expanded possibilities that are frequently discussed with regard to webcomics require additional skills like developing code and building databases. It's certainly not impossible for a cartoonist to develop those talents, but it is not unlike having a movie director also have to design the costumes, rig up lighting, and then sit down at the computer to develop all the special effects. Each requires enough specialized knowledge and skill that it's far easier and faster to have multiple people working on those different aspects.

Thus, while a comic creator might have many great ideas on how to expand how webcomics work, they could well be limited in their actual ability to develop those ideas. There are certainly both professional and amateur developers and database experts available to help, but for a cost—one which many new cartoonists do not

yet have the ability to pay. More established creators might have more ability to afford a development team, but they're generally less interested in doing such experiments because they've already landed on a system that seems to work for them.

Thrillbent was an exception in that regard, since Waid had long established himself as creator of traditional comic books and choose to do work online. But not having any programming experience himself, he had to hire people to do that (which he could only pay for by selling off his comic book collection of forty years [Nelson, 2012]). But he also recognized other creators were facing the same limitations and had the platform built to be easier for creators to implement those ideas without a great deal of technical knowledge.

The LINE Webtoon platform, first created by Naver Corporation in South Korea in 2004, utilizes similar tools. Ryan Benjamin (2018) relayed the ease with which their platform helped him develop some of the effects in *Brothers Bond*: "Animating is pretty easy. If you are familiar with Photoshop layers or website creation, then animating with the tools on Webtoons is not that complicated. Up, down, rotate, fade in, fade out, can all be done on each layer. . . . I can take the assets and animate a shot in @10 seconds to @5 mins." The tools, while standardized within the Webtoons platform, can result in radically different looking comics, based on how much a creator wants to play with those tools.

But to see more exploration along those lines—at least at any level beyond a small handful of isolated creators—cartoonists need more tools like the Thrillbent and LINE Webtoon platforms that remove the technical barriers. Benjamin (2018) has been fairly pointed on that topic: "I think the true challenge will come mostly from the development and programming of the delivery platform cause [*sic*] it already has a natural cohesiveness with comics. Where the platform goes artist will follow. As well as creators will have the opportunity to push the technology. After all, we do live in an innovative society." *Heroine Chic*'s David Tischman witnessed that innovation firsthand: "The Webtoons app is incredible. It's also very specific, and you have to throw away what we've been taught about what's possible on the 'page'. . . . So it's been a very liberating experience" (Chin-Tanner, 2016).

Economics, as had been alluded to already, is a driving factor in the formatting of many webcomics. While any number of creators would no doubt like to play and experiment with the media and

form more broadly, they still have the day-to-day concerns of having to pay for basic necessities. Creators are steered toward focusing on what pays their bills. After creating traditional print comics for Marvel and DC for over twenty-five years, Waid found himself surprised by the opportunity costs of creating online comics:

> I have yet to find a dollars-and-cents cost, but the cost in human hours—I was really not taking into consideration the fact that those are billable hours. In the grand scheme of things, that is money, in the sense that I could be writing another issue of *Daredevil* [for Marvel] instead of doing that. I was taken aback at the amount of time just the production end of it took, looking at it and getting it up on the site and debugging it and making sure the flow is right. That's an afternoon every week just assembling the damn thing, and that's just one strip. That was the part I was blissfully unaware of going in. (Alverson, 2012)

With that in mind, it makes sense that many creators forego a great deal of experimentation with formats in favor of doing things that are more likely to generate revenue. This means, in many cases, following the lead of another creator that's already become financially successful so that the amount of time spent chasing possible income streams is minimized. Kate Beaton, by all rights one of the more successful webcartoonists with her *Hark! A Vagrant* comic, admitted,

> I'm not the one who's going to say, "I'll take a risk and live on a dream," because I didn't go to art school. I'm not that type. Even though it was the thing I loved the most I was like, "Well, but I also need to make a living." And I didn't try to make it in comics until I had paid off my student loan and saved a pile of money, to make sure I wouldn't starve. (Mautner, 2015)

Of course, creative experiments still occur and can lead to financial success somewhat unintentionally. One of the most notable examples of this is Andrew Hussie's *Homestuck*, first launched in 2009. Hussie had already developed a following with his previous webcomic, *Problem Sleuth*, whose ad revenue earned him enough to be "entirely supported" by it "though things were still pretty lean back then" (O'Malley, 2012). Days after finishing *Problem*

Sleuth, he then started *Homestuck* and designed the format based on computer adventure games from ten to twenty years earlier; this suited the story as the narrative was largely written as if it were one of those games, with visible user commands between panels. He took the analogy further by creating "cut scenes" of short animation in some spots as well as, less frequently, playable interactions. After the original comic was completed, Hussie reflected on whether or not it should even be considered a webcomic:

> It's some form of freestyle sequential art, involving mixed media. But nobody wants to hear anything like that. People say, what do you make online? What if my answer was like, "PICTURE, if you will, that the entire internet is my canvas. Raw imagination is my sandbox. The limitations of my chosen format are bound only by . . . wait, come back. Don't leave. Please come back and listen to me." I would have to rehearse the part where I ask people not to leave as much as the rest of the answer. So, webcomic it is. (Alverson, 2018)

In creating a comic with animations, instant message style chat boxes, interactive games, and other features unique to being online, it would seem to be especially poorly suited to being converted into a published book format that, at the time, was generally considered one of the most solid ways to earn money from webcomics. However, the massive and devoted followed *Homestuck* generated led to some fairly lucrative product tangents including T-shirts, dozens of albums of original music, and a video game that raised nearly $2.5 million on Kickstarter, making it the fifth game to raise a million dollars or more through the platform (Curtis, 2012). Hussie has insisted that any financial success he has achieved through *Homestuck* was accidental.

> I seem to have this knack for falling totally ass backwards into highly marketable ideas, like the troll zodiac symbols. It really seems like such a money-making scam when you look at it. Like, taking these icons that have been around forever, give them all one color which is easy and cheap to print on a simple black shirt, associate them with some distinctive characters, and also the zodiac which people can intrinsically identify with (having a "patron troll") then just slap it on a bunch of merch and rake in

the dough. The god tier stuff also felt that way, 12 nice colorful icons, also associated with particular characters, special powers etc., and canonically associated with a particular garment, a hoodie (i.e. godhood), so any cynical observer looks at it and can say, "Heh, look what bulls*** Hussie cooked up to sell hoodies." But honestly this is always accidental. The ideas always just seemed cool to me, filling out the zodiac with troll characters, fleshing out the full god tier system and such. I've never actually put anything in the story to sell anything. But throughout the entire ride, every time I turn around, I'm saying, "Oh, whoops. Guess I gotta sell that now." (O'Malley, 2012)

That, however, was all secondary to the basic format conceit of this webcomic being presented as an adventure game. Shortly before starting *Homestuck*, he talked about his interest in trying to push the medium:

I still like comics, but after doing [*MS Paint Adventures*] for a while, I think [returning to "a more traditional, semi-daily strip"] would seem awfully static and rigid. It's a medium I've already personally explored quite a bit, with a good variety of styles and approaches. I'd rather keep feeling out new boundaries, as long as it's possible. This is even true with the next adventure. (Dean, 2009)

Hussie's esoteric mix of humor and sense of storytelling and an ability to connect with an audience is not likely to be repeatable by others looking to find a path forward in developing their webcomics. Many of the earliest webcomic experiments were not copied in any practical way either. But these experiments are certainly valuable in that they can spark ideas among other creators that perhaps do fit in better with their particular oeuvre, even if that largely consists of regular, three-panel strips that look like they would be right at home on a newspaper comics page. The functional economics of creating comics will steer the broader direction of what creators do with their work, but there will fortunately always be a contingent of artists who are more interested in pushing the medium's limits creatively and, in so doing, may find other interesting and useful options that others had not previously considered.

Financing

When webcomics first began appearing, they were little more than an interesting curiosity. The idea that the web could transmit images within the context of a page was still fairly new. The web was still largely utilized in the realm of academia, and much of the content reflected that. When *Dr. Fun* was launched in late 1993, the Mosaic Communication's newsletter heralded the novelty of it with its own line item announcement: "A major breakthrough for the Web: *Doctor Fun*, an online cartoon in the tradition of *The Far Side*" ("What's New," 1993).

Dave Farley (2002), the creator of *Dr. Fun*, had few financial aspirations for his comic: "For years, I drew cartoons and threw them in a drawer, and nobody ever read them. Or I sent them to magazines, and most of them got sent back. So this [posting them online for free] is an improvement." He worked at the University of Chicago Library and was not concerned about trying to make a living from his webcomic. It was barely a consideration for him at the time:

> So when I deal in situations where a professional cartoonist would expect money for something, I ask for the same fees, including reprint fees for *Doctor Fun* where any other cartoonist would charge money. Most of the time this results in no money, but what the heck. . . . I sometimes find myself in conversation with people who believe that by making money I'll somehow validate what I'm doing, which seems to me the best argument in the world to keep doing things the way I'm doing them. I do have a real job, after all. I'm not interested in being a cartoon star.

The notion that webcomics could lead to a financial security had yet to be proven. In *Reinventing Comics*, McCloud (2000: 180) cited that online, "There are three kinds of things you can sell: physical products, advertising space, and the intangible experiences of the web itself. In other words: atoms, eyeballs, and bits." Joey Manley (2005) divided things a bit more from a practical perspective: merchandise and book sales, advertising and sponsorships, and pay content—having readers pay via subscription or micropayments in order to read the comic online. (He actively dismissed donations as an option, stating "Begging is not a business" [175].) The question,

still open when Farley began *Dr. Fun*, was whether any of those options, in isolation or combination, could bring in enough money to earn a living. There were so few cartoonists even working online at that point that no one could determine if they hadn't quite hit upon the right mix of revenue streams, if the internet population on the whole had not yet reached a size to make webcomics a sustainable business, or if the webcomics that were then available simply were not strong enough to attract enough of an audience. A number of creators were determined to find out, though.

An advertising model seemed to be one of the most obvious things to attempt first. It had successfully worked for newspapers, radio, and television for decades after all. Additionally, at the time, the internet audience weighed heavily toward the popular twenty-something demographic, who spent most of the time online and visited the most pages ("Baby Boomers," 2000). "Most readers are young: high school to late twenties, with a significant number in college. The gender ratio appears more balanced than that of comic books, though not comic strips. They're well-off enough to have a fast connection and some leisure time, but not so settled they have no time to discover entertainment in out-of-the-way places" (Campbell, 2005: 16). Since this also reflected the demographic of many webcomic creators, the strips they created appealed most strongly to that group coveted by advertisers. Charles Rozakis (2003), in his thesis on webcomics business, pointed to such youth-oriented organizations: "Online roleplaying game companies, online games, and other internet-based businesses also tend to favor advertising with webcomics."

That said, since webcomics can cover any genre and draw upon a diverse group of audiences, getting advertising that suitably targets a particular webcomic's niche can sometimes be difficult. Todd Allen (2014), in his examination of the economics of digital and webcomics, stated, "This is a case where being a niche comic may be fiscally beneficial to you. For instance, video game-based comics like *Penny Arcade* and *PvP* can command higher advertising rates from video game advertisers. If you do not fall into a niche demographic, you'll probably be a general [ad] buy and get lower rates." He went on to note that *Penny Arcade*'s rate for a banner ad of 1,000 views in 2004 was between $5.00 and $5.50; by contrast, even a just slightly more general interest comic like *MegaTokyo*'s rate at the time was $1.25 (84).

Many creators were quick to try to secure advertising, as this seemed like a guarantee of at least some income and, if they were lucky, it might turn into a significant revenue stream. As time went on, however, advertising became something of dead end with the rise of ad blockers, software extensions that are specifically designed to remove or hide advertising from a website. While ad blocking tools had been around for several years, the number of users utilizing them really began to spike in 2013 and globally, the cost of ad blockers in terms of lost revenue roughly doubled every year afterward, reaching nearly $41.5 billion by 2016. Further, it tended to have a greater impact on websites "that cater to young, technically savvy, or more male audiences"—precisely the target demographic of many webcomics ("Cost," 2015).

Webcomic creators who did rely on advertising felt the effects fairly quickly. *Evil, Inc.* creator Brad Guigar recalled, "I used to run ads from three different ad networks. The monthly check from one of those networks used to pay my mortgage. Now, it barely covers the electric bill. And the other two are pizza-and-beer-money small" (Goodman, 2016). Kel McDonald (2018), creator of *Sorcery 101*, was more explicit: "In 2010, I made $17,933.19 off ads alone. . . . In 2016, I made roughly $4,000 of ads for the entire year." She clarified, too, that her webcomics' site traffic remained relatively stable during that time; her comic wasn't becoming less popular (and thus less in demand or less valuable) but the readers who were coming were using ad blockers and not even seeing the ads. Since ads are generally sold on the number of times they're displayed to viewers, the ad blockers had a direct impact on McDonald's income to the tune of nearly $14,000 per year.

As something of a method to combat ad blockers, Guigar (2015) suggested the possibility of full-on sponsorship: "I'm specifically thinking of the radio comedies of the mid-1900s. The sponsorship was built into the narrative in many clever ways. In fact, radio pitchmen became intrinsic part of the storytelling in comedies such as the *Burn & Allen Show* [sic], *The Jack Benny Show* and *Fibber McGee & Molly*." Sponsorship would entail essentially embedding the sponsor's name, product, or logo right into the webcomic itself, thus bypassing the ad blocking algorithms: "I would caution that this should come with a hefty dose of transparency, however. Your readers should be able to tell the difference between a paid endorsement and a genuine gushing over a product or service."

There is a fairly strong danger in the sponsorship model, as well. The intent is generally to provide some content of interest that will draw readers back to the site repeatedly, thus exposing them to the sponsor's message, which might be to drum up interest in video game properties or convince people to attend a particular convention. There are two challenges with this approach, though. First, there's usually not a direct connection between the webcomic and the preferred "call to action." Instead of going from "reading the webcomic" to "reading the webcomic in print," the goal goes from "reading the webcomic" to "purchasing a product unrelated to the webcomic" or "attending a convention." Even in best-case scenarios for webcomics, there's typically only around a 1 percent conversion rate (more on that shortly) so in these indirect correlation situations, that number drops considerably.

The second problem is that actually measuring the impact a webcomic has on these indirect calls to action can be extremely challenging. The reader almost has to read one of the comics and then immediately follow through on that call to action in order for the webcomic's effectiveness to be tracked. If they read the webcomic, left the website entirely, and then came back later for the follow through, that's much more difficult to attribute to the comic since the person could be influenced by a variety of other external factors. In tracking interest in a webcomic against actions for the webcomic itself, such as purchasing a print copy of the material or contributing to a crowdfunding campaign, the correlation between interest in the webcomic and the call to action is fairly direct and without many other factors to consider. In the case of a sponsorship, the call to action may have been triggered by third-party reviews, additional advertising, or something else on the sponsor's site. Further, if the call to action is something that can be done offline (i.e., a phone call or attendance at an event) attribution is next to impossible.

Both of these mean that, from a business perspective, the company that is paying to subsidize these webcomics might not see much (or even any) return on them. Even if the webcomic does help generate attention and sales for the sponsor, a direct line from one to the other is hard to draw. From the point of view of a ledger, corporate webcomics can be seen as an unnecessary and frivolous expense. This may or may not actually be the case, but it's difficult to prove their worth as a budget line item, thus making this business model particularly challenging for creators who might not have a

great deal of expertise in website analytics and parsing details in a granular enough fashion to satisfy sponsors.

Likely the second most obvious approach to earning money from a webcomic is to sell things related to it. Manley (2005) described it this way:

> In this model, the webcomic itself is "bait" and the real business is the sale of physical items, like books, t-shirts, or plush toys. These businesses are only distinguishable from old-world businesses using the Web as a promotional brochure by the frequency and quality of the content they publish. If you ignore those two elements (high frequency and high quality), something like *Diesel Sweeties* is not a lot different from . . . the clickable page excerpts from graphic novels at Amazon, business-model-wise. (175)

In business terms, the webcomic is a loss leader for whatever is actually being sold.

What a creator chooses to sell can vary widely. This can be influenced by a variety of factors including the format, tone, style, and genre of the webcomic itself; the availability and ease of producing physical products on the part of the creator; broader trends and preferences of the audience; and preferences of the creators themselves. For example, a hard science fiction comic probably isn't well suited to plush animals, but if plush animals happen to be en vogue and the creator has always wanted to see one of their characters in that format, it might get produced anyway. T-shirts were popular with creators for a time—they were fairly easy to produce on-demand and had a profit margin of around 50 percent (Allen, 2014: 77)—but that largely fell out of favor during what *Cat and Girl* creator Dorothy Gambrell called "the great T-shirt crash of 2008" (Dale, 2015). *Wondermark*'s David Malki reflected, "Part of that was just realizing that people like lots of things, not just T-shirts" (Dale, 2015).

Printed collections of the webcomic are a fairly common item sold from creators' sites. This is of course the most direct physical representation of the webcomic itself and, somewhat fortunately for creators, was one of the first industries to make on-demand production work financially viable. Print-on-demand (POD) services

> are companies that make use of digital printing technologies to print very small print runs—even individual copies—of books on

an as-needed basis. In traditional offset printing . . . the publisher orders a specific number of copies—usually a minimum of 1,000—and pays for the print run upfront. With POD, there's usually a set-up fee followed by a per-book cost, as copies are needed. (Withrow and Barber, 2005: 177)

This fairly low initial outlay of cash is very beneficial to new creators, who might have yet to earn anything from their webcomic. They don't need to pay for 1,000 copies upfront and then pay to have them stored in a warehouse until they're sold. Further, creators generally don't have to worry about shipping the books out to customers themselves; this is generally handled by the POD printer. The individual cost for each book, however, tends to be a bit high, which means that creators either take a smaller percentage of each book's sale price or have to charge buyers a price that is noticeably higher than industry standards, likely leading to lower sales volumes.

Another downside to selling books is that a webcomic needs to have a sufficient volume of material completed in order to fill the book. Steve Horton and Sam Romero (2008) laid out some practical scenarios:

Assume that a book contains about 180 pages of material. If your comic is once a week, that means you'll be doing a book every 3.5 years or so. Three times a week means that you'll have 156 strips by year's end—you can put all that into one book with some extras and call it a day. If your strip is five times a week, that means each book will contain about 8 months of material or so. No matter how you look at it, you'll need to have your webcomic going for a while before it'll be ready to collect. (189)

This assumes, of course, that the webcomic is even conducive to be published in book form in the first place. Webcomics that take advantage of the web's unique features like embedded links, the infinite canvas, cycle animations, and the like might not translate as well to a set of bound, printed pages—at least not without some modification. Matthew Inman of *The Oatmeal*, for example, found he had trouble getting many of his comics to fit even on poster-size sheets. His original model had readers being able to select any

comic as poster, and those were printed on demand. But many didn't turn out well because of the size, so Inman found that in order to keep a certain level of readability and quality, he had to manually limit which comics could be printed in poster form and have them printed in large print runs (Aboraya, 2010).

Sheldon's Dave Kellett suggested trying to take active advantage of the options available:

> The key to monetizing a Webcomic comes in repackaging. When I create any particular comic, I try to get paid for it at least three ways: 1.) From paying ads next to the strip, 2.) From book sales, when that strip joins others in a collection, and 3.) From sales of the original art. . . . The idea is to draw a comic once, but get paid for it multiple times. (Guigar et al., 2011b: 128)

The sale of original art is an interesting idea for a few reasons. Assuming the creator does not draw all their work digitally, it is essentially a ready-made product; it was created in the act of making the webcomic in the first place, so the only thing a creator has to do in order to sell it is hand it over to the purchaser. Considering that all the materials involved (the paper, inks, brushes, etc.) are all sunk costs anyway—that is, they had to be purchased in order to produce the comic regardless of whether or not they were later resold—the price charged to the buyer is effectively all profit.

Original art can be tricky to sell, however. As a one-of-a-kind item, potential online purchasers may be reluctant without being able to inspect the item beforehand. After all, it's not like a damaged one can be replaced in the same way a mass-produced book can. In-person sales can be difficult, too, because the most frequent opportunity for them is at conventions, which would typically have a poor audience for that type of thing. Guigar (2018) experimented with several ways of selling his art, and at different price points, before realizing conventions were the wrong place for them:

> Overall, convention-goers weren't interested in my original art—not only because it wasn't standalone, but because they had no connection to the work. After all, some of my readers did purchase the originals, but there weren't enough of them at any one convention to make the process worthwhile. . . . It's not that

my originals weren't worth $60 (or even $100, for that matter). The problem was that I was pitching this product to the wrong group of people.

A slight variation on the notion of selling the original art is to do freelance and/or commission work. In effect, the webcomic serves as an ersatz portfolio, showcasing the artist's talents and style. Some creators take advantage of that to offer to draw custom illustrations or graphic design. Since the work here is unique and not likely to generate secondary revenue, as in the case of the original strip artwork, creators often charge higher fees for this type of work. Gambrell (2013) was one creator who not only kept careful track of her income but for several years shared those notes online as well. In 2012, freelance work constituted 27 percent of her $32,000 annual income. Her freelance income soon outpaced her webcomic income, and led her to a full-time job in mid-2014, which she presumably secured, in part, for the health-care benefits it would afford her baby (2016).

Other creators use the option to take on freelance or commission work more sparingly, only when their schedules free up or they are in need of an immediate influx of income. While the option to do so certainly can help to make ends meet, it does also point to the variability and unreliability of leaning on that business model too heavily while trying to produce a webcomic. A creator may then have to find themselves wrestling with their priorities, trying to earn a living more directly through their comic or selling their services to customers who might like their art but are uninterested in the webcomic itself.

Ultimately, that is the root of the main challenge with selling anything: finding the right buyer who is interested in the product at a time when they can afford it. With webcomics, even finding an audience for the webcomic itself does not mean that a creator has found an audience of people willing to spend money on whatever they might have to sell. Across multiple types of content providers online, research has shown that sites can expect only between 0.25 percent and 1.25 percent of their readership to actually pay for anything (Crosbie, 2002). Chris Crosby, CEO of the webcomics portal Keenspot, agreed that he saw much the same types of numbers across the comics available through Keenspot: "Generally, you can count on at least 0.5% of your readership buying stuff, if the stuff

is at all appealing (and that can be tricky for some cartoonists). But it all depends on lots of factors" (Allen, 2014: 77).

That means that, using 1 percent as a rough average baseline, a webcomic would need 10,000 regular readers every month for just 100 to purchase something. If what they purchased yielded a $10 profit for each of them that would result in $1,000 going back to the creator. Even for a single creator, living by themselves, that's below the poverty line in the United States, and that's still assuming they could get those one hundred readers to buy something at a $10 profit every month for a year.

This is where some forms of crowdfunding come into play. The idea is to try to get a very large number of individuals to contribute (generally) small amounts to fund something, whether it's the production of a single book or the ongoing financing of a creator to handle their day-to-day living expenses. While the concept has been around for generations, the term was not coined until 2006 after online platforms that facilitated the idea began coming online. While earlier platforms were available, it was really Kickstarter's debut in 2009 that led to many webcomic creators attempting to use crowdfunding as a viable revenue stream.

The concept behind Kickstarter in particular is essentially one in which the advance payments needed to pay for production costs are pushed down to the very end of the distribution line; namely, the end customer. Rather than one or a few individuals shouldering the full costs of an entire production run, the costs are spread out over a large portion of the audience, minimizing the cash outlay of any single person. For the individual, it's almost identical to simply preordering a product, although most crowdfunding platforms are quick to point out that is not technically the case. Perry Chen, cofounder of Kickstarter, tried to explain the distinction:

> We haven't actively supported the use of the term [crowdfunding] because it can provoke more confusion. In our case, we focus on a middle ground between patronage and commerce. People are offering cool stuff and experiences in exchange for the support of their ideas. . . . So, you aren't coming to the site to get something for nothing; you are trying to create value for the people who support you. (Davison, 2015)

Each online crowdfunding platform, of course, has their own nuances to differentiate themselves from others, but the general principles remain.

Kickstarter caught the attention of webcomic creators for two main reasons. First, their model was set up with essentially an assurance contract; namely, that none of the funds would be collected until a prespecified goal was reached. That way, readers would not feel cheated if funding was not adequate to get a project completed and the creator was simply given the money without even the promise of any return. Creators immediately saw this as a good "safety net" for their readers. Second, Kickstarter happened to come along at an extremely opportune time, right after the aforementioned "great T-shirt crash of 2008" and just as revenue from advertising began dropping thanks to ad blockers. Webcomic creators were scrambling to find new income streams, and Kickstarter was the right platform that came along at the right time. It allowed creators to fund (among other things) publishing printed copies of their comics without relying on POD services. This not only guaranteed a minimum order of what were effectively presales but allowed creators to have their books printed much more cheaply, giving them a healthier profit margin per book.

Kickstarter was hardly the only crowdfunding platform available, but it attracted a good amount of press when it launched, with articles written up in the likes of *The New York Times* (Walker, 2011) and *Time Magazine* (Snyder, 2010). What really made webcomic creators stand up and take notice, though, was when Rich Burlew's campaign to republish his *The Order of the Stick* comics raised over $1.2 million, making it the second Kickstarter project to finish with over $1 million in pledges. Webcomic campaigns had been successful before, certainly, but surpassing the $1 million milestone, over 2,000 percent of his original goal, caught many people by surprise, including Burlew (2012) himself who said just after the campaign completed, "Any way you want to analyze it, it's surprising. Certainly, I'm still shocked . . . if this drive has proven anything, it is that I am *very, very bad* at predicting the future."

This level of success got a lot of attention in the webcomic community itself, with many proponents of the medium cheering Burlew's campaign on as it raised more and more funds. Although many creators were already earning a living from their webcomics by this point, Burlew helped solidify and, perhaps more poignantly, quantify just how successful making webcomics could be. There was no longer a question of just trusting a creator to tell people how much their comic was making (as relayed in more detail in the "Conflicts with Newspaper Strips" section); Kickstarter was able to

publicly show through their status as a third party just how much money a webcomic can generate.

As noted, Kickstarter was hardly the only crowdfunding platform available, even when it first launched. A variety of other companies have used variations on the same model, and others work from an entirely different setup. One other model focuses on ongoing support, rather than centering around a single, limited-time project. Creators are able to ask readers to send their contributions on a regular basis, and the request can be seen as thanks for work that is already freely available or as something more of a subscription service with exclusive features and content for those who financially contribute. Often, creators frame their presentation around both ideas: that someone's patronage is primarily in response to the work they're already doing, but it will also give readers access to additional content. This tends to elevate the idea beyond just asking for donations, but there's less pressure on the part of the creator to generate as much content as the regular webcomic already contains, as they might experience in a more straightforward subscription model.

While Manley's (2005) quote from earlier—"Begging is not a business" (175)—was fairly dismissive of the idea, the notion of simply asking for donations is worth expanding on briefly. He was certainly correct that simply asking for money is generally not a viable business strategy. Consumers expect something in return for their patronage, and trying to claim the money is for a webcomic that is already being given away for free is a weak argument. Further, even just presenting the idea can undercut a creator's attempt to look like a professional. Guigar (2013b) used a tip jar example to showcase that point:

> Take the standard Paypal donation button you see from time to time—sometimes disguised as a "tip jar." I want my readers to view me as a creative professional not a service-industry employee. I'm a businessperson; not a barista. . . . If I put that Tip Jar up, I'm sending a very clear message to my readers—and it's one I'd rather not send.

Of course, none of these business models are mutually exclusive to one another. Many creators, especially those who might not yet be well established, find they have to rely on some combination of ideas

to bring in enough revenue. They might have some advertising on the site, use one crowdfunding platform as a sort of ongoing exclusive subscription, use another to fund having books printed, sell POD T-shirts and mouse pads, and occasionally do custom illustrations on commission. All of those are viable income generators on their own, but it might take all of them to bring in enough for a comic creator to be able to make a living.

The specific mix of models will of course be different from webcomic to webcomic, but can also change regularly for a single webcomic. Both social trends and technological developments regularly impact how a creator might make money; the rise in use of ad blockers severely curtailed advertising revenue but an increase in the number of types of crowdfunding platforms allowed more creators to take advantage of them. But in order to avoid being caught in a financial bind because external factors may have changed how a revenue stream might operate, that means a creator needs to stay on top of not only their own finances but any disruptive elements that might impact their webcomic business whether that might be a new social media platform, a new type of computer chip, or a legal ruling that changes the rules of commerce. Only by keeping abreast of changes in the broader environment can a creator see when changes that might directly impact them might be coming. It's certainly possible to modify existing business models to ensure that a creator's webcomic remains their primary source of income, but it does require knowing how and when to make adjustments.

Regardless of what changes come, though, the same basic principles apply. While the specifics change a bit both over time and from medium to medium, the fundamental options for making money are not that appreciably different from those that have been available to TV, radio, and print for ages: advertising and sponsorship, sales of ancillary materials like T-shirts, and subscription/paywall models. Like those other media forms, each individual webcomic needs to find the right combination that is best suited for both the creator and their audience if they wish to be financially successful in the long term.

3

Key Texts

Girl Genius by Phil and Kaja Foglio

http://www.girlgeniusonline.com/

Girl Genius is one of the earliest widely regarded success stories from webcomics. Indeed, despite launching the comic in a more traditional format (distributing the printed copies to comic shops), creators Phil and Kaja Foglio soon saw that while their print comic was only breaking even, the webcomic version was proving to draw in considerably more income, in spite of the fact that the comic was available for free online.

Phil Foglio is perhaps one of the more senior webcomic practitioners working today, having professionally published comics going back to 1980. He got his start in science fiction fandom, becoming heavily involved in the Chicago Academy of Fine Arts' science fiction club and contributing a great deal to their fanzine, a platform which helped him win Hugo Awards for fan art in 1977 and 1978. It was this background that led him to creating short two- and three-page humor comics for TSR's *Dragon Magazine* beginning in 1980. From there, Foglio began longer form more dramatic comics like *D'Arc Tangent* (with Connor Freff Cochran), *MythAdventures* (with Robert Lynn Asprin), and *Buck Godot*.

Kaja Murphy had been a member of the Society for Creative Anachronism at the University of Washington, where she first met Foglio. They married shortly after she graduated and formally formed Studio Foglio, LLC in 1995 as a professional venue for their art, both individual and collective. Kaja became well known for her work on the *Magic: The Gathering* collectible card game, as well as

for the illustrations she did for Barry Hughart's anthology of *The Chronicles of Master Li and Number Ten Ox*.

Girl Genius began forming early in their relationship, with Kaja brainstorming off some of Phil's sketches: "I was going through all of Phil's old files and I was filing all of the old sketches, and I was coming across weird airships and cats in tophats with walking canes, and all of this . . . wonderful. . . . Victoriana sci-fi stuff . . . it was like 'Oh, this is everything I love!'" ("Phil and Kaja," 2008). Between Phil's interest in drawing "fiddley Victorian style gizmos" (Jordan, 2007) and their collective interest in mad science tropes, together they started crafting a world and backstory around a strong female lead. With so many comics coming out at that time that failed quickly, they were deliberate in planning the characters and their stories out to ensure they had a solid narrative arc to follow.

They announced the series in 2000 and came out with their first print issue early the following year. The issues were distributed through traditional comic shops, a venue that was largely only open because of Foglio's previous publishing history, and came out somewhat sporadically for the next several years. It was this history in print publishing which led the Foglio's to eschew the webcomic format initially, but their sporadic publishing schedule in turn directed them back toward the idea of putting the comic online.

Foglio explained,

> For a couple of years, I knew that the Internet was a viable business model. I had been telling new comic artists "What are you, crazy? Just put it on the Internet!," and, I don't know, I was just too stuck in the old ways. We got to a point where it was time to print the new comic, and we just couldn't afford it, so we put it online. We now think of the printed comics as advertising—when new issues come out, sales of everything else exploded, like "Hey, those guys are still alive!" (Scheff, 2008)

The *Girl Genius* comic itself centers around the titular heroine, Agatha Heterodyne, a "spark" who has a particular genius for invention. Foglio continued to sum up the character by saying Agatha is "the long lost and here-to-for unsuspected heir to an ancient family of mad scientists who everyone had thought safely

long gone. Because of who and what she is, everyone either wants to control her or kill her. Comedy ensues" (Jordan, 2007). The actual character design was essentially just a drawing of Kaja (2005), as she later relayed: "Agatha's look is the product of several different factors. The main one is kind of embarrassing, it's simply that back when we started working on *Girl Genius*, around 1993 or 1994 (I forget), that's how Phil drew me. He says he based Agatha's looks on me. Okay, what a nice man. I'll take it."

Agatha's adventures take place on the vaguely Victorian continent of Europa. The setting and many of the inventions of various sparks throughout the series have given reason for many readers to consider it firmly in the steampunk genre, which coincidentally happened to be gaining in popularity just as *Girl Genius* debuted. Kaja (2006), however, is generally insistent on using the phrase "gaslamp fantasy" to describe the setting, citing that their story has enough distinctions that preclude it from really falling under the steampunk umbrella:

> I've never liked the term steampunk much for our work, it's derived from cyberpunk (a term which I think actually fits its genre well) but we have no punk, and we have more than just steam, and using a different name seemed appropriate. I mis-remembered a term that I had come across in the foreword to an H. Rider Haggard book, where the author was talking about Jules Verne, H.G. Wells, Rider Haggard and that sort of pre-pulp adventure material, and came up with "Gaslamp Fantasy."

Agatha is introduced as a fairly isolated, less-than-stellar student in the town of Beetlesburg, working at Transylvania Polygnostic University under the supervision of Professor Tarsus Beetle. After the professor's accidental death and the loss of a special locket that kept Agatha's genius hidden even to her, she finds herself captured aboard Gilgamesh Wulfenbach's flying fortress/airship. It is during Agatha's escape that she begins acclimating to her new-found spark as well as accruing a cadre of friends and associates who recognize her potential to save them from any of a variety of evils, including Gilgamesh's father, Baron Klaus Wulfenbach.

Much of the comedy Phil alludes to in the earlier quote stems from this collection of Agatha's friends' diverse backgrounds,

ranging from literal royalty to working class circus performers to a talking cat to a variety of creatures called Jägers—a sort of intensely violent orc/human hybrid with bad faux-German accents and a penchant for elaborate hats. While the Jägers are sometimes used as overt comic relief, more of the humor lies in the culture and personality clashes that arise among Agatha's companions, frequently taking place in the background while Agatha herself is working toward loftier and narratively dramatic goals. Over the course of these adventures, she becomes more confident and assertive as she becomes more and more accustomed to her spark, and enjoys successes because of it.

The format of the strip itself is very much a product of its print origins. As the original installments were only designed for a traditional pamphlet style comic, the page format and layout reflected those norms as Foglio drew the pages in a roughly 3 × 5 ratio. Additionally, as the first issues were printed only in black and white as a cost-saving measure, the linework is more elaborate, replicating the filigree popular in Victorian designs. As color is introduced, the linework is simplified, with the Foglios foregoing doing any finishing inkwork and letting the colorist work directly off his pencil art. This naturally streamlined the production process for Phil himself, as much of the heavy detail he had been putting into his inking was transferred to the colorist. (It is worth noting that while Cheyenne Wright has been the colorist for the vast majority of the published work and is considered an integral part of the team by the Foglios, he was preceded by Mark McNabb and Laurie E. Smith.)

While bringing the comic online, they kept the formatting as they continued publishing the pamphlet versions in parallel for about two years. It was only after the thirteenth issue that they ceased printing the comics entirely and debuted new material exclusively online, releasing a new page every Monday, Wednesday, and Friday. Not entirely coincidentally, they began launching fully colored collected editions of over one hundred pages just as the print comic was ending; these were, however, not new material and simply reprinting the already published episodes. It would be almost two years before their previously web-exclusive material was to be collected in a trade paperback form. Since 2006, they have published one book per year, collecting the web strips roughly from the previous year.

This cycle reinforces the continued use of the 3 × 5 page layouts. Although perhaps not ideal for online viewing on horizontal computer monitors, and exceptionally difficult to read on a phone, it continues to serve its purpose of ultimately going into a printed form. Foglio has noted, "We no longer have to spend the time and effort to lay out individual issues, and with the time we save, we actually produce more *Girl Genus* material per year. Not producing the periodical comics saves us money—at least $20,000.00 a year. We consider the collections to be the end product" (Jordan, 2007).

This process also impacts how the story rolls out creatively. When the individual issues were still being published, there would be a story break every twenty pages or so at the end of an issue. Skipping that and going to the collections means narrative breaks can occur more naturally as the story progresses, and are not artificially enforced by a shorter format. A single chapter, not limited to the confines of a pamphlet comic, can be easily extended to thirty or more pages as the story organically necessitates.

The collection format also allows for a greater flexibility when it comes to overall length, with the books ranging anywhere from 128 to 320 pages. This means that as the Foglios are creating the story, they can expand or contract scenes to best serve the narratives without the constraints of a specific page count. Indeed, they can (and have) taken the story along tangents that would not be possible from a practical perspective if they were still crafting the story to fit the pamphlet format. This seems to have been well received by readers, who are able to see more of the secondary characters that may be personal favorites. These characters would likely not have been able to get nearly as much attention if the smaller story increments of pamphlet comics necessitated furthering the primary plot with Agatha in every issue.

Somewhat conversely, however, with pages being released only one at a time, it is more difficult to carry a scene from one page to the next, as readers generally have to wait days between updates. The Foglios, though, have modified their storytelling slightly to take better advantage of page breaks. Earlier installments, when still being printed in comic books before going online, had dramatic moments revealed sporadically throughout the entire book. With the individual page updates online, the dramatic tension tends to fall at the end of pages, as an almost rhythmic beat that entices the reader to return for the next installment. So while the overall

story is being written with the printed collections as the end goal, the individual pages are written very much with an eye toward their webcomic serialization. Virtually every page now ends with a narrative beat, whether that is the dramatic entrance of a character or the punch line of a joke or simply the end of one particular scene. In writing the story with the webcomic being the primary narrative driver, the Foglios seem to have tightened their writing process and are more conscious of how the very venue itself impacts the reading experience.

In discussing this idea, Phil noted this is in fact driven more specifically by how the audience might come to their comic:

> The big difference when we do a webcomic from when we were doing regular comics is we go into it with the knowledge that for many people, this may be the only page they see. So it is best if the page is self-contained in some way; it has a joke, it has a major plot point, you know, it has good costumes, it has something that people go, "Hey, this is amusing slash interesting" and they'll want to come back. Because if you just have a boring page, then people look at it and go, "Eh, screw it" and won't bother to click through. ("Writing Excuses," 2008)

Writing with the both individual page and the longer books in mind simultaneously might seem somewhat contradictory, as if the Foglios are trying to serve two formatting masters concurrently, but the wide range between the single page updates and the 120+ page graphic novels allows for both end points to be catered toward. The page updates work at a more tactical level, while the larger print collections work at more strategic one. Single pages can be created as stand-alone pieces and, at some level, are seen in isolation, while the overall story can be viewed at a greater distance over the course of weeks and months. The pamphlet comic, sitting between the two extremes in terms of narrative length, is too close to either to work as efficiently. Both the strategy and the tactics are more closely intertwined, and therefore more difficult to work toward in equal measure. This is indeed a challenge many print publishers face, and some fans of traditional superhero comics occasionally voice complaints of creators "writing for the trade" when the rhythm of the monthly comics seems stilted and artificial relative to the broader story.

This can be seen relatively clearly in the early installments of the *Girl Genius* story in which the Foglios were writing with the pamphlet format in mind. The overall narrative is cohesive and well structured, but individual pages are given less attention as far as story design is concerned. As noted earlier, dramatic moments occur somewhat sporadically and individual pages are not as concise and satisfying, narratively. It was only after they fully moved away from the pamphlet format and focused on the webcomic implementation that they begin treating each page as a more distinct storytelling unit, though they readily acknowledge that that came about organically as the strip evolved, and there is not a single point where the reader can detect a deliberate change on the creators' part. Kaja explained,

> We didn't change the style intentionally. There was no sitting down and having a meeting, and deciding to change anything. . . . We work the same way we always have, and people say, "Oh, well, now you've ended on a cliffhanger on every page," and I say to that, "Go back and read every page! That's a story that isn't finished yet. It's going to have a cliffhanger because you don't know what happens next!" (2008)

Unlike many webcomic creators, certainly those highlighted in this volume, the Foglios began their career in webcomics with something of a built-in audience. As noted earlier, Phil had been drawing comics since 1980. His "What's New with Phil and Dixie" strip was a staple of Dungeons & Dragons culture throughout the early 1980s, and it was successfully revived again in 1993 for another ten-year run. His science fiction series *Buck Godot* attracted a devout following, and he had garnered enough attention that he was hired by DC Comics to work on *Plastic Man* and *Angel and the Ape* which, while not especially high-profile books for DC, brought his work to an audience that he did not previously have access to. And while Kaja was not really known for any comics work previously, she was well known in the collectible card game community for dozens of her illustrations for *Magic: The Gathering* cards.

With these similar, but disparate, audiences, they were able to launch their original *Girl Genius* print comic, based largely on the strength of their names. It sold fairly respectively, given that they were self-publishing the book, and maintained its audience very

well. Over the four years the print book was being published, and despite multiple half-year-or-longer publishing breaks, the last issue sold almost exactly as many copies as the first in the direct market (Miller, 2001, 2005). While certainly not an inexpensive venture, this effectively became their initial marketing for the webcomic. Phil recalled,

> I must admit that I think that we had a slight edge over someone just starting out in webcomics, because we had an established readership, we already had a thriving web-based business site up and running, Phil and Kaja had been doing things in comics and gaming for over twenty years, we had a healthy relationship with Diamond and the retail community already established, and we had a basement full of already printed books for sale, and thus were able to have money flowing in from day one. (Jordan, 2007)

Readership only increased from there. Relying primarily on word of mouth and the strength of their story and characters, the Foglios quickly saw the benefits of giving away their comic for free and relying on the sales of collected print editions. Roughly two years after dropping the pamphlet comic format entirely, Phil posited, "Our readership is way up. At a conservative guesstimate by a factor of ten. Our sales [of the collected editions] have quadrupled, and not just from our online store. Sales through [direct market distributor] Diamond have gone way up, and I hear from store owners all the time saying that we're one of their bigger independent sellers" (2007).

Kaja (2013) explained, in a fairly tongue-in-cheek manner, the process for getting their collected editions printed: "Here's how publishing works. We use our time machine to jump forward in time to collect the money we have made from selling the books. Then, we pop back to the present, pay the printer, and they make the books for us." This somewhat facetious description of the process gets at one of the central issues concerning the publication of their books: in order to print the books needed to make money from the webcomic, they need to have money to have the books printed. This somewhat paradoxical approach is a perennial problem with self-publishing, and one in which online crowdfunding platforms have tried to address.

This basic model proved fairly popular among independent creators who often had difficulty getting their works produced in a manner they wanted because their own resources were frequently not sufficient to get the quality of production values they desired. A number of wildly successful campaigns on platforms like Kickstarter in 2009 and 2010 quickly raised awareness and interest in the model, and the Foglios themselves, despite having been successful in their webcomic model for over a decade, moved to running annual crowdfunding campaigns beginning in 2013. At the time, having already printed eleven volumes, they were fairly knowledgeable and upfront about printing costs:

> Printing the actual books is our biggest single expense. The first print run of a typical volume costs in excess of US $25,000. If that seems high, you must remember that we print eight thousand of them, and they usually run to around 120 pages. Our latest volume, number 12, will be even more expensive, as it comes in at 192 pages, and we'll be printing nine thousand of them, because eight thousand wasn't enough last time. (2013)

All of their crowdfunding campaigns have been successful thus far, reinforcing the dedication and devotion of their readership.

The numbers the Foglios cited earlier, coupled with the readily available data about their initial book sales and their Kickstarter campaigns, make for some interesting observations. The initial volumes of collected editions sold in the direct market roughly 1,900 copies for volume 1 in 2002 and 1,300 for volume 2 in 2004 (Miller, 2002, 2004). Their Kickstarter campaigns for volumes 12 through 17 each drew between about 3,000 and 4,500 backers. While each backer had the option to receive anything from only an electronic copy to multiple printed copies, it still points to later volumes having roughly double the initial sales of earlier ones. The roughly 5,000 books that are left printed up not presold are then used for readers wishing to purchase copies later from the *Girl Genius* website or at a convention where the Foglios are attending.

Also of note is that all of their campaigns raised far in excess of the $25,000 figure cited earlier. This is certainly not indicative of profits, however, as many of the campaigns feature additional

items like patches, pins, stickers, and so on that would require funds to produce, and all of the items then require payments to ship them:

> Actually, we have to ship them twice. Once from the printer to the fulfillment center, and once again from the fulfillment center to the customer. And whether a book is shrink–wrapped with thousands of its friends onto a pallet and loaded into a truck, or carefully packaged for individual shipping, several thousand pounds of books cost serious money to transport. (Foglio, 2013)

Despite having years of professional work under their belt, the Foglios still run much of the business operations side of things themselves in a relatively manual manner. Kaja (2018b) revealed how they still relied on friends and relatives to help over a decade into *Girl Genius'* publication: "For the first several Kickstarter campaigns, we packed and shipped everything from our basement. That means that my Mom was down there for ages packing things, then taking them to the post office every day. Sometimes our friend Carol from Cheapass Games came in and did the same thing." While there have been tools created to help alleviate some of these potential issues, there remain outlying issues, particularly as a creator completes more and more of these campaigns:

> The thing is, all those old Kickstarter campaigns are getting harder and harder to keep track of. A message on an old campaign page is easily missed, (although we do try to look things over regularly, it seems to happen more than we'd like.) So we're trying to consolidate things, to make things easier for our backers, and to make things easier for ourselves. (2018a)

All of this is on top of the work of actually creating the webcomic. The Foglios still have to sit down and build the *Girl Genius* story in the first place, and while they continue to look for new business models and adjust to changing industry processes, that does not often follow in the production. A curious phenomenon of the Foglio's success with the series, which has run longer with far more story pages than any of their prior works, is their relative reticence to push forward with technological changes. As noted earlier, they were recommending creators start off putting their work online

well before they themselves did. Phil actually credits their online success, in part, to the fact that they launched in the print medium originally:

> It may sound flippant, but the biggest step we took was [in 1991] twenty years ago, when we became independent comic publishers. What it meant was that when we went onto the web, we already had a working relationship with Diamond, and we already had several books in print so we could begin monetizing the strip immediately. Most webcomics start up, and then have to wait up to a year before they have enough material to put out a book. (Smith, 2011)

Additionally interesting is that Phil continues to draw the comic traditionally, with a pencil on a sheet of paper. This is still scanned to be colored and lettered digitally, and then posted online, but the source material is still pencil and paper. Kaja detailed the process they were still using as late as 2016:

> Phil will sit down with a piece of typing paper and storyboard it out . . . I will look at that; we'll go back and forth . . . back and forth with the plotting until we find a storyboard that we like and then he will draw it. I will take that and I will scan it and I will send part of it to Cheyenne. . . . He will be coloring it in Photoshop. I take another copy—just the black and white line art copy—I put that into Illustrator. Into Adobe Illustrator. And I do all of the scripting straight into Adobe Illustrator; this is why I can't actually have someone doing the lettering for me because that final writing pass is happening as I am putting those words into the word balloons in the comic. ("Worldcon," 2016; Figure 3)

So despite the previously mentioned streamlining of the production process by eliminating the traditional inking stage and working directly from pencils, this does not remove the scanning step. Many creators who do know their work is intended for online viewing skip this by drawing digitally in the first place, using an electronic drawing tablet. As they seem to have been in a solid creative rhythm for nearly two decades as of this writing, it seems unlikely this aspect of *Girl Genius*' creation will change any time soon.

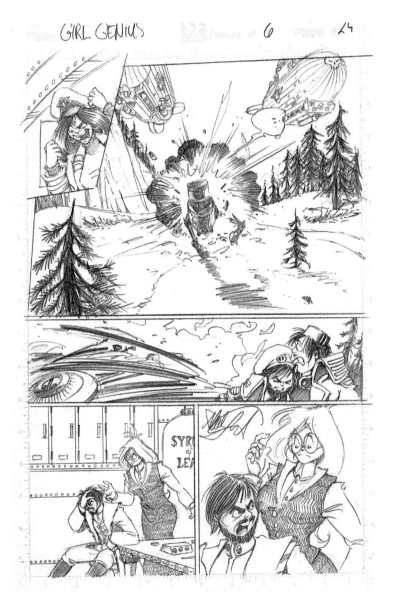

FIGURE 3 *Phil Foglio continues to draw* Girl Genius *in pencil. Original art provided by Graham Martin.*
Source: Studio Foglio LLC.

One key element to any work is the creators' ability to connect with an audience. While the Foglios' storytelling talents certainly connect with readers via the comic itself, the Foglios themselves are another noteworthy element. Even before *Girl Genius* was launched online, they made an effort to connect with readers by trying to bring them into Agatha Heterodyne's world. They offered, in lieu of a fan club, admittance to the in-story Transylvania Polygnostic University as a student. The Foglios set themselves up as professors of Very Nearly True History 101, and sent out report cards from their "very nearly perfected Automatic Grading Engine." Student ID cards could be clipped off the back cover of issue six.

While the increasing fan base made some of these personal touches increasingly difficult to maintain, the Foglios continue to tout their roles as professors at Transylvania Polygnostic and frequently refer to *Girl Genius* as a textbook for their class. They regularly dress in Victorian era costumes for public appearances and videos, and remain in character when they do any presenting. This is done in a fairly light manner, and they allow the wall between their real selves and their characters to be rather permeable, giving readers the sense that the Foglios are really just having a lot of fun working on the comic. This is somewhat infectious, giving readers "permission" to have fun with the comic as well. Fans will dress up as specific characters from the comic, or often create their own based on the comic's general aesthetic.

For a time, they even sold some costume materials on their site. Phil once recalled,

> Funny story . . . we had a guy come through Seattle from the distributor, trying to sell us more goggles. He showed us all the other models they carried. We said, "No, all those other goggles are too modern and industrial looking." "But," he said, "you're the biggest retailer for goggles in Seattle! Surely, you do a lot of welding!" "No," I told him, "we sell them to our fans— costumers and sci-fi fans." "Ooohh . . ." he said, "So they do a lot of welding?" (Scheff, 2008)

The comic stands on its own merits, as its three Hugo Awards can attest. But the Foglios present themselves as part of the product as well, and readers can connect with the two of them as creators as much as the story or any of the characters. This increases the attachment fans have for the series, and helps to bring them back

day after day and year after year. This fan loyalty helps ensure
the comic has a stable audience over an extended period, and has
allowed the Foglios to continue working on the series as long as
they have.

Girl Genius is one of the earliest webcomics that brought in
enough income for its creators to earn a comfortable living, although
this was indeed in part because both Foglios had established
individual fan bases for their work prior to launching the series,
and the series had launched initially in print and, as stated earlier,
acted as something of a marketing campaign before debuting online.
Despite having something of an advantage over other webcomics
at the time, it proved that webcomics could actually have a viable
business model, something that was very much in doubt at that
point. The Foglios' success prompted many direct and indirect
imitators although, interestingly, very few with their level of prior
print work. Though somewhat by accident, the Foglios hit on one
of the strongest (to date) business models for webcomics: selling
printed collected editions of the comics that were already online.

That said, it was still early enough in webcomics' history that
creators were still experimenting with other models.

Penny Arcade by Mike Krahulik and Jerry Holkins

http://www.penny-arcade.com/

Penny Arcade is frequently touted as one of the most recognizable
and enviable webcomic success stories to date. However, the unique
circumstances that led to its success are immediately seen as virtually
impossible to emulate or repeat, and many webcomic creators are
left dreaming of a similar deus ex machina style rise to prominence.

Mike Krahulik and Jerry Holkins, who knew each other from
high school, launched *Penny Arcade* in 1998 as a simple gag strip
about two gamers. They discussed a variety of topics circling around
games, from broad trends to specific games to industry news to
individual decisions made by gaming executives. (Game designer
John Romero appeared the very second strip.) Each strip was a self-
contained joke; however, the reader often had to be well versed in

gaming culture to understand it. Their views tended to be fairly raw and unfiltered, but generally well informed and sincere.

The comic debuted on the loonygames site and only updated once a week, but Krahulik and Holkins purchased their own domain the following year, in part because loonygames' owner wanted them to tone down some of the harsh language. On their own site, they began more frequent updates and the 12,000 or so readers they had already amassed followed them. Even after leaving the loonygames site, however, they maintained the strip's fairly narrow focus on video games, not even bothering to name their two main characters for months.

Early as it was in the web's existence, the gaming focus attracted an early audience, as computer and game enthusiasts, who comprised a large portion of people who were online at the time, both found the niche humor very relatable. The great promise of the web at the time was that a corporation would see someone doing something interesting online, throw loads of money at the owners in order to purchase the idea, and then continue to pay them exorbitant amounts to continue making things. This industry-wide thinking led to the dot-com crash that began in 2000, but before that happened, a company called eFront did snatch up *Penny Arcade*: "They sent us a check for like, $1,000 or something like that," Krahulik recalled a few years later (Peterson, 2004).

Mere months later, eFront got caught up in the crash and relinquished *Penny Arcade* back to the two creators. They continued making the comic, pulling in more readers every month, but they were scarcely earning much from their work, relying as much on donations as ad revenue, despite bringing in 7.5 million page views per month at that point. Krahulik explained their approach to business as, "The way we calculated that [how much to charge advertisers] was how much money we needed to live each month" (2004). This allowed them to pay their bills but that was always somewhat tenuous and there was little left after that. They managed like this for a couple years before one of their fans approached them in 2003 with a proposal.

Robert Khoo, an avid gamer himself, had been reading the strip regularly since 1999. He ran into them in a chance encounter and, in the ensuing discussion, learned they had no real business plan to speak of. Khoo realized they could be doing much better, and that a business manager would remove the stress of trying to run

their webcomic as a business and allow them to focus on creating
the strip itself. He said, "A few months later, I dropped a 50-page
business plan in front of them and said, 'Hey look, let me execute
on this. I'll work for two months for free. If I can pay for myself
after two months, keep me, if I can't, cut me'" (Bishop, 2006). Khoo
was so confident in his abilities that he quit his job to work for
them.

Khoo recognized a few things that Krahulik and Holkins had
not. First, he realized that they were sorely undervaluing themselves
in terms of advertising revenue, given the amount of traffic their site
was generating. Khoo felt they were charging 97 percent less than
what they could (Peterson, 2004). They were bringing in twelve
million page views per month and were not charging advertisers
accordingly (Guigar, 2013a: 215). Second, he realized that they were
only thinking in terms of promoting and selling their comic, and
not in terms of an intellectual property with marketing potential.
Reflecting back in 2011, Khoo recalled,

> I envisioned [Penny Arcade] as being a traditional media
> company (albeit a smaller version of one) with the big difference
> being that Mike and Jerry kept control. I felt like I could create
> an engine that allowed them to create, maintain credibility, AND
> be profitable, and looking back on it, there were some diversions
> here and there, but by and large the plan seems to have been kept
> intact. (Bitmob, 2011)

Roughly a year after Khoo began working for them, they launched
the Penny Arcade Exposition (PAX) in Seattle, WA. They had earned
enough in a single year to establish and host a convention focused
on video games, initially drawing 3,300 attendees and businesses
like Nintendo and Microsoft, which debuted their Halo 2 game for
the Xbox at the first show. Within five years, attendance swelled to
over 60,000 and, beginning in 2010, they branched out by holding
the convention in multiple cities, eventually including Boston, MA;
San Antonio, TX; Philadelphia, PA; and Melbourne, Australia.

Interestingly, despite debuting only a year into Khoo's tenure
with Penny Arcade, PAX was not part of his original fifty-page
business plan. The idea arose out of the notion that there was
not, at the time, a convention exclusively for gaming fans: "Before
PAX existed, the only place in North America you could see an

E3 [Electronic Entertainment Expo] style exhibition floor was . . . well, it was E3. Since that show was for industry insiders only, PAX has been the only place the public could see, hear and experience the insanity that is a game industry expo hall" ("What Is Pax?," 2016). However, Krahulik and Holkins were very clear they did not want to emulate E3, but instead provide a convention expressly for gaming fans.

Holkins was particularly keen on the community-building aspect of PAX early on. In 2006, shortly before the third convention, he noted,

> Our [gaming] culture is something that we experience individually so much. Then when we get together, we find out that there's all these people that have this shared history. It's just that it's virtual in nature. But it turns out not to matter that much when you get these people together. It feels just as authentic. It's still a pure social experience. (Bishop, 2006)

Penny Arcade's creative success was still primarily driven by Krahulik and Holkins' work on the comic itself. By 2004, they were getting 175,000 daily viewers as the content of their strips regularly tapped into the mood of gaming fandom (Peterson, 2004). Khoo described it as "a political cartoon for the game industry, really 'inside baseball.' Most stuff goes over people's heads" (Misao, 2014). Krahulik and Holkins had since adopted the identities of the strips' two characters (now named Gabe and Tycho) as online avatars for themselves, and their often well-informed opinions of specific video games, companies, and the industry as a whole were presented in a humorous, but unfiltered, manner that many other gamers responded to.

Even before launching PAX, they had become known in the industry for sharp takes on industry issues. "*Penny Arcade* is very well-respected in the gaming industry," noted Xbox Live's Larry Hyrb in 2004. "They're really an unbiased source, an unfiltered voice of the gamers" (Peterson, 2004). Hyrb went on to add that many of the developers in the Xbox offices were fans of the strip themselves, and had printed various installments of *Penny Arcade* to tape up to their office doors. Companies recognized, as Khoo did, that Krahulik and Holkins held a great deal of sway in the industry by virtue of their comics' reach. Whether they intended to

or not, their opinions could have a significant influence on a game's reception.

This led to another form of income for them. Beyond simple advertising revenue, they began offering sponsorships and creative services to companies. A video game developer could essentially pay them to create custom comics that could be used as strategy guides or even advertising. Although Khoo was the one who set up these arrangements, Krahulik and Holkins had final say and retained creative control over the actual content of these pieces. These comics are often posted on the *Penny Arcade* site itself under a "PA Presents" banner, separate from the primary comics, but they remain up for years after the initial launch of the game they were created for.

Khoo, in his advice to other webcomic creators, suggested that this was only possible after establishing their advertising model: "Work on the ad model first. Build those relationships. Pitching non-traditional work is a lot easier with that preexisting relationship. The pitch always comes down to the numbers. X dollars in traditional advertising gets you Y results. Spending X dollars in this new whiz bang offering will get your Y+Z results!" (Guigar, 2011a). This points to Khoo's methodical approach: the *Penny Arcade* as a business. There was a lot that he felt Krahulik and Holkins were doing wrong with regard to business practices, and in order to address everything, he has to start with what would make the biggest impact; in this case, changing their ad model in order to bring in more money.

Another relatively early effort after Khoo joined was the creation of the Child's Play charity. Sparked by a newspaper column scapegoating violent video games as the cause of violence in children, Krahulik and Holkins wanted to do something to put video gamers in a positive light. They challenged their readers to donate funds for toys and games for children in the Children's Hospital and Regional Medical Center in their hometown of Seattle. As with many of their endeavors, while the idea came from Krahulik and Holkins, Khoo was the one who was able to get everything organized and processed smoothly. He noted, "The idea was for the community to band together for something so simple and pure that you really couldn't look at it in any other way than positive. In less than a month, gamers raised over $250k, and from there it's

just snowballed into this incredible show of support, year after year, from both the community and industry alike" (Bitmob, 2011).

The charity was expanded every year, adding more hospitals and collecting more donations. In 2005, they were including hospitals from England and Canada, and raised over a half million dollars. The following year, they exceeded one million and included hospitals from Australia and Egypt. Their 2009 campaign raised almost a half million in its first week. In 2014, they began including domestic violence support facilities as recipients alongside the over one hundred hospitals they'd already partnered with: "As of 2016, the gaming community had raised over $44 million dollars to help children around the world through the power of play" (Eriksen, 2017). Khoo challenged the stereotypes of gamers, reflecting in 2011, "As far as the game community goes, I know I'm biased, but they're pretty incredible. They're intelligent, can mobilize in an instant, and [are] incredibly compassionate" (Bitmob, 2011).

Given the immense popularity of *Penny Arcade*, a webcomic about video games, it would seem to have been inevitable that it would be made into a video game itself. They partnered with Hothead Games to release the first installment of *Penny Arcade Adventures: On the Rain-Slick Precipice of Darkness* in 2008. The action-adventure role-playing video games were planned to extend over four episodes, but Hothead stopped development after the second. It would be another four years before Zeboyd Games finished the third episode, with the final one coming out a year after that. The games were moderately well received, with most of the episodes receiving reviews in the 70 percent range on aggregate review sites GameRankings and Metacritic.

In his review of the third episode, Shaun Musgrave (2015) suggested sales on the final two installments were poor: "Sales on some of the platforms must have been pretty weak, because although the fourth episode eventually came in 2013, it only released on Windows and Xbox 360.... *Penny Arcade Adventures 3* looks to be the last Zeboyd game on mobiles for at least the foreseeable future." This is backed up by the complete lack of promotion given to the games on the *Penny Arcade* site itself; they are not even available in the site store. It is worth mentioning the games' relative lack of success in light of their other projects; while *Penny Arcade* has been

wildly successful in many endeavors, like any media company, not every project is a guaranteed winner.

They began experimenting with video in 2009, launching a YouTube channel called Penny Arcade TV (PATV). It began as a series of episodes following Krahulik and Holkins as they developed new comics, worked at the latest PAX, and generally just chatted throughout the day. It expanded as the *Penny Arcade* staff did, and includes hours-long episodes where they play role-playing games and a series called *The First 15* where Krahulik and Holkins play the first fifteen minutes of a new video game. They've also utilized it as a platform to host content from cartoonists, which led to animated shows like *Ledo and Ix* and *Blamination*. One of the more ambitious experiments was a reality television game show called *Strip Search*, where twelve artists competed to win a cash prize and sponsorship of their comic by *Penny Arcade*.

Although arguably, PATV runs fairly far afield from *Penny Arcade*'s raison d'etre as a webcomic, Khoo explained the overall thinking:

> When you think *Penny Arcade*, it's about the comic strip, it's the core piece of content. From that, they've established a loyal reader base from that strip. Our job was to ask, "What other pieces of content service that, for people whom games are a lifestyle choice" So there's the comic strip, and everything we create is to service the people that read the comic. That's how PATV was created. We knew we wanted to create the reality TV show and it expanded from there.... Everything we do, we try to build out. We have the power to bring people in independently, and the goal is always to make it bigger than us.... We built this thing that's so big on its own; it's expanded beyond our sphere of influence. Same thing with Child's Play, which we created, but so much of it is supported by the gamer community and there are tons and tons of people that have no idea of its affiliation. We're trying to do the same thing with PATV. (Arevalo-Downes, 2011)

Despite having long-established a solid advertising base, they did experiment with crowdfunding in 2012. Their first venture was a Kickstarter campaign to launch a *Penny Arcade* card game called *Paint the Line*. Their goal was a modest $3,000 which they easily raised. Later in the year, they attempted a much more ambitious

campaign to eliminate advertising from their site. Their base goal was $250,000 to remove the "leaderboard" from the top of the home page; they ultimately raised over $525,000, which they felt warranted removing all the ads from their home page. It was also this success that prompted them to create *Strip Search*.

Although both of their projects were very successful financially, it would seem that the Kickstarter model did not fit well with their overall path forward, as they did not return to that platform again. They did, however, start a Patreon campaign a few years later. Unlike most Patreon campaigns that function as—or at least are promoted as—a means to support the creators themselves; theirs is set up more expressly as a fan club. "Club PA" as it's called was actually an idea they had given up in 2003, where fans would receive additional benefits such as downloadable wallpapers and additional comics for a fee.

The Patreon version of Club PA works similarly, but with two notable differences. First, the fee processing and digital rewards access is handled by Patreon. Second, membership now includes physical rewards that are delivered to the person's home. When the original Club PA was running, *Penny Arcade* consisted solely of Krahulik and Holkins, which meant they had to handle everything themselves. Now as a company with over dozen employees, they're able to expand the options available to members and deliver on them more efficiently.

All of this success, of course, does not come without attention, and not all of that is positive. In a comic parodying a small trend in gaming companies of creating very dark and gothic games based on childhood books like *The Wizard of Oz* and *Alice's Adventures in Wonderland*, Krahulik and Holkins created a mock advertisement of a similarly themed game based on Strawberry Shortcake, depicting her as a dominatrix. Because of their notoriety, this quickly caught the attention of intellectual property owner American Greetings, which promptly sent them a cease-and-desist order. They reprised the gag a few years later using Rainbow Brite, "an ancient, beloved brand that isn't under constant surveillance" (Holkins and Krahulik, 2011).

Likely more memorable for Krahulik and Holkins was a more drawn out legal battle with lawyer and activist against violence in video games, Jack Thompson. Thompson had written an open letter suggesting that a video game be made where it is people in

the video game industry that are killed and, if someone made one, he would donate $10,000 to charity. When multiple such games were produced, Thompson backed out, prompting Krahulik and Holkins to donate the money in his name. After Krahulik emailed Thompson to explain about how Child's Play had already raised over $500,000 for charity and that video game fans were largely good people, Thompson began harassing Krahulik by phone, claiming Krahulik was actually harassing him.

Holkins (2005) noted on his blog,

> Usually when a person threatens us with a lawsuit we don't really pay attention. The fact of the matter is that rude people and idiots often try to threaten people by gesturing wildly at the edifice of the legal system. But this man is *actually* a lawyer, and also demonstrably crazy, and he apparently has time to call random people who mail him.

Though Thompson filed lawsuits and attempted to get the Seattle Police and then the FBI involved, the suit against *Penny Arcade* was eventually dropped. Thompson was later disbarred. While eventually a "win" for *Penny Arcade*, dealing with it was, at the least, distracting for those years they were caught up, largely for being prominent and recognizable figures in the industry.

These types of concerns, ultimately, are relatively minor. Receiving the cease-and-desist letter cost them nothing, and the problems they ran into with Thompson, while undoubtedly stressful and probably being a small financial draw for a few years of legal fees, never went anywhere. But these are issues that effectively are never seen by most webcomic creators. These are problems that only came about because of the broad visibility *Penny Arcade* has. Other creators have railed against Thompson and his crusades, but their voices were too small for him to notice. Still other creators have created parody comics showing even bigger intellectual properties than Strawberry Shortcake doing even racier things, but without the spotlight *Penny Arcade* has generated for itself.

Some of the biggest challenges Krahulik and Holkins have faced due to the increased scrutiny their success has brought were of their own making. The coarse language that originally concerned loonygames' owner has never abated, and some of the humor that extended from that has received some backlash from their fans.

Krahulik and Holkins have occasionally made remarks in public that were, at best, insensitive to transgender individuals; although they would generally apologize later and Krahulik pledged to donate $20,000 to the Trevor Project, an organization working to stem suicide among LGBTQ youth.

One of the more sticking issues was a comic they made using rape as a punch line. They dismissed the criticism, and went so far as to make and sell T-shirts promoting the offending "dickwolf" character. Although the shirts were pulled and they apologized, Krahulik later publicly stated that he regretted that decision, for which he was called on again to apologize, which, in turn, led to a renewed outcry. While that didn't lead to widespread boycotts, Daniel Kaszor (2013) summed up how he saw it by saying, "My overall enjoyment of the products they associate themselves with lost their lustre to me. They became less interesting. . . . The refrain of 'I haven't really been on side with *Penny Arcade* since the dickwolves thing,' while not completely widespread, is certainly something that comes up fairly regularly on Twitter and elsewhere."

Despite the fact that all of their endeavors have spun out of *Penny Arcade* and the specific personalities that Krahulik and Holkins bring to the gaming industry, they have done some work to specifically separate the entities so as not to have Krahulik and Holkins accidentally damage the reputations of all of them. Though the *Penny Arcade* site links to their other outlets, neither the Child's Play or PAX sites link back to *Penny Arcade*; the Child's Play site goes so far as to never even mention Krahulik, Holkins, or *Penny Arcade*.

In an extended post in which Krahulik (2014) reflected on his failings in light of his anti-trans and dickwolves comments, he said,

> Early on in Child's Play's life it became obvious that its connection to *PA* was hurting it. We had a conversation with a group that was going to dedicate a fountain to the charity here in Seattle but later decided against it because of the content on *Penny Arcade*. . . . We promote [Child's Play] but it exists on it's [*sic*] own and I want any gamer regardless of how they feel about me or *Penny Arcade* to feel comfortable supporting it. I feel the same way about PAX. You'll notice that it is no longer the Penny Arcade Expo.

Many webcomic creators look at the drawbacks stemming from this attention and, either weighing them against the positives of Krahulik's and Holkins's success, both financially and emotionally, or ignoring them altogether, see the tradeoff as well worth it, wishing for someone like Khoo to step in to help them as well. Clint Wolf (2017), the writer of *Zombie Ranch*, was in awe of what Khoo did: "What Robert Khoo did for *Penny Arcade* is what I'm pretty sure most webcomic creators have dreamed about at least once, although I also think most of us would be happy just being able to live comfortably without dreams of anything beyond that."

Almost more importantly, though, is that Krahulik and Holkins are living comfortably on their own terms. The voice of *Penny Arcade* is authentically theirs and theirs alone, regardless of the size of the organization—not only the webcomic itself but their whole business model. Khoo explained, "Advertising and editorial have always gone hand-in-hand. But we decided early on that we would change that model. Instead of making the editorial advertising, we make the advertising editorial: No ads appear on *Penny Arcade* unless we like that game" ("Alumni Profile," 2008). Everything that appears on the site, down to the advertising, is a reflection of Krahulik's and Holkins's personalities and tastes, and speaks to Khoo's very early decision to stay out of their way as much as possible: "Things I don't touch are pretty much anything 'creative'—the comic, the newspost, that sort of thing. . . . Brands are nothing without the product or concept they're representing" (Bitmob, 2011).

Such authenticity, particularly with such a large and influential company, is rare. It speaks to their independence and integrity which, in turn, is part of what their fans like. Everyone at *Penny Arcade* seems to recognize that, as do larger companies that want to tap into that same market. Not understanding that authenticity, of course, is a large part of why most companies do not have it, and why they often think they can simply purchase it from *Penny Arcade*. Khoo recognized why that wouldn't work, even if the other companies did not:

> Pretty much any media company you can think of has made an offer to buy us off or buy us out. . . . There are too many things we couldn't do if we were part of News Corp or Viacom. I'm not sure there's enough money in the world worth ruining the day-

to-day experience and the amazing impact on this industry and culture that we're so passionate about. We like games. We like having fun. Our biggest fear is becoming corporate. ("Alumni Profile," 2008)

Despite the conventions, the videos, the video games, the charity, and everything else *Penny Arcade* seems to get into, the comic itself is still created by Krahulik and Holkins three days a week, the same update schedule they've maintained for over a decade. Khoo saw the potential for them to become a media enterprise based off the work in the comic, and they have absolutely become exactly that. In 2015, *Ad Week* listed Krahulik and Holkins as "Multimedia empire builders" in "The AdWeek Creative 100: America's Most Inventive Talent in Marketing, Media and Tech" (Gianatasio, 2015). Functionally, though, they remain gamers who create a webcomic. The accolades they might receive from the Washington State Senate or *Time Magazine* are a reflection of a business built up around them. They remain at the center, making jokes and gags about gamers and the gaming industry.

In the two decades they've been working on the comic, it hasn't changed appreciably in terms of style and structure. Krahulik's linework has got more refined, and his coloring provides much more depth; Holkins's vocabulary has increased, and his wordsmithing is more precise; both have become better storytellers. But the basic content has not changed; it remains a strip about two gaming fans ranting about the latest problems they see in the industry. Sometimes those are software updates, sometimes they're industry announcements, and sometimes they're corporate shakeups. The second strip they ever did centered around a game that was running very late and believed to be vaporware; a strip they did only a few weeks before this was written centered around two games that turned out to be vaporware.

Virtually every *Penny Arcade* strip for the past two decades has been a three-panel gag presented by Gabe and Tycho. While the source of most of the jokes is the gaming industry, the strip remains very much a love letter to it. Both Krahulik and Holkins have got married and had children since starting the strip; they have considerably less time to actually play the video games they love. But they still do. And they get paid to do it. And they get paid to make comics about it.

That, it seems, is what other webcomic creators really wish for: the ability to just make comics they love; to leave the daily hustle of running a business to others; and to draw a regular paycheck for doing something they love, and without having to do all the ancillary tasks they hate. Khoo gave Krahulik and Holkins a literally unique opportunity. They had already spent a few years putting in the work of the comic itself, and Khoo was just able to capitalize on it by being in the right place at the right time with the right tools.

Penny Arcade's success is almost certainly not replicable. Because Krahulik and Holkins started so early in webcomics' history, and happened to take on a subject that both they and many other internet denizens of the time cared deeply about but was yet to be fully served, it developed an early and large following. That Khoo came along when he did—after the dot-com crash that helped get *Penny Arcade*'s rights back in Krahulik's and Holkins's hands, but still early enough that no one had really started setting the "rules" of how to make money from webcomics—he was able to forge a path for them with his unique business proposition to fill a void that no one else had yet realized was there. There have been many webcomics since *Penny Arcade* that have been successful, but none have got their success in remotely the same way Krahulik and Holkins did.

Questionable Content by Jeph Jacques

http://www.questionablecontent.net

Jeph Jacques was born in Rockville, Maryland, and went to Hampshire College. Although he got a degree in music, he began working at a local alternative newspaper answering phones while remaining in the area. Since his job had left him with a fair amount of free time, but little money, he began toying with webcomics. "I ended up with a lot of time on my hands where I had nothing to do and an Internet connection" (Brown, 2008). In 2003, with little fanfare, he launched his first webcomic, *Questionable Content*.

Still in his early twenties, he focused the strip on what he was generally familiar with: mostly just personal relationships with some references to indie music. The initial cast was small and focused primarily on Marten and Faye, who meet for the first time in the fourth strip. While Jacques had originally intended for the strip's

focus to be between Marten and his robotic computer, Pintsize, he almost immediately saw more appeal in Faye's character. Faye's heavy sense of sarcasm from the start set the tone for the title; and most individual strips, while propelling the overall narrative forward, are still written to be read as a single, often sarcastic, isolated joke or gag. The cast has grown considerably over the years and, while the basic gag format and style of humor has remained, Jacques has done a lot to introduce a wide range of social topics.

The title was chosen almost more for marketing purposes than anything else:

> When I was looking for a domain name/title for the comic, I had a tough time trying to think of a good one. I didn't want to do some lame *Marten & Pintsize* or *Hipster Comics* thing, those are dumb ideas and way over-used naming conventions. I liked the humor behind *Something Awful* and *Something Positive*'s names, they do a good job of summing up those sites and have a sense of humor about it. "Questionable Content" is my little way of letting people new to the comic know that I write about boobs and farting and getting drunk sometimes, it is not a PG comic. (Jacques, 2004a)

Jacques's illustration style at first was relatively unpolished. His style progressed very noticeably, particularly over the first several years:

> The art is constantly changing, as anybody who reads the comic for more than two weeks could probably tell you. I'm always trying different things with the artwork—it's been a goal from day one to continually improve my drawing ability, and I think it's finally beginning to get to the point where I'm halfway decent at it. It's basically survival of the fittest—changes that I think fit in with the overall look I'm going for stick around and get refined, and changes that do not fit in get phased out, sometimes in the course of three or four strips, sometimes over a much longer span of time. (Curtis, 2006)

The earliest strips are almost completely unrecognizable from those five years later, which themselves are barely identifiable with what he's doing currently.

Although definitely intentional, as noted earlier, Jacques's improvement can in large part be attributed to rigorous and ongoing practice. While the strip initially launched with a twice-per-week schedule, it switched to three times per week after the first month. However, just over a year into the strip, Jacques lost his regular job and decided to try to make his living doing webcomics, switching to a five-updates-per-week schedule, which he has maintained since. Putting in this daily effort in drawing the strip gave Jacques (2004b) a great deal of practice, and his illustration skills began improving at an even faster rate. In announcing the new update schedule, he even predicted it would help sharpen his skills:

> I feel like the one thing that has been holding back the growth of the strip lately was only having time to do 3 comics per week. I am SO excited at the prospect of being able to do a comic basically every day, you have no idea. This will give me room to stretch out, to develop the plot and characters more, and to further hone my skills as a writer and an artist.

Like many webcomic creators, Jacques started the strip while still working another, unrelated job. This is, of course, a means to have some income while the audience for the webcomic develops. Frequently, creators lean on this job as a financial safety net, only switching to doing their comic full-time once it is earning, or nearly earning, what they would consider a living wage. In Jacques's (2004b) case, he was forced into the situation earlier than he may have liked, but he had at least built up a sizeable enough readership that he felt hopeful that he could earn his living from working on the strip, noting at the time, "I want to try making QC my full-time job now. It's the most fulfilling work I've ever done, and being able to make a living off of it would be a dream come true for me. Is this possible? I don't know. It might be, and I have enough hope to give it an honest shot."

The money Jacques first made from the strip was in selling T-shirts with original designs on them, mostly based on either shirts worn by characters in the strip or dialogue they used. He did not have shirts available right from the start, however. In a 2006 interview, he provided a specific suggestion based on his personal experience:

> I always tell people you should have 2000-4000 unique IPs hitting your site per update day before you even think about

selling t-shirts or other merchandise, otherwise you'll have trouble meeting minimum order numbers and will end up losing money. That's about how popular I was when I put out my first design, and it broke even. . . . The bottom line when it comes to making money off of your comic is that there needs to be a decent population of people to buy your merchandise. (Curtis, 2006)

So by the time he attempted to make the strip his full-time job, he had already proven his readers were willing to buy his material. Although, somewhat surprisingly, that did not include a collection of his strips—that would not be published until 2010, seven years after he launched the comic.

Interestingly, Jacques (2004a) eschewed the other primary method of trying to earn money via his webcomic by opting choosing not to run external ads at all, seemingly as a point of integrity. He does not seem to hold that advertising is bad in and of itself, but is more concerned with maintaining his independence as a creator: "I look at banner ads as a necessary evil. QC is fortunate in that I have not had to solicit any advertising to keep the site running, which means I don't have to worry about 'sponsors' or any of that junk." When he was later asked about maintaining an "indie" status and not "selling out," he responded, "'Selling out' has been rendered a largely meaningless term by its thoughtless overuse. As far as I'm concerned, you've only 'sold out' once you've put making money ahead of making good product. Even that is a very subjective situation—everybody needs to eat, and everything is a compromise" (Marshall, 2008a). While he does include ads on his site for his own material, he has so far proven that he does not need the additional income external ads may have provided.

One of the great financial windfalls of which Jacques did take advantage, however, was the creation of Patreon. Unlike many other crowdfunding platforms, which have contributors pledge money to a creator for a specific creation—like a book or poster— on specific occasion, Patreon is geared more for ongoing support and contributors pledge a typically smaller amount for an ongoing basis, something akin to a subscription. Like most crowdfunding platforms, Patreon takes a small percentage of the money before passing the rest along to the creator. Creators do tend to use incentives like additional strips or advanced viewings of regular

strips to encourage people to select larger amounts, but there are rarely physical rewards that require additional shipping. Jacques began using Patreon in 2014 and quickly began gaining patrons, bringing in over $5,000 just from Patreon in the first month. This increased to a point that seemed to surprise Jacques himself and, as of this writing, his patrons are collectively sending him over $120,000 per year just through this sole crowdfunding platform. While Jacques did at one time at least consider the notion of advertising as something he might do given the right circumstances, the success he has been experiencing with this direct funding of his works makes the likelihood of that extremely remote.

As with most Patreon creators, his rewards are all digital, meaning there are fewer logistics than is typical with platforms like Kickstarter or Indiegogo. Obviously, he does not have to deal with the physicality of shipping anything, but in addition the Patreon platform itself handles the distribution of all digital materials. This means that when Jacques uploads a bonus comic to the site, he only needs to tag it as viewable by a certain tier level of his patrons, and all patrons at that level are given access and notified. He uploads the file once, and he's finished. His workload does not increase at all as more patrons join, no matter if that is by one person or a thousand.

Jacques has removed himself from the fulfillment side of selling physical merchandise as well. Initially, he and his first wife handled all of the distribution themselves, with shirts and hoodies being stored in bins in the same room Jacques was creating the strip in (Brown, 2008). The two would pack, label, and ship the merchandise themselves. Eventually, Jacques (2009) turned all of that over to Topatoco, citing that it had got far too overwhelming for them to process by themselves:

QC has just gotten too big for Cristi and I to handle everything ourselves anymore, and Topatoco has a well-deserved reputation for being awesome. . . . What does this mean for us? Not wanting to kill ourselves because WE HAVE SO MANY T-SHIRTS TO MAIL OUT OH GOD which has pretty much been our state of mind for the past four years.

As noted earlier, the strip's primary focus at first was in the relationship between Marten and Faye. Jacques has stated that

he had intended to follow something of a *Penny Arcade* model of storytelling with the two main characters, talking mostly about a niche topic; in this case, indie rock:

> When I was starting out, I took a lot of my cues from *Penny Arcade* and *Nothing Nice To Say* in terms of referencing things I was interested in, namely indie-rock. But as the series progressed and the character interactions came to the fore, I found it more interesting and in many ways easier to write jokes about how people wanted to make out than to think of something funny to say about Built to Spill. It was never a conscious decision, but the decline in music references was partly because it dated strips . . . and partly because one of the most common complaints about my comic was that nobody knew the bands I was referencing! (Marshall, 2008a)

As the strip focused more on interpersonal relationships, Jacques would sometimes add additional characters: sometimes as a love interest, sometimes as a foil, sometimes just to fill a functional role. Whether intentional or not, Jacques would imbue these new characters with enough character that he (and his readers) would find them interesting and engaging in their own right, so he would find ways to bring them back into the strip. This increased fairly noticeably after his 500th strip in which he resolved the question of whether Marten and Faye would become a couple. This turned out to be a hugely significant turning point for both the strip itself and Jacques's (2012) approach to it. He explained this shift in the Introduction to his third *Questionable Content* collection:

> This is the point where the comic really started to come into its own, in my opinion. After the big Marten/Faye talk around comic 500, the focus of the strip shifted from a rather one-dimensional will-they-won't-they romance to a much broader ensemble comedy. I found myself having all sorts of ideas for new characters, story arcs, and relationships, and I suddenly had the space to explore them. While Marten and Faye remain the core of the cast, the comic isn't really "about" them anymore—it's more about the intersecting stories of a group of friends, the challenges and changes they go through, and the meandering paths they take through life.

As if to emphasize this shift in focus, it was in fact the tail end of this arc in which Jacques introduced Hannelore, who would go on to become one of the strip's most popular characters. Hannelore helps to signal Jacques's shift in two ways. First, while she is first introduced as pursuing a friendship with Marten and Faye, she has no romantic notions toward either of them. This showcases a tonal shift away from that of a love story to one about relationships in general. Second, she has a drastic case of obsessive compulsive disorder. While this is sometimes played to comical effect, it is more noteworthy in that her friends never make fun of her sometimes unusual habits and simply accept her for who she is. This notion of acceptance becomes an increasingly important theme as the strip goes on, and Jacques is often explicitly told by appreciative readers how much that means to them: "You feel bad for Hannelore, you want her to be okay! But she is rarely okay. Readers, by and large, seem to love her. . . . I've gotten quite a bit of very touching email from OCD sufferers who really identify with her, and that makes me happy" (Marshall, 2008a).

Those connections readers make with Jacques's characters become increasingly important as he begins introducing more characters that traditionally ignored or marginalized groups can identify with. As Jacques's shift started, those groups were primarily people who deal with a variety of mental health issues. Besides the already mentioned OCD, there are stories that address issues with post-traumatic stress disorder, self-esteem, sociopathy, insecurity, and alcoholism among others. Rather than treating each as an *ersatz issue du jour*, however, Jacques uses them as traits endemic, sometimes even central, to some of his characters. The issues are ones the characters deal with as part of their everyday lives, and help to inform how they act and react, so these topics get woven in to the strip to varying degrees just by virtue of a given character appearing.

Jacques is clear, however, that the types of mental health concerns his characters have are not their sole defining characteristic. Just because a given character shows up does not mean their particular issue will be the focus; in fact, more often than not, those mental health issues are not expressly mentioned. Rather they float in the background, mostly as an explanation for someone's actions. That he has readers identify with those characters without poking fun at

them or portraying them in a negative manner is important, as he alluded to in a 2014 interview:

> They're also problems a lot of other people struggle with, and I think having a piece of entertainment that addresses them in a positive light can be very helpful. I get a lot of satisfaction from emails telling me my comic has helped people deal with their own problems. The longer I do the comic, the more interested I become in writing experiences other than my own, and I think the writing is beginning to reflect that. (Cook, 2014)

That notion of writing experiences other than his own expanded, too, to begin to include gender and sexuality. Jacques has introduced characters that are gay, lesbian, bisexual, and asexual; Marten's mother was brought in as a professional dominatrix; a newer character named Claire was later revealed to be a transgender woman. While Jacques himself is a cisgender heterosexual, he was aware that portraying the characters in an insensitive manner would result in any number of problems. He's cited both doing basic research and putting a considerable amount of time thinking about the social implications involved. Going to school in a fairly liberal area, his characters also reflect the relatively accepting attitude he saw around campus when he first encountered other types of individuals with different experiences and backgrounds from his.

From a creator's perspective specifically, though, he views this approach as simply good writing:

> My goal is to portray people of all orientations as people, first and foremost. This has a number of benefits—it makes for good writing, it helps people who share those orientations feel included, and it helps people who have other orientations understand them better. I live in a very liberal, sexually diverse area of the [US], and a good portion of the diversity in the comic is reflective of the reality in which I am privileged to live. (2014)

This alludes back to his previous notion of constantly striving to improve his artwork. Jacques recognizes that any skill, no matter how well practiced, can still be improved and he continues to work on his craft.

Similarly, Jacques also seems to enjoy stepping outside his comfort zone and pushing himself to create interesting characters that are notably different than himself. That is part of the challenge in writing, and part of what he enjoys about it, as he talked about in 2014:

> There's this common misconception (mostly among bigots) that writers keep a sort of "diversity checklist" that they feel compelled to complete in order to be "properly" socially conscious or whatever. The reality is that writing diversity is fun! It's challenging and risky, particularly if you're the straightest, whitest dude in the world like me, but it's fun. So there's definitely stuff I'd like to expand more on in the future. For instance, I don't have enough people of color in my comic. And it would be fun to write more gay dudes! (2014)

By focusing on making everyone a fully realized character, instead of just a prop or some trait to check off a list, Jacques not only is able to make a more inclusive, fully realized world but also ends up making his comic very representative for a wide range of potential readers.

Further, that all of the characters are accepting of one another— there are few characters that might even be called an antagonist, and they make exceptionally rare appearances—means that *Questionable Content* provides that acceptance as not only a baseline but as a thematic element to the strip:

> One of the major themes of my comic is acceptance, and the characters generally accept each other for who they are. They've all sort of wandered into this group and been accepted, and I think that's a big part of what keeps them close. They support each other in all sorts of different ways—Marigold and Hannelore in particular seem to have formed this weird sort of symbiosis where they help each other be more functional. And then there are the robots, whose literal purpose is to help out "their people." (2014)

Regularly seeing characters who are trans or bisexual or suffering from PTSD or any of the various forms of "othering" that get

brought up but are still liked and enjoy friendships based on who they are resonates very strongly with readers.

As with many creators who readers strongly connect with, Jacques has remained fairly accessible, while still retaining some level of distance. He has been relatively open about people contacting him via email, Twitter, and Tumblr. He claims to read everything, even if he's not always able to respond. He hosts a message board for his comics (both *Questionable Content* and his now-completed *Alice Grove*), although he doesn't actively participate there very much. He's estimated that 99.9 percent of the responses that go to him are positive and, of the 0.1 percent that are not, half of those include useful criticism (Curtis, 2006). His own story comments shortly after some of his major story points touching on sensitive issues also suggest that most of the responses he gets about them are very affirming.

Despite the amount of investment readers have in *Questionable Content*, and the amount of time they put forth discussing it, very little of that seems to impact the content of the comic itself. Jacques has noted, "As far as readers 'bending' the story or whatever, that doesn't work with me. Historically, my readers have been pretty bad at second guessing me. Suggestions for strips or stories are cheerfully accepted but don't have any bearing on the comic itself. I'm pretty stubborn." He takes pride in the work being his own, and not feeling creatively beholden to anyone besides himself, tying into his previously mentioned attitude toward advertising. He has to satisfy himself creatively first and foremost:

> I've found that a good gauge of whether I'm pacing the story properly is to simply pay attention to how it makes me feel when I'm thinking about it—if I feel excited and find myself looking forward to a certain event or plot point, I'm probably moving along at the right pace. If I find myself getting bored or stressed out, it means I should probably change things up a bit. (2006)

Although working as both the writer and the artist, Jacques starts each strip by writing the script out in a simple text editor. Although he seems to keep in mind the basic structure of the comic as he writes, "I start with panel #1 and work my way forward—typically what I'll do is write out all the dialogue I think is necessary, then

break it up into panels, adding or removing stuff as needed. Once I've got a finished script, or something close enough to finished that I don't feel angry and frustrated, I start drawing." He does all his work in Manga Studio using a large Cintiq drawing tablet, starting with his initial sketches, going through the finished linework, colors, and lastly dialogue: "Typically I will go back and revise little bits and pieces of the script as I draw, and often the final punchline will be different from the one I had when I started working on the art" (2006). The resulting work is thus entirely digital and completely editable in his primary source file. He tends to work at a very large scale, over 600 percent of the size readers see online. This helps to hide small errors in his linework, but it more importantly gives him a great deal of flexibility when it comes to using the work in other formats, like in printed collections.

While his income from the comic is high relative to other webcomics, he still maintains reasonable concerns about money, a necessity when using a lot of higher end equipment. Not only does he need to maintain his primary desktop and drawing tablet, but he has a smaller drawing tablet that he uses to complete his strip while traveling. Jacques (2017) noted problems he began having with his equipment in late 2017, when multiple devices were on the verge of permanent failure, by complaining, "My mac pro [sic] can't go more than 24 hours without crashing, and now my cintiq [sic] is acting up . . . I feel like next year is gonna be Expensive Hardware Replacement Time." In Jacques's case, were either to completely fail, he could still use his mobile setup to ensure his comic continued, but the concern about major expenses stemming from keeping his tools operational is noteworthy. Were he not successful enough to either have a backup or to afford replacements, these could be grave concerns, given that these tools are directly tied to his income.

But Jacques stands out as one of the major success stories in webcomics, and is lauded by younger webcomic creators as the ideal model to follow. His biggest success has been his first strip, which began with fairly crude artwork; it gained a following just based on word of mouth and not from any advertising; he was making enough money from his comic after the first year that he didn't need his day job; he made enough money through sales of his merchandise that he's never needed advertisers; and his crowdfunding campaign has given him a six-figure income. His example is effectively a textbook case of how to earn a living making webcomics.

Jacques, however, maintains that he does the comic for himself first and foremost. He refuses to cede his creative integrity to anyone, and his sense of character and humor simply happen to connect with a large audience. This also makes him an ideal case for how to make a webcomic from a creative perspective. He has spent over a decade following his muse and is constantly trying to make the best comic he can for his own sake, without following a rigid outline or even pursuing a particular ending. He creates the work on a daily basis, and almost just acts as a conduit for a cast of relatable characters:

> *QC* is tremendously fulfilling for me, mainly because I know I'm doing the best I can with it at any given point. The fact that so many other people seem to enjoy it and identify with the characters and laugh at the jokes is a nice bonus, but I'd still be doing the comic even if nobody was paying any attention. If it wasn't "worth it" I wouldn't do it. (Curtis, 2006)

Stand Still. Stay Silent. by Minna Sundberg

http://www.sssscomic.com/

Swedish-born Minna Sundberg originally had the idea for *Stand Still. Stay Silent.* in 2010 not long after she began going to the School of Industrial Arts at Aalto University in Helsinki, Finland, for a degree in graphic design. However, not having much background in comics, she thought it would be prudent to begin working on another comic before tackling the one she was really interested in.

Of her background and knowledge of comics prior to attempting to create one, she noted in 2014,

> I haven't really been into comics before I got into this whole webcomic thing, so I only read what my parents happened to have, which was mostly Donald Duck and a whole bunch of central European comics like Tintin, Asterix, Iznogoud, The Smurfs, Spirou and Marsupilami. Oh, and the old *Alien* comic, but I wasn't allowed to read that one as a kid. Of course I still did and got pretty traumatized when the very first spread I opened was the one where the Alien burst out of that one dude's stomach. (McElmurry, 2014)

The Donald Duck comics she read is most likely why she usually cites Don Rosa, the most prominent and prolific Disney duck artist from 1987 through 2006, as one of her primary comics influences.

Because of that prior lack of deep interest, Sundberg (2013) had not spent a great deal of time practicing that type of art and thus felt her drawing skills weren't adequate enough to really tackle this type of project:

> I really wanted my dear comic to look nice from the beginning, which I knew would not be happening because it had human characters in it and I . . . did not . . . know . . . how to draw people. I could [work] through almost copying from reference pictures or with a live model, but that's not good enough for anything. I needed practice, and I sure wouldn't let my newly hatched pet project be the victim of said practice!

She began toying with other ideas for different webcomics that she could use to hone her skills. Her first idea featured anthropomorphic animals working at an energy plant, but the idea ultimately never inspired her and she dropped it after a month. Her second idea revolved around cyborg seals with prosthetic arms and legs who studied "normal" seals, but who were later attacked by enormous wolverines. Sundberg worked on this idea longer and developed a complete set of story thumbnails for it, but discarded it after realizing that she didn't really connect with any of the characters. It wound up being seven months after she decided that she needed a "practice" comic that she came up with the idea for what would become *A Redtail's Dream*.

A Redtail's Dream is based on some of the ideas and stories in Finnish mythology, in particular, the Kalevala, the Finnish linnunrata, and the Karelian sielulintu. Sundberg spent much of her free time during her academic career working on and publishing the webcomic, increasingly buoyed creatively and emotionally by the regular audience she was cultivating. She later reflected, "I kind of stopped caring about getting good grades during that time" (2013). Although originally intended to be less than 150 pages long, it wound up taking over 550, only finishing up as she graduated in 2013. The response she received during the course of the story

encouraged her to have it printed, so she ran a crowdfunding campaign on Indiegogo that successfully raised well over 500 percent of her financial goal.

Sundberg chose to run her *A Redtail's Dream* campaign (as well as her first *Stand Still. Stay Silent.* one) through Indiegogo instead of the more popular Kickstarter for the simple reason of geography. At the time, Kickstarter projects were only able to be run out of the United States and United Kingdom, thus preventing Sundberg running a campaign from her home in Sweden. Campaigns were opened up to additional countries over the next few years, but no Nordic countries were included until late in 2014 just after Sundberg launched an Indiegogo campaign for *Stand Still. Stay Silent.* (Woods, 2014). By contrast, Indiegogo was much more international in its reach, with availability in dozens of countries very early on. (As an interesting aside, by the time she was ready for her next crowdfunding campaign and could have theoretically used Kickstarter, she had paired with Hiveworks who ran the campaign for her out of Portland, OR.)

As she neared the completion of *A Redtail's Dream*, Sundberg (2013) began working on *Stand Still. Stay Silent.* in earnest, publicly posting some of her first notes and sketches about the comic in 2012. While she was certainly using those to try to drum up early support of her next project, she also used that as an incentive for herself, much like she did for *A Redtail's Dream*. A few days before formally launching *Stand Still. Stay Silent.*, she noted,

> I knew it would be very easy and tempting to call it quits after just 50 pages and pretend that I never even tried if I didn't tell others about my project. . . . But if I told strangers on the interwebs that I was going to make this comic and finish it with my head held high, then quitting halfway through would bring shame upon my being and discredit myself as a reliable artist, and the proof of my failure would forever be etched into the unforgiving memore [*sic*] of the internet and total strangers. Now that's a great incentive to keep pushing forward!

Stand Still. Stay Silent. is the story of a group of researchers trying to gain knowledge and insights about the largely deserted, postapocalyptic world beyond their very local borders: "It's a story

about friendship and a long journey to explore uncharted places in a forgotten world, sprinkled with some Finnish and Norse mythology, magic and a tiny dash of horror" (2014a). However, the inadequate funding they're provided and the group's lack of any practical experience are only the first challenges the team comes up against. That they don't all speak the same language doesn't help matters much either.

Growing up in Sweden and Finland, Sundberg's fluency in those languages in addition to her knowledge of English helps to inform her comic. The strip takes place on the Scandinavian Peninsula which, of course, incorporates several countries which don't all use the same language. The research team, being comprised of people from those different countries, thus collectively come to the table with a built-in communication challenge. While some are multilingual like Sundberg herself, many are not, which leads to some characters having to translate for one another and/or finding other ways to communicate.

Within the comic itself, Sundberg writes all the dialogue in English. However, as a novel convention for indicating which of the five languages any character might be speaking that isn't English, she draws that nationality's flag in the speech balloon as a visual marker for the language. This way, the reader is never at a loss for what is being said by any of the characters, but it is also immediately clear why they might not be understood by another character. This provides the added benefit of making distinctions between what a character actually says and what they're understood to be saying by others. It adds texture and character by showing how some characters might try to ease tensions by deliberately mistranslating complaints or insults, or how others might be seemingly willfully obtuse to someone's gestures and facial expressions. While it's not unheard of for comics to have characters that speak different languages, that we have six languages represented with a fair amount of regularity in this one comic is unusual, thus making the need for a clever shorthand like what Sundberg has devised almost necessary. It avoids using translation footnotes, which take up extra space and pull the reader away from the associated images, and it makes for a quick and clear indication of how and why two non-English-speaking characters might still have difficulty understanding one another (Figure 4).

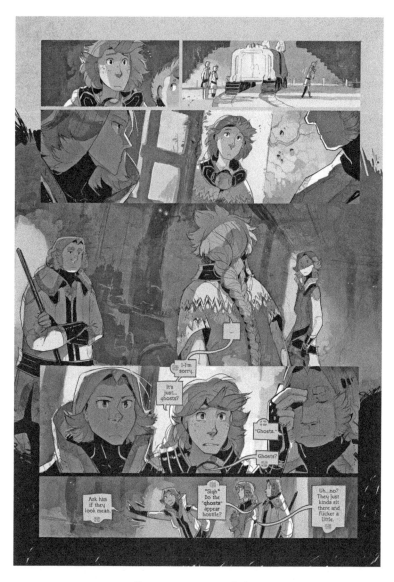

FIGURE 4 *Minna Sundberg uses national flags to identify characters speaking different languages.*
Source: Minna Sundberg.

Sundberg's multicultural upbringing also informs some of the character backgrounds as well. While they all generally follow the same mores and principles, the specifics of their customs and traditions are different. Here again, it is not unusual for a comic to depict a couple of different groups together that need to overcome cultural barriers, but they are frequently presented as radically different from one another. In *Stand Still. Stay Silent.*, the cultures on display through the various characters are all in fairly close proximity to one another, both physically and sociologically, so the differences are not always immediately obvious. This, coupled with the fairly long-form narrative, allows Sundberg the ability to examine these in a much more nuanced manner than might be possible in, for example, a single graphic novel.

Besides language, one of the obvious cultural differences shown among the characters is that of religion. The characters hold to different belief systems, sometimes referencing their gods by name. Additionally, they come across old Christian churches in their travels, further showcasing the varied religions of the area. While the team members generally hold fast to their individual beliefs and occasionally display a dismissive attitude for learning about others' religious practices, they do all ultimately respect that they might not all worship in the same manner. When the character Reynir asks for guidance with regard to learning some magic, for example, Onni apologizes, "I'm sorry, I can't help you. I don't know your gods" (2016a).

What becomes fascinating in this approach is that, despite the recognition and acceptance of several religions, all of the spiritual elements are bound together, seeming to operate and inhabit the same ethereal space. Reynir, Onni, and Lalli all act as mages of varying skill levels, but function and operate in the same netherworld dreamscape, despite their different theologies. Further, they also encounter some lost souls of the deceased on that plane, some of which are clearly depicted having belonged to still other religions. In fact, the lost souls of dozens, if not hundreds, of individuals at one point all seek salvation via a Christian church and pass through the dreamscape in the process.

The intersection of religious practices occurs again as Reynir begins trying to craft runes capable of warding off any lost souls intent on harming them. His runes are based off those he knew and grew up with on his family's farm, obviously steeped in his family's

religious practices. Despite that, they are shown to be very effective against any of the spirits that they're used against, and seem to be usable by anyone on the team, regardless of their beliefs. Reynir passes out small sheets to everyone with his runes drawn on them, and later paints a large one on the back of their vehicle.

The implication Sundberg seems to be trying to make is that, despite a variety of superficial differences, magic and religions of all sorts intersect and functionally act the same; they are all simply different entrances to the same venue. Though the team members do not all share the same belief system, they all spiritually connect in the same way and interact with the spirit world in the same way. This further implies a universality or commonality among everyone, regardless of their background, suggesting that people are less dissimilar than they often like to believe. Given the team's basic differences in personality and the communication barriers they often face, a case could be made that the teamwork and common ground they find to work as an effective team is a small-scale model for peace among all nations, regardless of theological differences. The practicality of experimenting with these ideas in real-world scenarios remains up for debate, of course.

Interestingly, despite the heavy use of different nationalities on display, some readers have noted that there is a noticeable lack of racial diversity. A poster by the name of Krehlmar (2015) began a thread on the Stand Still. Stay Silent. Fan Forum that posed the question: "Especially considering the amount of immigrants scandinavia [sic] takes in per capita (some of the highest in the world) . . . I just feel a bit weird-ed out by the complete lack of anyone of color. Is there any explanation on this matter?" While a number of readers posited ideas that might work as an in-story justification, Sundberg (2014c) herself has been relatively quiet on the matter. In the closest she provided to an in-story explanation herself, she did note elsewhere that the indigenous Samic people "pretty much melted right in with the other nationalities, Samic people aren't exactly isolated from the general population even in current times. . . . Same goes for surviving Faroe people, Fenno-Swedes and other miscellaneous pockets of survivors." This, however, does not address the original immigrant question posed by Krehlmar.

When the same topic was brought up in the comments section of the webcomic itself, Sundberg (2014b) only said, "Just in case

someone is itching to start a raging comment war about the characters' skin colors while I'm sleeping and not here to stop it. . . . It's like the 'why is half the cast pretty boys who look like girls?'-thing, sometimes I simply draw stuff without a deeper reason behind it." The intended inference here is that Sundberg is not deliberately excluding people of color, but the idea is instead something she has not given any consideration. Since the practical result is the same, however, that lack of consideration is itself a form of exclusion. Given the apparent tone of her response, it would seem to be a question that has been brought up on more than a few other occasions, and Sundberg seems keenly aware of the emotional nature of the question itself. However, given that the primary characters were firmly established early on as not being people of color, and that the point of the story is that they are traveling alone in an isolated wasteland, it seems unlikely Sundberg even could add much racial diversity to the story once the characters had set out on their journey. The cast is small and static, without even the opportunity for additional background characters or crowd scenes. This makes the story an interesting case for webcomics dealing with ethnic diversity, but almost at the expense of racial diversity.

Even after these discussions, however, there would still be occasions where some racially insensitive points came up in the story. For example, upon discovering an old, abandoned bookstore, the group came across a book written in a language none of them understood. In debating what language it was, before "Mandarin" was proposed, the characters suggested that it might be "Chinge-ling" or "Chinalandic." Although deleted before they could be archived, the comments section of the page, as well as some of Sundberg's personal communication channels, apparently overflowed with readers pointing out the racism in such wording. The next day, Sundberg (2016b) responded on the site:

> This scene, that was intended as a short humorous confirmation that there could very well be other isolated culture pockets around the world, resulted in a flood of vitriolic and aggressive messages sent to me through various channels. Some of that (thankfully milder than what was sent to me privately) also occurred in the comment section and . . . well, you can imagine the mess that developed.

Sundberg refused to remove the scene entirely, but changed one of the suggested language names to "Kung Fu" adding that if the comments continued, she would change the foreign language entirely to something more familiar to her, like Russian, although this would have required rescripting most of the page, since there's a several panel discussion on how "Mandarin" can refer to a language or a fruit. It was at this point that Sundberg (2016b) seemingly chose to close herself off to all discussions of racial diversity with regard to the webcomic, noting,

> In the end the volume and sheer aggressiveness of the messages has instilled a notion that there's no room for honest mistakes or benefit of the doubt vis-a-vi [sic] cultures that aren't close enough to one's own, so exploring those concepts any further in this comic just doesn't seem worth it. Not when there's so many other equally interesting things to write about without the animosity. There's simply too much that's considered offensive in some anglophone countries that I'm not aware of, and it's not a minefield that I'm keen on navigating, nor am I interested in the dumbing down that results from having to walk on eggshells around every single joke or avoiding jokes all together [sic]."

While she no doubt received some very emotional and probably upsetting messages, it would seem that she opted not to use it as a learning or culturally expansive experience, somewhat ironically choosing a path counter to the story's narrative.

This last example showcases some important points about webcomics. Sundberg is naturally developing *Stand Still. Stay Silent.* from her own perspective, utilizing her experiences in and around Scandinavia. The customs and languages seen in the comic are primarily those she's most familiar with, and even the weather patterns depicted in the story reflect what she is accustomed to. That she might casually drop in racial slurs that she didn't even seem to realize are offensive, only to have any number of readers point that out to her, highlights the truly global nature of posting comics on the web. Regardless of how insular her own upbringing may have been, or what might be considered socially acceptable in her region, Sundberg was given a sharp, though ultimately unheeded, lesson in intercultural norms. Her audience comes from the *world* wide web,

and reads her story with perspectives that may well be different than her own.

A second point worth noting in that example is that Sundberg literally changed her script *after* the page had been published. She drew the entire page, added dialogue and word balloons, and then posted the page for everyone to see. It was only then that she started getting feedback about insensitive nature of her language. Within about a day, she had reworked the dialogue, and replaced the page online. Readers then saw the updated version, not the original. Had the Internet Archive not happened to have captured a snapshot of the page on that first day it was posted, the initial page and the offending dialogue would have been left as a memory for a fraction of readers and only a matter of speculation for everybody else.

This sort of correction is simply not possible in print. Printed comics can and have been recalled for offensive errors such as this, but this is not an inexpensive process as the printed comics are generally pulped and have to be entirely reprinted. Additionally, not everyone complies with recall requests, leaving some of these errors in circulation anyway. The cost of correcting such an error for Sundberg was little more than her time, as there are no appreciable costs in replacing an image file online, which would be then consistently shown to everyone. Readers coming to the site more than a day after the original posting would never have seen the offending dialogue at all, perhaps wondering what Sundberg was referring to in her notes on that page.

Part of the ease with which Sundberg was able to make changes owes to the fact that she draws all her comics digitally. Rather than having to make corrections on a physical sheet of paper and re-scan it to upload, she can simply make a few quick tweaks in the source file. While certainly a boon for artistic creation, it does mean that replacement costs can be financially challenging. Sundberg (2017b) used a Wacom [Cintiq] 12WX for about six years beginning in 2011, but it eventually began experiencing problems that pointed to an imminent critical failure in the near future. She ended up buying a used version of the same model from an online auction, in part for cost reasons. She explained,

I have tried the successor 13 inch cintiq [*sic*], which I did not like for various reasons. The other possible option would be the slightly larger 16 inch version that might fix some of the issues,

but that one costs almost 1700€! At that price point I better be sure I'd love working on it for years and years, which was not the case this time.

Sundberg's last comment is poignant. Not surprisingly, she wants to make sure she is receiving long-term value for a relatively expensive tool, but with the amount of time she spends working on *Stand Still. Stay Silent.*, she also recognizes that she needs something she is comfortable using day-in and day-out. Her initial update schedule for the comic was a new, full page five days a week, with an approximate two-week break between chapters. (This was, in fact, down from the six-days-a-week schedule she kept for the final year of *A Redtail's Dream*.) She maintained *Stand Still. Stay Silent.*'s initial schedule from the comic's launch until late in 2016, when she dropped to four days a week so she could dedicate some time to other projects.

In her announcement of the change, she provided readers with a sense of how much of her time really was getting put into the comic:

Now why did I decide to do this? Frankly, I've always planned on "eventually" slowing down to 4 pages a week, because while 5 pages is doable it's quite exhausting in the long run. Each page takes me about 15-16 hours to finish, so my typical work schedule for the last few years has been almost 80 hours/week just to draw the comic pages. It's a bit of a grind sometimes, especially during chapters that span over several months on end. (2016c)

The amount of time she puts into the comic on a weekly basis, much of it working directly on her digital tablet, thus virtually requires a tool that she is completely comfortable with.

Given that she can, at her most productive and only for a limited period, work on the comic for about fourteen hours in a day, this would suggest that her schedule generally prevents her from finishing a page in a single day (2017c). In fact, Sundberg's process is such that she doesn't create the pages strictly sequentially anyway. She detailed her creative process in a 2013 interview:

For my comic, I like to first write a rough script of whatever story arc I'm working on, then I draw an equally rough thumbnail script of about 10-30 pages at a time to better visualize the pacing

of my script for each page. After that I jump right into sketching my pages. I tend to work at them two at a time, designed to work as a proper book spread, and start start sketching out more pages before the pair I'm drawing is finished. (Dowdle, 2018)

At the time, she also hoped to get fast enough to complete a page per day, although that did not seem to happen, judging by her quoted passage in the previous paragraph.

Sundberg (2012) had also noted while working on *A Redtail's Dream* that she tended to batch her processes together, drawing the linework of several pages out before going back to color them:

I've colored a bunch of the linearts from last month, and I have to say, coloring these things is far less brain-juice consuming than the lineart part. When drawing the linearts, I was completely exhausted after the usual 2-3 pages per day. . . . So, 2.5 page linearts per day on an average was well enough to consume all my energy. But now that I'm coloring these things, all that I seem to be running out of is time.

This may have been, in part, a function of doing the primary drawing on paper; it's unclear if that remains the same with *Stand Still. Stay Silent.* as she moved to a fully digital process.

Not surprisingly, given the time Sundberg is putting into her comic, she has little time for other projects that might generate income. She has been commissioned for a few book covers in the past, but does not seem to have done any since 2015. Sundberg (2018) seemed to confirm this via her DeviantArt account: "So, I haven't posted anything here on deviantart [*sic*] for years, eh? It's really mostly because ever since I've managed to become a full time comic artist (working on my own comic) I have done almost no illustration work, just comic pages." This suggests that Sundberg is indeed in the company of those webcomic creators whose webcomic earns them a living and, like many others, the specific sources of income come from different activities.

Sundberg (2017a) herself does not attend conventions to sell her work in person ("I avoid convention-like places like the plague"), so her income is likely almost entirely derived from what happens on the site itself. The most immediately visible and obvious, *Stand Still. Stay Silent.* does incorporate a few ads located around the comic itself, though with the rise of ad blocking software, this

almost certainly is a declining source of revenue. The other two sources from the site are the sales of digital wallpapers via Gumroad and the sales of books and prints via Hiveworks. In both cases, the payment processing, warehousing, and shipping are all handled by the respective companies (obviously for a small percentage of the profits). Sundberg has specifically cited that not only did Hiveworks run the Kickstarter campaign itself but they also dealt with the printer for her book, shipping the final rewards, and even managing the development and production of a plush doll based on Kitty, the team's feline mascot in the story. This allows Sundberg to focus almost exclusively on creating her comics, and not worry about the business end of making money through her work.

Stand Still. Stay Silent. highlights the internationality of webcomics, both through its story and its creation. The team of explorers are pulled from a number of different countries and work jointly despite their cultural differences, and Sundberg herself sits on the literal other side of the world from many of her readers. The reach of her story on the web dwarfs what she's likely to have been able to get had she only developed the comic for print. And considering that at least some of her motivation is developing the comic in a somewhat public sphere, forcing an internalized level of accountability, it's possible she would never have developed the comic at all if posting it online were not an option.

Although once she started working in the webcomic format, it appears to have ignited a sense of creative purpose she did not have previously: "I really just want to get as much of the stories I want to tell out in comic format before I die from old age. It'll be what's left of me once I'm gone" (McElmurry, 2014).

The Adventures of Gyno-Star
by Rebecca Cohen

http://www.gynostar.com/

Rebecca Cohen was a comic book fan in high school, sketching Marvel superheroes in her notebooks. Some of her own creations worked their way into her sketches as well and, while she didn't do much with them at the time, she used the concept in a short series

of strips that she contributed to an underground paper in college. Years later, her husband saw those old strips and encouraged Cohen to do something with the idea. After her husband's "persistent nagging" in 2010, she was eventually convinced to start creating new comics and posting them online (Dealey, 2012).

Gyno-Star's tagline, "fighting the forces of evil and male chauvinism," makes it clear to the readers from the outset that Cohen is using the strip to promote social justice. Perhaps less immediately obvious, however, is that the comic is structured like a comedic gag-a-day newspaper comic, despite having many of the stylistic trappings of the superhero genre. For example, Gyno-Star and her sidekick Little Sappho use their superpowers to battle villains like the Glibertarian and the Objectifier. Many of the characters are obvious anthropomorphized ideas centered on inequality, but Cohen presents them in such a highly satiric fashion that the parody—and hopefully the underlying message—is virtually impossible to be lost on any readers.

A year after launching the strip, Cohen relayed her early goals:

> I feel like Gyno-Star presents an opportunity to sort of "sell" feminism. I have a lot of awesome feminist readers, but I also know that many of my readers are people who don't self-identify as feminists and don't see themselves as part of any feminist movements. They just enjoy superheroes, or webcomics, or politics, or things that are funny. Gyno-Star is an opportunity to present the lighter side of feminism. I can show that feminists do have a sense of humor. There's certainly a stereotype of the humorless feminist, and it's fun for me to dispel that. (Berkenwald, 2011)

Feminism is a significant part of Cohen's self-identity; she claims that she's always been a feminist, even before knowing the word, and being drawn to television shows like Wonder Woman and Charlie's Angels even as a young child of three or four. The very name "Gyno-Star" in fact pulls from a feminist comedian in the 1980s, whose name Cohen has since forgotten, that talked about wanting to follow in the tradition of other hyphenated identities like African-American or Italian-American and thus be considered a Gyno-American (i.e., an American with a vagina). She credits that attitude at least in part to her parents and a deliberate attempt to

raise her with feminist principles: "I don't specifically recall when I attached the term 'feminism' to my views about gender equality. By the time I was old enough to know that feminism existed, I knew that it was something I believed in" (2011).

Cohen's goal with the strip, however rooted it is in her own ideology, is primarily humor. In 2012, she noted, "Every time I write a strip, I'm aiming to be funny, not to spread a message. My humor definitely arises out of my point-of-view, and I have strong feelings about politics and society" (Alvarez, 2012). When she launched a crowdfunding campaign on Patreon a few years later, Cohen (2014) had changed her perspective somewhat, but kept the focus still on the comedy: "I try to play a role in changing the conversation. Sometimes I do that unironically. Sometimes I do it sarcastically. And sometimes I don't do it at all, and just try to make you laugh and feel reassured that you're not alone and not delusional."

This additional notion of "changing the conversation" is partially a response to the changing social environment and partially a response to the wider audience she has been able to reach. Speaking in 2013, Cohen reflected that part of what encouraged her to heed her husband's suggestion to return to Gyno-Star was: "A few years ago things got so politically ridiculous with the Tea Party and resurgence of out-and-out aggressive, racist, sexist attitudes I revived Gyno-Star" (Freleng, 2013). However a few years later, seeing other women respond to what was happening and having some of them comment on her work, she noted, "Hearing from trans women and women of color and women with disabilities and women who live their lives at all these different intersections of oppression—that has hugely influenced and expanded the way I think about feminism" (Pittman, 2015).

Given that feminism itself has been something of a lightning rod among some groups, it should come as no surprise that Cohen has been on the receiving end of vitriol periodically. Broadly speaking, and this is a point that Cohen herself has actively cartooned about, feminism is about gaining equality—political, economic, personal, and social equality—among the sexes. This is sometimes misunderstood (often willfully) to mean increasing the oppression on cisgender, heterosexual men, rather than reducing the oppression of everyone else. Additionally, some groups who do indeed champion women's equality are willing to do so at the expense of minority groups, even if those minority groups include women.

Cohen (2013) has spoken about the inclusivity of feminism as she sees it:

> Feminists cannot, by definition, hate men. You can only protest rape culture if you believe that men are capable of not raping. You can only fight for equality if you believe that men are capable of agreeing to women's equality. Otherwise what are you fighting for? Something you don't believe can ever happen? Envisioning a world of gender equality requires loving men . . . and women . . . and gender non-conforming people, because you have to believe that we're all capable of something better.

She went on to add, "Let's also note that feminism is a crowd-sourced movement. It's not a single ideology nor a single organization. It encompasses a huge variety of people, philosophies, goals and approaches. It's an ongoing conversation."

Frequently, when someone tries to confront Cohen on the topic, they are quick to showcase how they are misinformed. In 2013, she created a comic satirizing how some people were trying to continue promoting the Second-Wave Feminism of the 1970s in the twenty-first century. While she was pointing out that the ideas of that movement may have been progressive for the time, they also remain fairly exclusionary nearly a half century later. Cohen explained, "They want to make the movement unwelcoming to trans women and trans men. They may not think it's what they're doing, but it's what they're doing." Some women who supported the 1970s movement refused to see this and began harassing Cohen, while others pleaded for her to try to understand their perspective: "The idea . . . was not that ideas from '70s are bad. [But] one little pamphlet is the sum total of what their brand of so-called feminism is. It seems so limited and closed off from new ideas." That they created a parody Facebook account specifically to harass Cohen only serves to underscore her point (Freleng, 2013).

Cohen tries to be open to other ideas and criticism, but she is self-aware enough to realize that even valid criticisms can be difficult to take in simply as a product of human nature: "Good constructive criticism is crucial to improving as an artist, so I would never shut out anyone who can offer that. But let's be honest: criticism of any kind is hard to hear. But I welcome it, as long as it's fair, specific, and at least trying to be helpful" (Dealey, 2012). While Cohen will listen to cogent arguments and study their validity, however, she

might still ultimately return to her original ideas. In relation to the specific incident noted earlier, for example, the most even-tempered complaints suggested she had not taken the time to understand where those types of feminists were coming from, she responded, "I've taken the time, I've listened and read and I think it's worthy of mockery" (Freleng, 2013).

Working on her own, fortunately, affords Cohen that freedom and flexibility. Were she working for a publisher, or even with an editor or other collaborator, any issues that viewers might criticize might be up for a larger debate creatively. Any decisions along those lines would need to meet approval by everyone involved, thus potentially watering down the message Cohen is trying to convey. She recognized this early on, noting in 2012, "Webcomics represent a great opportunity for female creators. I can have total creative control. I don't have to prove myself to editors or publishers who might doubt me; I don't have to change what I'm doing to match what somebody else perceives is good, or funny, or marketable" (Alvarez, 2012). That nothing like *Gyno-Star* is currently being published by any print publishers speaks directly to that opportunity.

That lack of opportunity comes from an ingrained misogyny in the print industry. Rachel Edidin* (2013), a former editor at Dark Horse Comics, succinctly pointed this out as one of the problems with traditional comics publishers:

> Men are the overwhelming majority of the people in the industry with institutional and hiring power. Even most of the most senior women in editorial departments answer to one or more male boss, usually a dude who has been in the industry long enough and played its games effectively enough to be pretty solidly entrenched in the existing power structure; and, even if he is basically a decent human being, to have capitulated to and internalized and regurgitated and privileged appeals to tradition and status quo over things like personal dignity and safety and *minimal motherfucking professionalism.* (emphasis in the original)

That the web's open structure by its nature does not have any of this gatekeeping (often by way of sexual harassment) attached to it is the opportunity that Cohen speaks of. She is free to post her own

*Now going by the name "Jay Edidin."

ideas via *Gyno-Star* regardless of how they might comment on the existing power structures. While the harassment Edidin alludes to can still happen to webcomic creators like Cohen, as noted earlier, her harassers do not hold any vocational power over her; they have no ability to withhold a paycheck or censor her work in any way. Cohen has no boss to report to, male or otherwise, and thus no one "entrenched in the existing power structure" to force their status quo on her.

Her primary "opponents" are those who post to sites like The Bad Webcomics Wiki and Kiwi Farms, two open-source sites whose purpose is nothing more than to make fun of people. The latter site goes so far as to call Cohen a "lolcow," which they define as "people and groups whose eccentric or foolish behavior can be 'milked' for amusement and laughs" (Zero, 2016). While the sites aren't expressly targeted against women, their collective misogyny is fairly evident in notes like these, a response to Cohen's Tweet that she had "made it" because *Gyno-Star* had been attacked at Bad Webcomics: "I guess it can go here [in the site's 'Not Crazy Responses' section] since it really is 'Not crazy.' After all, you know how hysterical women can get" ("Not Crazy," n.d.).

It is, in fact, the very lack of gatekeeping that some of these bad actors openly dislike. The Bad Webcomics Wiki complains on their homepage: "Meeting no standards, having no restrictions and being far from thing like laws, rules and quality control has its toll. . . . Daily, hundreds if not thousands of aspiring people try to reach the masses through works of fiction which follow none of the guidelines that make the respectable business of printed comics what it is" ("Welcome," n.d.). This type of speech, while superficially opining for a higher level of quality, is actually trying to enforce a status quo that is already entrenched in print comics. They are seeking to discourage ideas and voices from anyone that hasn't been approved by a committee of cisgender, heterosexual white men: the very gatekeepers Edidin was speaking against. That creators like Cohen are subverting those existing roadblocks by posting her work online for free with no oversight frustrates those who prefer their privileges of birth (e.g., gender, skin color) continue to give them a default advantage over others, regardless of talent or skill. While some might relent in the face of such attacks, Cohen remains adamant about continuing to spread her message of feminism, stating in a 2015 interview, "If someone wants to look

me in the eye and tell me that all people have the same rights and opportunities and nobody in this country is facing discrimination, they're welcome to try" (Pittman, 2015).

With this freedom to regularly and creatively bring feminist issues to a wide audience, it is little surprise that Cohen was named by *Nat. Brut Magazine* as one of the "12 Emerging Feminist Game-Changers in Media, Journalism, & the Arts" in 2015. Her other cartoons have also drawn national attention, such as when she illustrated filmmaker and social justice activist Bree Newsome as Wonder Woman committing acts of civil disobedience. This type of cartooning, while certainly appreciated by those who share similar views, was also viewed as controversial by some who claim that Newsome's activism, being an act of civil disobedience, should not be depicted as heroic. This type of controversy was quite predictable, and thus it wouldn't be surprising that many publishers might well opt to avoid the issue entirely. Here again, though, Cohen was able to utilize her own platform to promote her message and artwork without any sort of creative oversight.

Despite some of this attention, though, Cohen's comic has not transformed into a full-time living for her. As of this writing, she has not collected any of her work into book form and the only "advertising" on the site are for comic collectives she participates in. The "Shop" link in her navigation leads to an Etsy shop with only a few prints of her non-*Gyno-Star* work, and she notes that 25 percent of the purchase price for prints of her Newsome illustration will be donated to the American Civil Liberties Union. She does have a Patreon set up, but that brings in less than $300 per month. The only other revenue stream she takes advantage of on her site is a link to make a onetime donation through PayPal; given that she suggests that for only small donations ("Buy me a coffee") one would not expect much coming through that channel.

Cohen briefly alludes to *Gyno-Star* being somewhat impractical for her to make a living from in the comments section of her June 1, 2018, strip. A reader named "Dopeomat" suggested that if Cohen herself, like some of the characters in her comic, made cheap hats in Indonesia to sell, she wouldn't need a Patreon account. To this Cohen (2018) replied, "First you have to find buyers," implying that her readership had not yet grown sufficiently to warrant putting much time and resources toward making physical products to sell. She's somewhat more overt on her Patreon page: "Look, not a lot

of media outlets are paying big bucks for thoughtful but snarky feminist art" (2014).

This can be attributed to a number of potential factors. It may simply be that not many readers connect with Cohen's message and/or style of humor. Even the basic concept of feminism, as noted earlier, does not resonate well with some groups. But it's also noteworthy that Cohen doesn't actively promote the site as much as many other comic creators—her non-*Gyno-Star* art pieces that are more self-contained and viral promote her personal site not the webcomic, for example—so potential readers may be less likely to come across it.

One additional note which may or may not be an issue is the regularity of updates. Her aim is to post a new comic once a week, but she readily admits that doesn't always happen, and *Gyno-Star* has experienced a number of delays and unannounced hiatuses. There is an ongoing debate within webcomic creator circles on how important or significant maintaining a regular update schedule is. Some argue that maintaining a consistent schedule is important because it helps to set up an expectation among readers that the creator (and by extension, the comic) is reliable. The argument goes that readers do not wish to invest their time and emotions into a story that may simply disappear without ever coming to a conclusion; they want some tacit reassurance that they will be able to continue reading the story knowing that it will eventually reach a satisfying close for the characters. A strip that is not updated with regularity can suggest that the creator is not personally invested in the characters and the story, and could abandon it in favor of other priorities.

Conversely, some argue that a consistent schedule for webcomics is entirely arbitrary and unnecessary since there are any number of automated means to alert readers a new comic has been made available. Following a creator on social media, subscribing to their email newsletter, or pulling their site's RSS feed into a feed reader are all easy ways for readers to be alerted when a new comic is posted, regardless of how erratic the schedule is. The reason print comics follow a regular schedule (e.g., every day in newspapers, or once a month in comic book shops) is because in those cases, the physicality of the medium means a reader has to go out of their way to find and obtain the material. A webcomic, thanks to the ubiquity

of the internet, is available almost anywhere at any time. Readers can catch up on their favorite webcomics from their desk at home, on the train on the way to work, in a lounge chair on the beach, or virtually anywhere a cell signal or Wi-Fi is available. Since the comic can be read anywhere at any time, the characters and the story take precedence over concerns about the comic potentially ending prematurely because the reader's investment is inherently lower than for print comics. The time it takes to load a comic's home page, even under the slowest download speeds, is still several orders of magnitude faster than going out to buy a printed comic.

Various creators have taken different views on the subject, and experiments in both directions have led to different results. Some creators who maintain rigid schedules see no change in their traffic when their updates become more sporadic, and some creators who manage to get an irregular comic onto a consistent schedule don't experience an increase either. But those results are not consistent themselves, and some creators see drastic traffic changes when their schedule alters one way or another.

One thing that certainly seems to help in general is ensuring that the creator is clear with their readers about their expectations. If they state they will update the comic every Monday, Wednesday, and Friday, but do not follow that schedule, for example, that has a tendency to upset readers more than saying they'll update things whenever they can. Cohen tends to fall into the latter category, as alluded to earlier. She has noted, after returning from extended breaks, that she has run up against time crunches thanks to other paying work (2015, 2016) and that her long-undiagnosed Attention Deficit Hyperactivity Disorder (ADHD) has sometimes distracted her from being more productive on *Gyno-Star* (2016b). However, despite her intent to post more regularly, Cohen (2012) is upfront with her readers, stating on the site's About page: "New comics are posted whenever they're finished. Sorry—I've tried to maintain a consistent update schedule, but I can't seem to stick to it." She goes on to suggest some of those automated means of being alerted when new strips are available. Ultimately, whether or not that has had an impact on her readership is virtually impossible to gauge, however.

Despite challenges such as these, however, Cohen remains committed to continuing and improving her work. As with many

webcomic artists, her illustration style notably improves as the comic continues, a natural result of the ongoing practice of making a webcomic:

> Before I started my webcomic, I didn't believe my line drawing skills were good enough. That's part of the reason I waited so long to start making comics—I really didn't think I had the skills. But after only a few months I started to see improvements in my own work. . . . I think it's clear that just making comics regularly for several months has improved my basic illustration skills. It's beyond what I would have ever thought. (Dealey, 2012)

She does, however, have to draw inspiration from a variety of sources. While there are numerous examples of superhero stories told in a comic strip format (*Superman* was even originally conceived as a serial newspaper strip), there are exceptionally few examples of a humor strip that utilizes the superhero genre; most simply follow an adventure format, which require a markedly different sense of pacing and timing.

Cohen, therefore, draws on a number of different sources that ultimately coalesce in the form of *Gyno-Star*: "I spend a lot of time looking at what other creators are doing, both in print and digital comics. I take a lot of inspiration and ideas from other people's work." Despite trying to look at a wide range of work to help inform her own, she still has one primary source of inspiration, which she revealed in 2012: Berkeley Breathed, the creator of *Bloom County*. "I literally read through my *Bloom County* collections when I feel stuck or need ideas, and borrow from the way he structures story arcs and individual strips. Everything about his strips, from the political point-of-view, to the style of humor, to the overall story structure has influenced what I do." Given that Cohen was an English major in college, it is probably inevitable that some of her favorite prose authors continue to impact her writing: "Also, my head is filled Dorothy Parker, Mark Twain, Kurt Vonnegut and Gore Vidal and Joseph Heller. . . . I don't think I've ever come up with a joke that I didn't subconsciously (or intentionally) steal from one of them" (2012).

Her drawing influences, however, come from decidedly different sources. Cohen's typical illustration style most probably resembles the house style from Disney. Though not intentional, the time she spent as a child drawing those characters has become somewhat

embedded. When this comparison was pointed out to her in 2012, she responded, "For most of my childhood and adolescence I wanted to be a Disney animator. . . . I used to spend a lot of time drawing Disney princesses, until that just sort of became my style of drawing" (Alvarez, 2012). She sporadically continues her drawings of Disney characters to this day; although, her drawings now tend to wind up in editorial comics expressly commenting on and satirizing Disney's marketing practices, particularly with regard to their diminishing the prominence women of color. Despite some superficial influence the Disney house style holds over Cohen's work, she has gone on to mention another artistic aspiration in a somewhat different vein: "Honestly, what I'd LIKE my comics to look like is John Byrne's work on the X-Men titles circa 1980. That is what I had in my mind when I envisioned a Gyno-Star comic strip. But that's not how I draw" (2012).

These disparate influences actually work in Cohen's favor from a narrative perspective. With an illustration style that bears a passing resemblance to Disney, Cohen can subvert readers' expectations of the typically saccharine princess characters Gyno-Star is subconsciously and vaguely modeled after visually. The character's aggressive stance against chauvinism is then unexpected, and becomes a more impactful story point. This is even more pronounced in Gyno-Star's young sidekick, Little Sappho, whose "Righteous Lesbian Rage" superpower has resulted in the character literally ripping the arms and legs off some of the villains.

Ultimately, though, Cohen's purpose with the strip is to present feminism in a fun and entertaining format. She wants the message of feminism to still be heard, though, so her visual and narrative metaphors frequently are not especially subtle. This has earned Cohen some adversaries herself, but none that give her any cause for real concern. She remains happy working on her comic and showing that feminists are not uptight and angry all the time:

> *Gyno-Star* is an opportunity to present the lighter side of feminism. I can show that feminists do have a sense of humor. There's certainly a stereotype of the humorless feminist, and it's fun for me to dispel that. Also, I think it's important for feminists to be able to laugh a little. We can be a serious bunch a lot of the time; we're always talking about heavy, important stuff. I think it's healthy to be able to laugh at your boogeymen; it takes away

some of their power. At the same time it's even more important to be able to laugh at yourself. That, I believe, makes you stronger. Taking yourself too seriously is suicide. In fact I think that's one of the major themes that has emerged out of *The Adventures of Gyno-Star*. (Berkenwald, 2011)

Dumbing of Age by David M. Willis

http://www.dumbingofage.com

When David M. Willis launched *Dumbing of Age* in late 2010, he had already been creating webcomics for over a decade. Each new strip he's launched has been more successful than the last, certainly due in part to his steadily improving craftsmanship, but seemingly in part because of the increasingly biographical nature of each new strip.

Like many creators, Willis started cartooning in school, frequently drawing characters instead of studying: "I drew comics in the margins of my notebooks in school constantly, like in elementary school, junior high, high school. . . . Something I can't not do is draw comics" ("ConnectiCon," 2011). When he later started college, he quickly began publishing the strip *Roomies!* in Indiana University's student paper. He attributes getting his work in that paper largely to a dearth of competition: "The *Indiana* (University) *Daily Student* newspaper asked for submissions the first week of freshman year, I already had a bunch of comics drawn of course, and nobody else submitted anything so the glory was all mine!" (Townsend, 2015). The strip initially centered, not surprisingly, on some college roommates and their circle of friends.

Willis, being a science fiction fan generally and a Transformers fan in particular, began introducing science fiction elements to *Roomies!* as the strip progressed. Not long after he also began publishing the strip online in 1999, using GeoCities as a free hosting service, he fully switched the format to a more obvious science fiction strip, renaming it *It's Walky!* after one of the characters who had come to prominence. Many of the other characters carried over as well. Willis eventually ended the strip but, after only a few months hiatus, returned with a direct sequel called *Joyce & Walky!* in August 2005. This strip itself ran until 2015.

At about the same time Willis launched *Joyce & Walky!*, he also launched *Shortpacked!* While this strip was a direct spin-off from *It's Walky!* and featured some of the same characters, the science fiction element was discarded and the strip focused on the interactions of retail employees at a large toy store. The jokes and story elements drew directly from Willis's time working at Toys "R" Us, making the strip somewhat autobiographical. When questioned how autobiographical it remained over the course of its ten-year run, Willis responded, "As long it's about being a fan of toys and being a reluctant fan of reading message boards about toys, that semi-autobiographical hook will always be there" (Marshall, 2008b).

It was then, in 2010 while he was still working on *Joyce & Walky!* and *Shortpacked!*, that Willis launched *Dumbing of Age*. While all of his previous comics shared a single continuity, he treated *Dumbing of Age* as an entirely new setting, despite using essentially all of the same characters. He put all of the characters back in college, most of them as freshman meeting for the first time. This decision was made with two considerations. First, Willis could use the character interactions to help exercise some of his own personal demons and second, he felt he could connect with a larger audience:

> Honestly, a lot of the time while writing *It's Walky!* . . . a lot of the sci-fi stuff felt like a distraction from what I really wanted to do, which was sort out my feelings and emotions about how to talk to people and be understood. . . . *Shortpacked!* got a little closer to what I wanted, as it presented a farcical world in which the oddball stuff that happened was more transparently a ploy to set up more mundane character interactions. But there's something about a college setting that just pulls back the blinds and lets more people in. Not everyone goes to college, but they understand college! They understand a time in which you're on your own for the first time and figuring things out. (Townsend, 2015)

Despite the changes in theme and tone from strip to strip, the characters have remained fundamentally the same. Thus, by the time Willis launched *Dumbing of Age*, he'd been writing most of the characters about thirteen years already, and had had plenty of time to reflect on why he created and developed them the way he

did. Willis (n.d.) is very upfront with the autobiographical nature of the characters, and spells this out very clearly on the strip's About page:

> This is important: Joyce is autobiographical. Like Joyce, I believed in the complete inerrancy of the Bible—Earth is 6000 years old, Noah's Ark, gay folks are evil, everything—and our family attended multiple churches of various persuasions, from Methodist to Baptist to Evangelical Free. But not shallowly, no. We spent years climbing up the social hierarchies of those mofos until we uncovered assholes and/or corruption and had to move on. I went to youth group every week, attended every sermon (because there was more than one) every weekend, and went to church summer camp (at Anderson University). My dad was routinely a Deacon. At one point he even tried starting his own church. Consider this information before goin' off on me about how I don't know anything about Christians or whatever. And like Joyce, I was raised as a nondenominational fundamentalist (nonaligned Protestant), which means she's not Catholic.

While *Dumbing of Age* has an ensemble cast of characters, Joyce features heavily, and much of her story revolves around meeting and interacting for the very first time with people and a wider world than her homeschooling dealt with. Her decidedly sheltered upbringing is the cause of everything from harmless quirks like not letting different foods touch on her plate to a major existential crisis when she learns that her best friend is a lesbian whose father proceeds to drag back home at gunpoint. Joyce is repeatedly forced to confront her ideologies removed from the backdrop of her insularly instilled dogma. It is, of course, common for students attending college for the first time to encounter many new ideas and experiences, and the narrower the experiences they had prior to attending college, the more challenging the transition can be.

This is precisely what Willis himself experienced as well. He recalled in 2015 how, not long after he started creating comics in college, he neglected to include any students who weren't heterosexual:

> When I was writing my first webcomic, *Roomies!*, I was asked at least once where all the gay people are, and the terrible

explanation I had for myself was that gayness just didn't exist in this world. I didn't want to talk about it. This obviously didn't hold as that particular universe went forward, but the gradual inclusion of more people who were not like me was grown from me realizing my views were terrible and wanting to put myself in the brains of other people and rehabilitate myself. (Townsend, 2015)

Similarly, Joyce goes from trying to find Biblical justification why her best friend cannot be a sinner to simply accepting her homosexuality as part of who she is.

Like many creators, Willis (2013) puts some of himself into virtually all his characters:

They all take things from me on some level. Joyce is a collection of my sexual and religious insecurities. Ethan is the jerk part of me that interacts with fandom. Amber is my frustration and rage, Dina is my struggle to understand human interaction, Walky is my childishness, Ruth and Billie are my self-destructive tendencies and depression, and Mike says what I want to say but don't. . . . Some day, I hope I will be Dorothy. That is my end game. But I still have lots of stuff to work out first.

While Joyce remains the central character, and what she experiences is largely a reflection of Willis's own college experiences, many other characters and their reactions are other expressions of the author as well.

However, Willis is not beyond basing some characters on other real people in his life. The character of Galasso was originally borrowed from a patron from when he worked as a host at a theme restaurant, and *Shortpacked!*'s character Reagan was obviously based on the former president. Perhaps most significant, though, is Danny:

Honestly, Danny in *Roomies!* was not me, but my father. He was influenced strongly by how I viewed my dad at the time: perfect and demanding, setting a high moral standard, a disciplinarian. I was afraid of disappointing him, to the point where my would-be self-insertion character had to be squeaky clean. A lot of my motivation as a kid was to avoid shame and disappointing my

elders. . . . As the strip went on, I started to hate Danny more and more. I never really rebelled against my parents, yet as I started to struggle in school and in life, I grew to resent how fucking perfect Danny was. So, of course, I planned to destroy him, an allegorical "take that" at my dad. (2013)

That notion, of wrestling with his feelings over his father's behavior, is a large part of how Willis writes *Dumbing of Age*. He uses the strip to work through his emotions being raised in a manner that he later understood to be overly restrictive. He had recognized this in himself by 2007, stating,

For seriously, drawing comics is my shrink. You know how psychiatry is basically just talking to some guy and all he does is nod for two hours, and then you realize that you should stop hating your mother because she lied about going to Taco Bell for dinner when you were three? Drawing comics is like that. I deem individual strips successful if I start out yelling at somebody for being stupid and by the last panel I'm mocking myself for being so dramatic. (Pagan, 2007)

In a 2015 interview, he elaborated on why the comics medium is a more effective means of dealing with his internalized issues:

Life for me has mostly been a decades-long lesson that drawing comics is the best way I have to express myself. I'm not great at talking, that's for sure, and whenever I write something I feel like pictures would be better at sharing half the work. With comics I can approximate my feelings way better than I can do with my face. It took me a long time to understand that. (Townsend, 2015)

After reading the strip for an appreciable period of time, it becomes clear that Willis, much like Jeph Jacques in *Questionable Content*, puts a fair amount of effort into developing his characters into fully realized ones with their own desires and motivations. Despite putting some of himself into many of them, as noted earlier, there is much about various characters that he came to the table with no innate knowledge of. Also like Jacques, he puts a good deal of time and attention to understanding how a character's background

might affect the decisions they make, and so he makes an active effort to learn about social topics that his upbringing left him very ignorant of. He tries to consult directly with people on these subjects; however, as he's repeatedly admitted that his natural introversion and general discomfort with interpersonal interactions can make that difficult, he frequently resorts to a lot of reading on these topics directly from individuals dealing with it in real life:

> For me, the largest part of research is just passively listening. I follow a lot of Tumblrs and Twitter accounts and Facebook feeds of some wonderful people, and I like to hear what they say about what bothers them, what upsets them, what makes them happy. . . . And, of course, I have some folks who I go to when I have questions to ask. Combining that constant flow of information with the desire to really put yourself in the head of another person is a recipe that I hope works, since it's what I've been doing. (2015)

Empathy is thus a strong element in Willis's writing:

> I try to write everyone as if they are the hero of their own story, and not just the sidekick to somebody else . . . you need your characters to be people and not a list of faux pas you read from one person on the Internet. Also, if I'm not making myself a little uncomfortable, I'm probably not confronting my privilege enough, so I try to keep vigilant that I'm not just writing stuff that props up my place in the world. I want to learn, and learning means revising false information. (2015)

This notion of "revising false information" becomes something of a recurring theme in many of Willis's strips, as characters who have previously displayed socially unacceptable or at least socially questionable behaviors are often later shown to have perfectly understandable reasons for them. Willis is generally careful not to make those reasons excusable—indeed, many of the behaviors they are used to explain are problems like alcoholism and violence, and are unequivocally depicted as maladjustments—but only as means to provide motivations to their actions. Walky's sister Sal, for example, is constantly shown to be cold and rebellious, but it's eventually revealed that she is reacting to their parents' apparent

preference for the younger Walky because of his lighter skin color and straight hair, compared to her darker complexion and naturally kinky hair. She feels, with some justification based on what limited exposure they make in the strip, her parents consider her "too Black" relative to her brother, betraying a subconscious bigotry in how they treat the two siblings differently.

Despite this type of theme of having empathy for others and trying to put oneself into their shoes being brought up repeatedly throughout *Dumbing of Age*, Willis remains confused how some of his readers repeatedly seem to miss that. The storyline where Becky came out as a lesbian and her angry father showed up on campus to bring her home at gunpoint ended with Becky's father hospitalized and under arrest. Becky, trying to bring some emotional closure to the events, visited him in the hospital and, when he demanded that he was still in the right, she resolved to live her life happily without him and left while flashing two middle fingers. At the time, some readers found that this was going too far, and Willis (2015) responded by wondering,

> It's pretty weird how Becky disrespecting her father (who pulled her out of school, tried to brainwash her, pulled out a gun at her, kidnapped her, etc.) is the final straw for some people. There is a very narrow line a character like Becky is allowed to tread for her to be allowed empathy, and her not giving the white male authority figure the respect he was given by birthright is just a bridge too fucking far. Whether it's comments like these or the billion [fan-created] edits to the strip that remove Becky's UNSEEMLY use of middle fingers towards her abusive father, it's just weird all around!

This speaks more broadly to Willis's attempt to use the strip to understand the human condition. As noted earlier, he more actively is seeking to work through his own feelings and emotions.

Empathize This by Tak et al.

http://empathizethis.com

Of all the key texts highlighted in this volume, *Empathize This* is the most recent and the one whose writers probably have the

least experience in creating comics. In many respects, the strip acts as something of a counterpoint to the others focused on here; the concept, message, execution, business model all work in a different way than many webcomics. This serves to showcase that, while many creators come at their own webcomic project with essentially similar goals, those are not necessarily shared by everyone.

Empathize This is something of an anthology webcomic, with the source stories being submitted by readers, which are then edited and rewritten slightly for clarity by one of three writers, and then the stories are drawn by a variety of artists. The topics range from ableism to homelessness to social anxiety. "*Empathize This* is a place where people can tell their own stories about how prejudice and hardship affect their lives" ("About," 2017). The goal is to let readers get a sense of some of the issues faced by those dealing with prejudice: to develop empathy for them, hence the title.

Tak (2019a) came to webcomics in a rather circuitous manner. He grew up in Canada and got his masters in philosophy from the University of Victoria, although he notes that "it's really only philosophy because it was the most interdisciplinary route. . . . My thesis combined ethics with law, as well as neuroscience, cognitive science and criminology." He spent a lot of time considering people's subjective experiences and the social injustices that arise out of that; further, that until there is some form of reconciliation between those on either side of those social injustices, there will be a constant tension inherent in that culture. "To further simplify: peace requires empathy," Tak summarized.

The question for Tak then arose: How to best convey the problems and challenges of others in a way that can lead to greater empathy? He quickly came to the notion of individual stories; statistics and broad outlines do not supply adequate context for someone to really understand the opposite side, and it's really in the personal connections people make one-on-one that allow the full impact of those social injustices to be felt.

Tak first conceived of using video, where stories would come directly from the people's mouths. His concerns were twofold here, though: first was the practicality of producing them, getting people in front of a camera, making sure the sound and lighting was sufficient, doing all of the postproduction, and so on; second was that it would be harder to get to show the underlying issues. Prose could be intimidating-looking to read if people got too verbose.

Using comics would allow everyone to work remotely without having to coordinate schedules, and the illustrations could allow for visual metaphors that would help to convey a person's feelings more so than words alone.

While Tak was familiar with comics generally, having spent some years in Japan and absorbing a good deal of manga there, he was new to developing them. He started by enlisting artist Brian Lamey, to whom he was introduced by a friend, on the earliest stories to start to get the process of taking people's stories and developing them into comics.

Empathize This is nearly unique among webcomics in that the stories are all written and submitted by readers. The site routinely encourages readers to send in their own stories, noting, "We are looking for stories that highlight how you experience, have experienced, or continue to experience hardship and/or prejudice, and how you live in the world differently from those with power and/or privilege" ("Share your Story," 2017). The *Empathize This* team is clear that these are not their stories, and they try to act as a conduit for readers to talk about their own experiences. One of the editors will work with the original authors to tighten up the narrative of submitted works, as many of the submissions are "stream of consciousness type things" (2019a) but they try to keep as much of the original text as possible and ensure that the submitter fully approves any and all changes to their words.

Although such editing does take some work, one of their biggest creative challenges is in translating those stories into visuals. Tak (2019a) explained,

> Most of these stories center around internal struggles and reactions, so we often have to get creative about how to turn that into an effective image. This is particularly difficult because we also have to make sure we don't show anything that would be hard for the author to see and relive (how do you show someone getting abused without showing someone getting abused?).

They make sure to consult with the original writer on what imagery they insist on including or omitting, down to what individual characters should look like. Again, the original writer is consulted repeatedly and regularly so that the end result is very much more their story than anyone else's.

As alluded to previously, this challenge in developing the stories into visuals is one of the reasons why Tak felt comics were the best approach to this project. Using visuals of some sort can make a story more memorable and, by utilizing illustrations instead of photographs or video, there's more opportunity to present the stories in ways that are not always a literal interpretation of events, but can highlight the emotions in a more metaphoric manner. The reader isn't just hearing or reading the words of the author, but the comics support the reader's imagination as they try to put themselves into the author's place. Showing a person as a dangerous, red-eyed demon instead of a concerned bystander trying to help someone suffering from a PTSD flashback, for example, can help others more viscerally start to understand and appreciate how someone else might perceive the world.

The other benefit to using metaphors to convey the story is that there is a smaller chance of the story acting as a trigger for others who've had similar experiences. Seeing a person being bullied or abused or raped can force those who've gone through something similar to emotionally relive that trauma. Abstracting the events through a metaphor that focuses on the feelings of the author as opposed to the actual events significantly decreases the odds of the story becoming triggering. Readers who might still be dealing with those issues would not be further traumatized if they came across the story accidentally, which is a distinct possibility given how *Empathize This* is shared across social media.

Almost as a side benefit to using the comic format, the abstraction that naturally occurs in comics enhances the impact of the story. Readers are more likely to connect with the cartoon drawings of the author than if they were presented with more literal depictions of the author themselves. Comics theorist Scott McCloud (1993: 30–1) wrote,

When we abstract an image through cartooning, we're not so much eliminating details as we are focusing on specific details. By stripping down an image to essential "meaning," an artist can amplify that meaning in a way that realistic art can't. . . . The ability of cartoons to focus our attention on an idea is, I think, an important part of their special power, both in comics and in drawing generally.

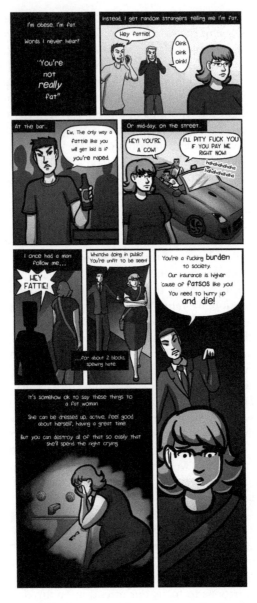

FIGURE 5 Empathize This *tries to showcase immediately relatable content, while still revealing something new to most readers.*
Source: *Empathize This.*

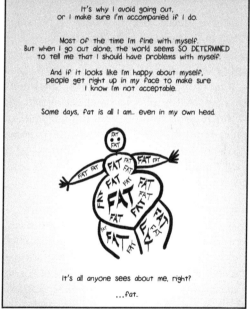

FIGURE 6 Empathize This *tries to showcase immediately relatable content, while still revealing something new to most readers.*
Source: Empathize This.

While McCloud's premise here in cartooning has been questioned by some, it is an idea that holds merit for the team at *Empathize This*. Had they opted for a more photographic approach, viewers watching a person talk might focus on how the person's hair is styled, what clothes they're wearing, the way their mouth moves, or any of a thousand other specific nuances of how they present themselves. A comic version of them, however, removes many of the peculiar details of a specific individual, simplifies them enough to get the basic idea of the person across, and allows the reader to more readily step into that character. Where a photograph represents a single individual, a comic illustration can represent hundreds or perhaps thousands. The reader perceives the piece as less by the specific author, and more universally as by someone who shares many of the same traits. All of which goes back to Tak's original idea of getting people to empathize with one another by seeing the world through someone else's perspective.

As expanded on in the comic's About page,

> The goal of this site is not to position personal stories as entertainment, but rather as a safe space to share experiences. The point is to be non-exploitative: all stories are shared voluntarily, and the author has approval over every step of the story/ comic process right up until it's published. Our hope is that this project will create a space for people to speak—particularly people who aren't already comfortable with the language often used in activist circles—and that this way we might in some small way help bridge the gap between the in-crowd of social activism and the so-called "mainstream" which doesn't always understand why these issues matter. ("About," 2017)

The creators generally try to step back from the stories on the site as another means to make sure their voices aren't the ones overpowering the discussion. The editors of *Empathize This* acknowledge that they are not experts in whatever issues the writers are discussing: "We just present it as is, and let the story speak for itself. It's not our story to comment on" (Tak, 2019b). The discussion they try to encourage by removing themselves from the conversation is one of acknowledgment. The spotlight should be on the readers submitting these stories and the issues they're discussing, not on the people who bring the issue to the attention of others.

The *Empathize This* team takes it a step further by recognizing that they aren't even a part of the community that experiences those issues. Their focus is to give voice to those who feel marginalized, and host a safe space for the affected to have discussions on those topics. Functionally, they only know as much about the issue as what winds up getting presented in the comic. This goes back to the very title of the webcomic itself; the goal is to encourage empathy, not sympathy. For as much as the creators can sympathize with the writers, it is virtually impossible to truly understand the situations many of these writers go through. The team recognizes that, and allows others who have (unfortunately) internalized the emotions that go along with these incidents to have their own discussions.

Interestingly, despite the efforts to make a safe space on the site itself—every single comment is moderated before it is posted—much of the discussion actually ends up occurring off the site. Because the individual comics are written in a stand-alone format, they frequently get shared on social media and through blogs and other sites. Tak (2019b) has been really pleased to see the comics get out to audiences beyond the site itself, stating,

> The comics are usually shared on sites by people who are also in similar circumstances, on sites dedicated to the issue. . . . It's really neat because then the comic is being discussed by a large number of people, and they all relate to the comic in some way. Even if they experience it a little differently, they totally see themselves in it too. It's all very respectful when shared by people who share the same experiences.

This is another way in which *Empathize This* is somewhat set apart from most webcomics: the lack of interaction from the creators themselves. What captures readers' attention in many cases is the connection they feel with the creators; the comics speak to them in a manner that other material does not, and this is usually through the particular attitudes and worldview of the creator as they're expressed in the comic. Often this carries through in other venues as well, as creators will engage with readers directly on message boards, via social media, or even in person at conventions. Readers become fans by seeing the creator's work and thinking they share

similar feelings and ideals, and the creator is able to express them in a creative way.

With *Empathize This*, however, most of the creators take a back seat to the message of the comics themselves. As Tak noted earlier, they let the comics speak for themselves, but even the writers—the readers who submit their stories in the first place—do not seem to engage much, relative to the people who see the comic. This is in part because the comics are actively encouraged to be shared and, thus, can spark conversations in places the writer may not have even heard of. The team has set up alerts to let them know when and where the comics are shared, and has found that there's often "a lot more feedback" on those sites, "places like reddit, tumblr, other blogs and aggregate news sites, Facebook, and Twitter" (Tak, 2019b).

Because the messages of these comics are frequently very powerful, they do stand well on their own, and readers can and do discuss the issues wherever they happen to read them. The conversations that end up happening are not between the creators and the readers, but the readers and other readers. They all wind up connecting with the comic itself and collectively share their own stories to further validate the original. Tak (2019b) reflected,

> It's really neat because then the comic is being discussed by a large number of people, and they all relate to the comic in some way. Even if they experience it a little differently, they totally see themselves in it too. It's all very respectful when shared by people who share the same experiences. The common thing we usually see is the idea that they've never seen any medium represent and express how they live before.

That validation is a significant factor for both the original writers and, frequently, the readers. The comics talk about experiences that are often common but, for these marginalized individuals, are considered taboo or at least uncomfortable enough to broach with anyone but perhaps their closest friends. When asked if these writers were able to use the experience of crafting these comics as a form of therapy, or potentially even a source of catharsis, the editors responded by saying that there might be some of that, but many are still experiencing these issues on an ongoing basis, so there's no sense of closure. The comics really act more to validate

the individuals' experiences where they may have been previously dismissed.

Tak (2018b) explained,

> The main "power" of these comics is that they are stories told by people who experienced them—and then read by people who also experienced them. It's easy to see the stories as a "lecture" to outside folk, but I think that's not really what's happening here. The most common experience across all our authors is that when they've explained it to other people in real life, people question them. "Are you sure that's how it happened?" "Maybe they were just being nice?" "I think you're being too sensitive"—these are responses you'll hear back no matter what the issue is. We're here saying "yes, we believe you. Let's show the world."

Tak's personal experience can be brought out as an example. While he finds virtually all of the comics they publish eye-opening to the experiences of others, what has really struck him is when he shares them with people close to him, "and they matter of factly tell me that they experienced the same thing all the time . . . and I never knew" (2019b). That the incidents relayed in these stories is so common among so many people, yet seem to have been largely dismissed or ignored by a large portion of the population speaks to how powerful it can be for a single person to be able to raise their voice about the issue. The platform they have created with *Empathize This* allows those voices to be amplified, both by virtue of being on the internet and being told through the powerful storytelling techniques of comics.

A sampling of readers' comments following the "I Have Asperger's and I Read Your Comments Too" (Tak, 2014) comic highlight how valuable people find it just to see their experiences aren't unique:

> I can't thank you enough for putting this out on the internet. I sometimes feel like the only person who feels this way, even though I know I can't be. . . . This has helped me realize what I should have known, that I'm alone with many others who experience similar challenges.

> —Kali

What has helped me tremendously was finding my Autistic community. . . . It was empowering and affirming to know that I was part of a larger Autistic community.

—Leisus

I am grateful for you to give voice to what so many of us feel . . . you're not alone, and we all are looking for others who might understand us and how we feel. Thank you for bringing us together.

—Keith

To the author of this article: can I be your friend? And I mean that as literally, completely, and without weird meanings underneath it as someone with aspergers [*sic*] like me can mean. We already know each other based solely on the content of this article. I want to be friends.

—Deanna

While *Empathize This* is almost certainly not the first space online to try to become a haven for marginalized people, the nature of its material (i.e., webcomics) acts as something of a beacon in a way that many other sites don't have the opportunity to utilize. Other similar online communities frequently do not have much reach, and can struggle to make their presence known. Many of these communities, whether accidentally or deliberately created, don't have the funds to advertise their presence and rely on the word of mouth of their participants. While *Empathize This* also has limited funds for advertising, the comics themselves can be shared and distributed more easily and readily across a range of venues. Even when the comic images are shared without directly linking back to the site, the image files have the site address embedded in them, so readers can always navigate to EmpathizeThis.com. The comics themselves acts as drivers to the site, and don't require readers to further upsell the experience, as might be the case on a simple message board.

Additionally, despite having a strong incentive to encourage others to join an online community of marginalized people—the more people who join, the more of an internal support network

the community becomes—participants can find it difficult to target suitable audiences, given that one of the effects of being one of these marginalized people is that they're routinely encouraged through social norms and mores to *not* bring up their experiences. As the editors themselves have experienced, many people they personally talked to had experiences similar to what was depicted in the comics but they were completely unaware of. Publicly encouraging others to join a community like this acts as admission of being part of that group, and can open them up to harassment.

Utilizing the comics, however, offers an easier bridge. Readers can share the comic with a message that speaks more to the notion of trying to understand others without necessarily admitting to being part of that marginalized group. The whole *Empathize This* team has recognized that the authors they work with have a great deal of courage to speak out about their experiences, but not everyone does. Indeed, that anyone needs courage at all even just to tell their story highlights the social taboos surrounding many of these subjects. *Empathize This* offers a sort of buffer for those who feel unable to share their personal connection in a public forum, but still wish to encourage others to join. The fact that the story is by and about another individual can draw attention away from the person actually sharing the comic. It becomes just a story being passed around, not an explicit request to join a community. That aspect is decidedly more implicit and, even then, only after someone visits the site.

Tak (2019b) went on to note how pleased he was that some of the *Empathize This* comics were indeed affecting change:

> I don't want to get into specifics, but because these comics tend to get shared among people who are in similar situations, we've had some really amazing outcomes. I know in one instance, one of our comics talked about an experience involving a big organization. To make a long story short, the comic went viral and the organization learned about the issues, and reached out to the author. The author ended up being on a decision-making committee to help them avoid the issues in the future. There have been other instances, small and large, where we know the stories made a real-life difference.

Unlike many webcomics, that is a primary driving force and they collectively have committed to *not* making money via the site. The

site is operated at a loss with hosting fees and payment for the artists ("at a lower rate than what they could make through other projects") coming primarily out the editors' pockets (2019a). The site does take individual donations via Patreon, but that income is minimal—less than $30 per month at the time of this writing—and the lone reward tier offers only a thank you and occasionally some looks at the sketch work done before a comic is completed. But even the notion to make the comic as a source of income is anathema to the project. They explained some of their concerns on their Patreon page ("Empathize This Is Creating Webcomics," 2014):

> There's only so much control Google Ads lets you have. We're also not big enough to solicit ads on our own. We also don't want to be financially dependent on not offending sponsors. . . .

> We can't really control ads, and we need to make sure we create a safe space. Imagine a scenario where we have a story pointing out problems with the way poor people, or women, or black people are portrayed in the media. What if there's an ad that does exactly that at the top of our website? That would be horrible.

> Or how about a story about PTSD at the movies (we have a story like this), with a movie ad for something extremely violent?

> There are too many possibilities of ads going wrong on our site. This is the reason why we had to make the decision to never incorporate ads.

It would seem that their overt efforts at transparency and honesty about their processes do a lot to establish their integrity in the minds of readers. Submissions were a little slow initially as they were setting things up, but after gaining some traction, they seem to get more stories from readers than they are able to illustrate. This, of course, allows them a greater amount of flexibility in the stories they choose to develop, as they have more options to choose from and can present stories that might have more powerful visuals to associate with them: "Most of the difficulty comes from a lack of specific imagery. For example, someone might say 'It's really disturbing when someone says xyz,' but it's a lot easier for us to create a comic if there's a specific instance they can tell us" (Tak, 2019a).

What this variety also does is help to establish the overall pattern. One person's story by itself could be considered an outlier or an aberration; multiple people contributing multiple variations on a theme help to establish their experiences as typical. "It also made me think that the volume of stories (rather than one that crammed a few ideas) was more valuable, since it wasn't just one or two things, or one or two people," Tak (2019a) elaborated. "Having volume would instantly dismiss criticism about it being an individual problem."

Given the wide range of subjects they have covered, it is not surprising that some receive more attention than others. Naturally, some of that has to do with how compelling the original author's story is in the first place and how well others can relate to it. But some of it, too, follows the news cycle and what topics are trending at any given time. An incident where a celebrity is accused of rape might drive more interest to those comics, or a popular movie that features a character with cerebral palsy might encourage people to look at and share those comics. An individual strip's popularity might rise and fall with the tides of pop culture more so than might typically be seen in a webcomic precisely because of the spectrum of issues brought to light. Indeed, this harkens back to the origination of the idea and how it was sparked, in part, by then-topical discussions about President Obama's election.

But owing to the nature of webcomics, the strips can be accessed at any time. If any particular issue comes en vogue for whatever reason, the comics are already there and available to be read, shared, or re-shared. If public interest in that particular topic dies down, the comic can reside comfortably in the background until broader interest is renewed. Their relative perpetual availability and the timelessness of the stories themselves means they can continue to serve to help people, regardless of when someone comes across them or how long it's been since the strip first went live. Comments for specific strips on EmpathizeThis.com often span the course of several years.

The website's navigation is set up for this as well. Unlike serial webcomics which focus on a single linear progression often with chapter breaks, or typical gag strips which can be read sequentially but are also prone to having both calendar-style archives and a "random" button, *Empathize This* relies on topic categories. Since

the comics can be read independently of one another, there's no need or even desire to read them sequentially. A person reading about ableism might have little interest polyamory; someone curious about problems in foster care might not want to read about bipolar disorder. Readers are encouraged to navigate from one strip to the next by selecting keywords to call up installments related to that subject. Most strips are tagged with multiple keywords and can be found through several different paths. The very atypical nature of the comic's structure dictates an atypical approach to site design and navigation.

A great many webcomics follow one of a few now-standard paths in terms of their basic setup and structure. There's a wealth that can be done within that framework, of course, and that's easily seen in the wide array of webcomics that are online. But while webcomics has become something of its own industry, with many creators using techniques proven by their predecessors, there is still room for experimentation and making webcomics in a nontraditional manner. Because Tak's fundamental goals from the start were very different from most creators, he and the other folks at *Empathize This* have had to largely forge their own path. They didn't have to reinvent webcomics from scratch, of course, but there were considerably fewer proven successes in their vein to emulate, despite launching a full two decades after the world wide web began.

By some measures, *Empathize This* is indeed less successful than many other webcomics. It is, by design, not making the creators any income. With the artists' paid at lower rates than they might earn working on other projects, they might not be able to afford to spend as much time on the artwork as other critically lauded comics. Most of the writers aren't even professional authors or storytellers; they're readers just like everybody else, so the scripts might not be as polished as other webcomics. But in terms of social impact, in terms of helping people, in terms of connecting with a specific audience, and so on while it might be hard to quantify success in those terms, the *Empathize This* team, at least, seems very pleased with the comic's results.

4

Critical Uses

Discussing Webcomics

Comics, when they were introduced in newspapers and later as periodicals in their own right, were largely considered dismissive entertainment. Although academic papers discussing comics date back to at least the 1940s—former *Superman* artist Paul Henry Cassidy wrote "An Approach to the Profession of the Comic Strip Cartooning Based Upon an Analytical Survey of Current Trends and Personal Experiences" as his thesis at the University of Wisconsin-Madison in 1942—it would be several decades before they would be widely enough accepted to be considered normative. Indeed, Will Brooker's doctoral thesis was entitled "One Life, Many Faces: The Uses and Meanings of the Batman, 1939–1999" and he was still jokingly referred to as "Dr. Batman" into the twenty-first century, even as more and more academics began formal comics studies programs and comic-centered academic journals were published.

But given that comics in general did eventually become acceptable topics of study, it might seem surprising how rarely webcomics specifically are addressed. It's easy, as suggested by the two examples cited earlier, to find pieces examining the superhero genre or even specific characters like Superman and Batman. And there are a number of titles that show up and are studied regularly as part of an unspoken comics canon: *Pogo*, *Peanuts*, *Maus*, *Watchmen*, and so on. But references to webcomics are few and far between, much less finding entire pieces dedicated to them.

Certainly many printed works have an advantage over webcomics here by virtue of their longevity. *Peanuts*, after all, began over four

decades before the world wide web even existed, and it had ample time to accrue not only a body of work to study but a body of studies based on that work, before a single word was written about webcomics. That webcomics are simply a newer form necessarily means that not as much research has been conducted on them yet.

However, that fails to address why so few newer pieces examine webcomics. Beyond academia, the press at large seems to mostly ignore webcomics. As noted in the Introduction, even primary comics news outlets have minimal coverage of webcomics and, as of this writing, there are still only six books at all that have been written about webcomics, four of which quickly went out of print.

There are likely two explanations at play here, one for academia and one for the broader press. The press in general remains very tied to capitalism, and requires sales (either as ad revenue or reader purchases) to continue operations. It then stands to reason that much of what they put out is centered on what can broadly draw in larger audiences. Webcomics are, by and large, fairly niche in their targeting and difficult to speak to significantly sized audiences. Financially, it makes more sense for an organization to discuss the latest Batman film that earned over $1 billion than a webcomic that might earn enough to support one individual. Webcomics are generally too focused on a decidedly specific audience to attract mass market numbers.

This is less of a concern in academia; however, there are different set of concerns hampering greater study. Dr. Dominic Davies, founder of The Oxford Centre for Research in the Humanities, notes that one of the reasons comics in general were slow to be studied by academia is their interdisciplinary nature; they fall in a grey area between art and literature and so neither branch is particularly well equipped, historically, to study all aspects of comics adequately. Davies goes on to say,

> However, probably the real reason for the slow uptake of comics by academia is that comics have traditionally been seen as a "low" cultural form, one that is filled with coarse language, silly jokes and subversive sentiments and thus not worthy of critical attention. . . . It was only with the publications of longer comics such as Art Spiegelman's *Maus*, Harvey Pekar's *American*

Splendour, or Joe Sacco's *Palestine* . . . that academia started to take them seriously. So these longer, more obviously "serious" comics, have gained the form recognition in academic circles, and even today academics still tend to focus on them. (Pickles, 2016)

In his book *Breaking the Frames: Populism and Prestige in Comics Studies*, Marc Singer (2019) pointed out part of the issue in how he structured the book itself: "The comics I discuss here are those that have most preoccupied scholars to date: superheroes, memoirs and nonfiction comics, and realistic fiction" (34). Webcomics don't really factor into that equation, with the possible exception of memoir webcomics. (Although, interestingly, one of the most popular memoir webcomics to be studied is Raina Telegmeir's *Smile*, which was removed from the internet entirely when Scholastic first published it. The version that is read and studied more often, therefore, is in fact a printed version that many readers might not even be aware was originally a webcomic.)

Singer also alludes to the notion that this focus on a narrow set of genres is based on the two primary sources of comics scholars: "comics fandom" and "literary culture." His suggestion is that some scholars are people who had been comics fans previously and got to studying them more formally as they grew older, and that these people would naturally have a preference for superheroes—the predominant genre of comics beginning in the 1960s. The other groups are those who approach comics from an academic literary studies perspective, and their tastes more closely hew to that field. While Singer goes on to note that there have been more recent studies "to devote more attention to neglected genres such as romance, humor, and children's comics, and to creators who have been excluded by the comics canon," his research remained focused on the "primary subject [of] comics scholarship in its present form" (34). That is, superheroes and memoir/nonfiction.

Jared Gardner has in part blamed a lack of options for getting their work published: "The truth is that younger scholars must focus their scholarly energy on topics for which there is a likely venue for publication" (Caswell and Gardner, 2017: xix). This explanation partially overlaps the notion of comics scholars coming from adjacent disciplines. The first comics-centric academic journal,

INKS: Cartoon and Comics Art Studies, did not debut until 1994 and lasted only until 1997. Its successor, *INKS: The Journal of the Comics Studies Society*, did not launch until two decades later. Any academic comics writing outside of those timeframes had to be shunted into publications ill-suited to the study of comics and reinforced a more "literary culture" adjacency.

Certainly, there are academic papers referencing and discussing webcomics, but they are far from the norm. Singer, Gardner, and others have argued for a greater diversity in areas of research within comics scholarship. In theory, though, more webcomics, particularly those that have decades-long histories, will be included in more research in the coming years, especially with greater academic attention being afforded to comics scholarship in general. Undoubtedly, some of the best webcomics will accordingly begin to become adopted into the overall comics canon.

Webcomics as a Genre?

One of the issues that seems to confuse people who don't study comics is that comics are a medium, not a genre. As this series from Bloomsbury illustrates, comics can be in virtually any genre: memoir, superhero, historical fiction, literary adaptation, and so on. Webcomics, just going by the key texts highlighted here, are similarly able to tap into any genre. The question in a text on webcomics, then, becomes: Are webcomics worth studying as distinct from comics in general but irrespective of genre?

Since webcomics can and do fall under a variety of genres, it of course makes sense to discuss those particular comics under their specific genre conventions. Michael Terracciano's and Garth Graham's *Star Power* and Sean Wang's *Runners* are excellent science fiction webcomics, and from a genre perspective, it would be completely valid to analyze, compare, and discuss them alongside *Star Trek* or *Doctor Who*, despite them appearing in different media. Many of the genre conventions remain intact regardless of the medium, and they can be examined on that basis. Comparing them, though, to Corey Mohler's *Existential Comics* or Dan Walsh's parody *Garfield Minus Garfield* seems decidedly more incongruous. While they are all indeed comics that appear on the

web, the similarities in style, tone, structure, and general messaging are so divergent as to be incomparable. It would be like comparing a front-page headline article to *Beetle Bailey* because they both appear in the same newspaper.

Webcomics, however, do share a delivery mechanism that is separate and distinct from other types of comics. The classification of any comic as a webcomic sets it apart from other forms of comics; because that delivery mechanism is distinct from other types of comics, that means that the reading experience will be different. Regardless of what device a webcomic is being read from, or the particulars of the reader's web browser, the interaction a reader has with a webcomic is inherently different than a printed one.

Some of those distinctions are obvious: how a reader moves from one page to the next, for example. Other differences might be subtler, but can be equally relevant: the overall sensory experience of holding, feeling, and smelling a piece of pulped wood is different than what it's like to hold a tablet or phone. The very quality of the material itself—how paper merely reflects light whereas a monitor actively projects it—impacts how the brain processes the images.

And certainly the surrounding context in which comics are read has an impact on the reading experience as well. Frequently, when reading through a browser, there are other items in that same device calling the user's attention, whether those are incoming messages or other browser windows open with both related and unrelated reading material available or simply the device's battery indicator. Not to mention the potential for immediate and direct interaction with other readers or even the creator themselves, whether that's via email, built-in message boards, social media, or some other venue that's only a single click away from the comic itself. The printed page, though, is a self-contained unit; even if it's as expansive as a full newspaper, the information in it is static and won't change for the duration of its existence. Any distractions it might provide are finite. Interactions of any sort are impossible and need to be conducted through another venue.

Not all of these differences are fully understood. As the University of Stavanger's Maria Gilje Torheim (2017) notes, "This is a very new research topic . . . a lot more studies are required to be able to make conclusions with any level of certainty. However, such findings do highlight something very important, namely that we

may have a different mental attitude to what we read on a screen [relative to print]."

All of this means that reading a webcomic will lead to a different contextual experience than a comic in any other printed (i.e., static) form. The nature of webcomics' delivery system means the context any given page or installment of a webcomic that is read is fluid and dynamic. It means that any webcomic, regardless of genre, is going to be read differently than anything directly comparable in print, in many cases, even if the content of the comics is identical! While the full impact is not yet known, it is worth examining the various aspects of webcomics that are unique relative to other comics. By studying a cross section of styles and genres, readers can then find commonalities among webcomics that set them apart from their print brethren.

Genres in Webcomics

If webcomics themselves are not a genre and, instead, they are just a delivery mechanism for other genres, what are the genres represented in webcomics? Do some genres feature more prominently than others and, if so, why?

It should come as no surprise that, like many forms of media, the variety of genres represented in webcomics is as broad as the types of genres available. The key texts and other examples noted in this volume can scarcely begin to scratch the surface of what can be found online. The lack of gatekeepers frequently touted in this volume as one of the great advantages of webcomics means that there are no editors or publishers that are selecting what can or can't be pushed out to a potential audience; anything a creator might want to work on can be published with little concern about whether there is a sufficient audience for the material. Speaking about their often surreal webcomic *A Lesson Is Learned but the Damage Is Irreversible*, David Hellman noted, "I'm personally very encouraged by the reaction to this comic. It shows that if you make something of a reasonable level of quality with something interesting about it, the Internet will respond." Cocreator Dale Beran added, "That's what is so wonderful about the Internet. It was a way to connect immediately with an audience, without an editor" (Rall, 2006: 42).

Attaching a genre name to a webcomic is often useful as a kind of shorthand to explain a comic's basic setup, style, and structure; however, this can also be an overly simplistic means of explaining a webcomic.

> And while it's expedient to categorize groups of comics—based on certain shared conventions of content, style, and theme— under such neat appellations as adventure, fantasy, science fiction, comedy, romance, mystery, or autobiography, the works themselves are in practice much harder to classify. Each genre can be divided into countless subgenres, and hybrids of genres so abound online that we end up describing one strip as "manga-esque romanic-comedic epic-fantasy-adventure aimed at gamers" and another as "satirical gag-a-day personal journalism with a touch of absurdist magical realism." (Withrow and Barber, 2005: 18)

That said, some broad genre trends do seem to bubble to the surface more frequently in webcomics than they might in other venues. As noted in the "History" section, many of the web's early adopters were technologically oriented, as computers were hardly as ubiquitous as they would later become. Consequently, with an audience of the primarily tech-savvy, many early webcomics in particular centered on or around technology. T Campbell (2006: 18) explained, "'Nerd' has a few related meanings: for the purposes of 'nerdcore,' 'nerds' made up in technological skill what they lack in social awareness. . . . In the 1980s and early 1990s, Net users were nerds, almost exclusively. And they had no one to talk to but each other. . . . So nerdcore humor was conceived." This nerd focus can be seen in the very names of some of the early webcomics that debuted around this time: *NetBoy, User Friendly, Ctrl+Alt+Del*, and *Helen, Sweetheart of the Internet*, to name a few.

As more people—notably, more types of people—came online, the genres of webcomics expanded as well. What began happening, however, is that the genres that proliferated more widely tended to be ones that were not served as predominantly in the print industry. Both Marvel and DC Comics, for example, put out a wealth of superhero titles on a regular basis, and there are comparatively few superhero-based webcomics. By contrast, the number of professional editorial cartoonists has dropped significantly in recent

years, and the web seems to have responded by a greater number of creators who do editorial cartooning online. Between 2007 and 2019, the number of paid editorial cartoonists dropped from 84 to "about 30" (Shafer, 2019).

While there are certainly a variety of reasons for this shift (including the decline of the newspaper industry in a general sense), the speed and greater autonomy on the web is a notable contributing factor. Editorial cartoonist and comic journalist Matt Bors reflected, "Once a news story breaks people are instantly tweeting one-liners about it. The writers of *The Daily Show* are busily typing scripts for a show going out that night. A lot of great takes are already out there by the time the next day's paper hits the stoop" (Spurgeon, 2011). The speed with which a cartoonist can have a comic online is almost incomparable to getting the same image distributed in a paper.

A creator's autonomy online also has a tendency to impact the fundamental quality of editorial comics as well. Jack Shafer (2019) opined, "Once upon a time, there were more editors willing to give cartoonists the latitude they needed to make great work, but nowadays, too many editors find it easier and cheaper to pick a safe one from a pile of syndicated drawings than employ a cartoonist." Bors, lamenting the same notion, complained of that type of approach, "Some guys who work in a more traditional style will have virtually the same comic on a topic and you can usually predict the incoming cliche days in advance. That type of work is the road to irrelevancy for this field" (Spurgeon, 2011).

One other noteworthy genre of webcomics that has also gained traction in large part to the speed of posting is diary comics. They might be considered a subgenre of the memoir, but are deliberately created in shorter time intervals, often appearing daily. These can be thought-provoking or esoteric, but frequently are simply a recording of some of the events of the day. Kevin Budink, who has created diary comics under a variety of titles, explained his thinking behind them by saying,

> Sometimes I get really worried that diary comics are this narcissistic exercise, so I try to temper them with humbleness. I mean, catharsis is a huge thing, because so much of my writing, especially now, is about how I process events that happen to me that make me uncomfortable . . . it's the bad stuff and the

anxieties, but it's also the good stuff. So there will be moments where I feel overwhelmed by something beautiful, or this really great moment of personal reflection, so I need to put that into comics as well. (Thomas, 2014)

James Kochalka, whose *American Elf* webcomic ran from 1998 until 2012, liked the freedom and autonomy from the format, stating,

> One of the reasons I wanted to leave the graphic-novel format behind is that it seemed artificial to impose that kind of novel-like structure on my life, which is always in progress. It goes through ups and downs and twists and turns, and certain things repeat themselves, and there are surprises. So the daily-diary format enables me to follow my life in any direction it might go, without having to worry about structure. (Murray, 2004)

Once the web evolved past the initial, early, tech-savvy adopters, the twin advantages of immediacy and lack of oversight allowed a number of cartoonists to begin posting work that would not likely have caught the eye of a traditional publisher. And, while webcomics of every genre can be found, the ones that take advantage of the internet's unique features have seen a proliferation beyond what they had previously seen in print.

Defining Success

As noted elsewhere in this volume, there are no gatekeepers limiting a creator's reach with their webcomic. In traditional publishing environments, creators are required to clear an often ill-defined bar in order for their work to be distributed. Editors, publishers, and distributors have a say in how widely a creator's work will be seen and, as a consequence, how they wish to define the relative success of the work. Frequently, this boils down to economics.

This should not be surprising as most of these gatekeepers are businesspeople trying to make money in a capitalist society where success, broadly speaking, is defined in economic terms. So a comic book publisher will often look at the cost of printing a comic and gauge that against the profits they're able to make from selling it. A newspaper syndicate will look at the cost of processing and

distributing a comic to a variety of papers and gauge that against the profits they're able to make from how many papers subscribe to their service. How much profit a comic might make will generally be seen as a determining factor in its success; although, this is often expressed externally through surrogate metrics like the number of issues sold or the number of newspapers a strip is run in.

This, of course, does not speak to any other measurements of success. While publishers, and even creators, like to use financial-related metrics as a means to imply a high degree of creative success, that is certainly not always the case. A high-selling comic might be poorly executed but still sells well because of clever marketing, while an excellently crafted comic might sell poorly because of limited distribution.

Interestingly, webcomics effectively have no real comparable metric in this regard. The cost of publishing a webcomic is flat; that is, the costs in ensuring that one reader can read it are the same as ensuring 100,000 readers can read it. And because webcomics are largely available for free online, no measure of readership can equate to revenue. So for webcomic creators, "success" may well be defined very differently.

A creator may look simply at their site traffic and hope to hit an arbitrary number of regular visitors. They might consider it a success to be recognized by another creator or a particular outlet. They might define success in more abstract terms of how completing a regular comic makes them feel. Regardless, a webcomic creator's measure of success can vary from individual to individual, and even two creators ostensibly using the same type of benchmark may still see differences in where their precise definitions lay.

It is worth pointing out, though, that maintaining a webcomic, particularly over an extended period, is very difficult. The process of creating a comic takes time, of course, and that is a resource that is not always available. Jennie Breeden (2006) of *The Devil's Panties* started off advising would-be webcomic creators this way:

> Commit four years. At least four years of keeping your day job and spending all your "spare" time on the comic. Four years of not breaking even and doing it as a labor of love.
>
> Still with me?
>
> If you're going to do a daily comic then avoid having a social life, significant other comes second (sorry honey), and get used to eating ramen.

Breeden touches on a very salient point in that creators, particularly those starting out, still need an income separate from their comic for basic necessities like food and shelter. This often comes in the form of an unrelated job or freelance work. Sometimes both. *The Adventures of Gyno-Star*'s Rebecca Cohen (2016) commented after an absence from her comic, "I just wrapped up work illustrating a children's book for this really cool educational nonprofit company. Between that and my job with a different educational nonprofit, I unfortunately haven't had many moments to spare to work on Gyno-Star."

With that in mind, it is not surprising that many creators define success as being able to work on their webcomic without the need for additional sources of income—to be able to focus exclusively on their comic without getting distracted by other vocational duties. Not only does getting their "labor of love" (to use Breeden's phrase) to become their primary source of income mean that they can concentrate on something they already enjoy but it also means they're not at all beholden to anyone but themselves. They can work in any manner they see fit and can be creative on their own terms.

Questionable Content's Jeph Jacques summed up his experience by saying,

Doing a webcomic as my job has been the most stressful, frustrating, terrifying, surreal, amazing, wonderful thing that has ever happened to me. It's the hardest job I've ever had but it's also the most rewarding. I have the nicest, most intelligent, excellent readers I could possibly ask for. Also I get to sleep in on weekdays most of the time. I cannot overstate how awesome that is. (Curtis, 2006)

Earning a living from a webcomic also puts the creator in rare company. In a 2015 survey, David Harper (2015) found that roughly three-quarters of webcomic creators polled earn less than $12,000 per year on their comic—this is less than the official US poverty threshold for a single person. Over 80 percent said they could not live off what they made on their webcomic alone. These are, again, only of those who responded to the survey. Jacques added anecdotally, "The percentage of webcomic authors who make ANY money off of their strips, let alone those of us who live on them, is almost infinitesimal compared to the rest of the webcomic population" (Xerexes, 2006).

However, seeing those creators who do succeed in that manner can skew a creator's expectations. Much like seeing movie stars and assuming every actor has a shot a stardom, the creators who have achieved some measure of financial success impact how others see the profession. David Malki, creator of *Wondermark*, poignantly noted,

> The biggest mistake I think people make when they start webcomics is viewing people's success and having a sense of expectation. And that's a very hard thing to not do, but it's a very valuable thing if you can divorce yourself from a sense of entitlement. Because it's way more rewarding to develop your own definition of success over time than it is to try to see somebody else and wish you were doing the thing they're doing, which maybe isn't the thing you're best at anyway. (Davis, 2014)

While it might be easy to dismiss Malki's comments as coming from someone who is in fact earning a living making webcomics, it's a very valid consideration. Frank Page (2013), creator of *Bob the Squirrel*, has been insistent for pretty much the entire duration of his strip—just shy of two decades as of this writing—that he'd rather be really connected with readers than anything else. When talking about how cheaply he sells his original art, he noted that he "would rather sell five pieces to five different people who really appreciate it than to one piece to one person for more who doesn't."

Sheldon's creator Dave Kellett is even more pointed on that front: "I find that the best things I've read and the best things I've created come from an inner sense of joy and an inner sense of wanting to create it . . . to follow the passion to pursue the character and the story and the writing first before anything else" (Davis, 2014).

Success can, of course, take many forms but the quantifiable and readily measurable aspect of earning a living wage from a webcomic is an easy metric to default to, particularly in relation to webcomics' print-based cousins. That it also speaks to a creator's ability to devote more time to their work implies it frequently works as a proxy for their internalized sense of success. Certainly for many creators, it is a clearly defined and aspirational goal. While financial riches are generally not a key driver for most creators, the independence afforded by working on their own financially self-sustaining webcomic often is.

Success: Easier or More Difficult?

In the early days of webcomics, success (creatively, at least) was relatively easy by virtue of minimal competition. There were so few creators putting comics on the web that it wasn't difficult to stand out. "The one webcomic about gamers" was literally the one webcomic about gamers. But because the pool of people online was comparatively small, print audiences for even small press books were still often larger than the number of regular readers one could attract online, and that generally meant that popular success for webcomic creators was elusive.

As the pool of online readers grew, so did the pool of creators. There are thousands more options when it comes to webcomics now, and millions more potential readers. So does this make webcomics today more or less difficult to be successful at, relative either to print or to earlier webcomics?

In terms of popularity, several of the biggest success stories in webcomics—some of which are highlighted in this book—are among the oldest around. *Penny Arcade*, *Sheldon*, and *PvP* all began in 1998; cartoonists like David Willis and Dorothy Gambrell began publishing webcomics in 1999, while Brad Guigar and Shaenon Garrity started the following year. Undoubtedly, some of that success has to do with their "first mover" advantage, but they have also put in continuous work in the subsequent decades. Whatever success they now enjoy is at least in part due to having put out thousands of pages of comics more than a newer comic may have even had the opportunity to publish.

But what these success stories don't relay are the number of webcomics in those years that failed. The webcomics portal Big Panda ran from 1997 until 2001, and hosted nearly 800 different webcomics. For every memorable title like *Sluggy Freelance* that was hosted on that portal, there are dozens that are all but forgotten. Webcomics that were not successful are plentiful even from a period when the most successful webcomics debuted.

The conventional wisdom among creative circles is that a webcomic, or any creative endeavor, really only needs 1,000 "true fans" to be a success. Spike Trotman (2013b) defined a true fan as "a reader willing to spend $100 on your work a year" (5). While many webcomics cater to very specific niches, that so many people are online now that such numbers are achievable, although

Trotman is quick to add that "achievable doesn't mean easy" (6). (It should be noted, too, that the $100 each of those 1,000 fans spends amounts to income, not profit. Success, as Trotman is defining it here, is still fairly modest: "just an escape from obscurity" [3].) Given the increasing numbers of creators earning a living from their webcomics, it would stand to reason that financial success is easier than it used to be, despite the increased competition.

Relative to print comics, success would also seem to be easier. The true fans metric, while still only a rough guide, applies to many creative pursuits and it can act as a reasonably comparable yardstick for both print and webcomics. The primary differences would mainly be in execution. While a print creator could certainly leverage the internet to reach a broader audience now than in days before the web existed, winning over fans of any sort, much less true fans, would necessarily be more difficult by virtue of the audience not really being able to get a full sense of the creator's work without committing to spend their money on the comics, largely sight unseen. Webcomics here have the advantage that they can be used to engage with the audience and draw them in more readily than even a sampling that a print creator might be able to provide online.

This all, of course, is based on a number of assumptions, most notably that success is being defined strictly in financial terms. Weighing critical or emotional success of works against each other is difficult and impractical at best, given that there are no real metrics for doing so in the first place. Readership could potentially be used as a surrogate for audience interest, but the financial models of the two approaches are so different (where webcomics are generally provided for free anywhere in the world and print comics have a price tag that comes tied to being able to physically provide the comic to the reader) that it seems unfair to use that as a point of comparison.

Another assumption here is that there is an accurate sense of scale. As noted earlier, a great many webcomics have not succeeded, but their presence was still known by some level of permanence. Even if a creator gives up on a webcomic and simply leaves it unfinished, it can remain discoverable online for years afterward, letting future readers record and judge it. (This is certainly not universally the case, of course. A webcomic can be removed from the internet, and many indeed have been scrubbed so thoroughly

that even internet archiving projects do not have record of them.) Print comics, by contrast, may fail, but do not have the longevity or visible reach to be seen later. A print creator who gives up may take their unsold comics, and throw them in their basement, never to be seen by anyone but the handful of people who actually purchased a copy. Recording that these print comics ever existed is virtually impossible, making the ratio of successes to failures even more difficult.

Ultimately, there are any number of variables that make direct comparisons of webcomics' versus print comics' rate of successes vague and ill-defined at best. But it would appear that webcomics do have something of an edge, using what metrics we can work with, and that there are more likely to succeed now than they were in the earlier days of the medium.

The Negative Side of Creator Access

One of the benefits about webcomics, from the perspective of the reader, is the ability to communicate very directly with the creators. The nature of the internet allows users to share not only files like webcomics themselves but also messages and communication in a variety of formats. It is then not surprising that webcomics often include the means with which readers can contact the creators. That might simply come in the form of just including the creator's email address on the site, but more frequently it will include a variety of methods that a creator feels comfortable using. This might include links to their social media presences, online message boards, or perhaps even a voice-over-IP line. Regardless of the specific methodology, this access is not only easily possible but often encouraged very heavily by other webcomic creators.

Sheldon's Dave Kellett has tried to emphasize this: "By interacting with your audience, you can create passionate, passionate, *passionate* [emphasis in the original] readers. And that should be your goal, above all other marketing, P.R. and sales goals. Because everything else follows from the passion your readers feel for your Webcomic. And that is the best reason to cultivate your relationship with them" (Guigar et al., 2011b: 105). He went on to quote Dale Carnegie's much earlier summation of the same basic idea: "You can make more friends in two months by becoming interested in

other people than you can in two years by trying to get other people interested in you" (109).

The comic is, in many cases, a filtering mechanism. While it showcases the mind-set of the creator, it's often open to interpretation via whatever metaphors—both verbal and visual—the creator happens to use. Additional discussion about the webcomic, whether in email, message boards, or other forms of paratext, can illuminate a creator's position on a subject more concretely. Although this is obviously still subject to misinterpretation, that possibility is theoretically diminished by virtue of it complementing and clarifying whatever is presented in the webcomic itself. The very existence of these paratexts allows readers a greater insight into— and, by extension, emotional proximity with—the workings of how the webcomic is developed.

For other webcomics, however, the impact is emphasized even more strongly if the creator is working on a diary webcomic specifically. Since these feature the real events of a creator's day-to-day life, they give readers a very open and unfettered look at who they are: their preferences, their habits, their beliefs, their struggles, and so on. Further complicating matters is that these comics are often created very soon after the events which they depict, meaning that a creator has less opportunity to reflect on whether they are sharing more than they might be comfortable with later. A creator using their own life for content can certainly engage more directly with readers than one who presents works of fiction, but this also opens them up to potentially stronger emotional connections than they realized they were generating.

One basic problem here is that, while the creator might be reaching out in an effort to draw in readers, the conversation can become one-sided. A creator is presenting themselves as something of a public figure via the webcomic, its direct paratexts, and other personal information that might be available via other social media outlets. The internet allows for a reader to go directly from a webcomic to a social media account designed to promote the comic to the social media account of the creator specifically. Not to mention any other easily available information online, potentially covering everything from interviews to public tax records. This can lead to situations where a reader knows far, far more about the creator than the creator might be comfortable with.

This is not a situation unique to webcomic creators, naturally but, as Brad Guigar (2013a: 117) of *Evil, Inc.* puts it, "There are as many boundaries as there are webcomics, but no matter how carefully you set yours, the time will come when a reader crosses it." This may or may not be intentional on the part of the fan, but for a creator, it can range from mildly uncomfortable at best to frighteningly threatening or worse. Guigar went on to enumerate three options for handling such situations: modification, mediation, and moderation.

Modification is the basic notion of not reinforcing unwelcome behaviors and trying to encourage welcome ones. By not engaging with people exhibiting unacceptable behavior and simultaneously showing deference to those who are acting more civilly, a creator can subtly direct the behavior of both the individual in question and others that may be witness to the interaction.

Guigar then suggests mediation; basically, talking to the person frankly.

> But if we take a step back from our initial reaction to this behavior, and point out to the person that his behavior is hurtful (or odd or threatening), you'd be surprised how often the response is a quick and sincere apology. What we regard as bizarre reader behavior can sometimes be a reader who just doesn't know the appropriate way to handle his or her own fandom. (117)

It is only after those two approaches fail that Guigar suggests more heavy-handed moderation on whatever sites or platforms the reader is trying to engage the creator in: disabling their posting privileges on the webcomic site itself, blocking their social media accounts, blacklisting their email address, and so on. "As a webcartoonist, you try to gather as many fervent fans as possible, but sometimes you have to be willing to part ways with the ones whose fandom leads them to become disruptive forces in your community and in your personal life" (117).

While the connections made with readers over a webcomic is centrally key to developing a passionate audience, it does come with the risk of encouraging fans who are overly enthusiastic about the creator, to the point of causing a creator to fear for their own safety. This is an issue of concern for anyone who spends time online any

more, but webcomic creators are one group that put themselves in that position more obviously in their efforts to attract attention to their comic.

Permanence versus Etherialness

One feature that many webcomics have is an archive of their older strips. A reader coming to the site for the first time can often find every installment of the comic going back to its origins. These are sometimes even included in a database that might be searchable by character or topic, as well as date. The availability of this option is a boon both for new fans, who can catch up on however much of the comic they have previously missed, and for academics who can direct students to reading materials that are easily accessible.

This has some obvious advantages over printed comics that can be harder (and certainly more expensive) to acquire. With no need for a webcomic to keep going back for repeated printings, they maintain something of a permanence in their availability. Significant events in the comic, such as dramatic revelations or the introduction of new characters, cannot sell out in the way print comics can, thus affording an ongoing accessibility to the overall story, potentially decades after their initial publication.

Simultaneously, however, webcomics also have a decided impermanence to them by virtue of their digital nature. Some creators, in their contracts with print publishers, agree to remove all or parts of their webcomic from the internet once it is published in printed form. Raina Telgemeier's *Smile*, Noelle Stevenson's *Nimona*, and Tony Cliff's *Delilah Dirk and the Turkish Lieutenant* all started as webcomics that were subsequently removed from the internet at their eventual respective publishers' insistence. As noted in the "History" section, John Campbell also somewhat famously pulled his entire *Pictures for Sad Children* website down during the stress of fulfilling a Kickstarter campaign. But deliberate actions like these are hardly the only way a site might disappear. Accidental issues stemming from host server problems, or just a creator's lack of technical savvy could also cause a webcomic site to disappear.

Less severe, but also noteworthy, can also be when the site as a whole remains in place, but certain installments are removed or changed. In some cases, that might be a single page. Ethan Young

went back to change some elements of his *Tails* webcomic, to further emphasize a physical resemblance between the protagonist and his parents and, as noted in the Key Texts, Minna Sundberg altered some of her pages to remove some offensive language. While this may bring a comic more in line with what a creator would like to ultimately convey, it can still provide a disconnect among different readers who see different revisions of the same story, one now being entirely lost to the ether.

In the case of *Bob the Squirrel*, readers can only look at comics going back as far as late 2010, despite the strip starting several years earlier. According to creator Frank Page (2012), the older strips "aren't available because when I switched over to the WordPress platform from the old rickety HTML, I had to totally change the naming structure of the strips . . . so I just went back only so far, otherwise I'd have to rename almost 2000+ strips. Some say lazy . . . I say . . . well, lazy."

So while a webcomic can be more accessible by virtue of being "always" available, that "always" is a qualified one. Even though there are organizations like the US Library of Congress and the Internet Archive that are explicitly trying to archive webcomic material precisely because of its ephemeral nature, the vast amount of webcomic material that is online already, coupled with the ongoing nature of updates to that material, means that inevitably, not everything will be captured for posterity.

Additionally, these sources may not be able to capture either any dynamic content and/or paratexts that may be significant but not directly tied to the webcomic itself. A set of message boards or a wiki, for examples, may be hosted on a separate domain. In some cases, webcomics may appear in different platforms with differing levels of synchronicity. As of this writing, Brian Fies's *Mom's Cancer*, for example, continues to be serialized on Andrews McMeel Universal's GoComics.com despite Fies completing the comic on his own site in 2005. These can all complicate ensuring an archival record of any given webcomic exists.

To be sure, print comics have their own archival issues and concerns as well. Paper is, after all, an organic material and subject to decomposition in even the best of environments. But mankind has spent centuries finding ways to preserve paper and the information often written on it. Digital storage is a relatively new concept, even in the broadest sense, and webcomics' even

more recent origins mean that long-term storage has not even had a chance yet to be tried and tested. Archivists are certainly exploring what options they can, but there are no guaranteed methods of preserving digital content beyond a few decades simply because digital content has scarcely been around longer than that. Magnetic media (i.e., floppy disks and early hard drives) have a practical life span of no longer than twenty years, so it's only been recently that the earliest webcomic creators began discovering some of their own personal archives were failing. Optical media devices (i.e., CDs and DVDs) seem to have a similar life span, and those are beginning to see failures as of this writing. Ultimately, people are still discovering the various technical issues surrounding long-term digital storage so, while print material does have its own conservation factors, they are much more well known and understood than their digital cousins.

Paratexts

One of the features webcomics generally have in abundance relative to print comics is the availability of paratexts, additional content provided by the creators and/or publishers to lend additional context to the primary text. In the case of print comics, this might be something as common as the publisher and copyright information typically found in the indicia, although it rarely might go so far as to include annotations, end notes, and additional "back matter." These latter examples are found more frequently in larger bound collections, and are not as common in the typical monthly serialized form.

Webcomics, of course, have their own sets of paratexts as well, and they are frequently much more robust thanks in large part to the nature of the internet itself. A common practice among many webcomic sites is the inclusion of additional pages of notes that run as navigation throughout every page of the site. Readers can often find links to pages with a broad summary of the title itself, detailed character and setting outlines, creator biographies, and frequently asked questions that might cover such diverse topics as update schedules, notes about the creative tools being used, and anything else that the creator might get tired of repeatedly answering in individual conversations. One of the things that stand out about

these elements, relative to anything comparable in print, is that these paratexts are generally readily available from any installment of the webcomic often, as noted earlier, via site-wide navigation. Using said navigation as part of a page template means every page on the site will have direct access to these paratexts with no additional cost or effort on the part of the creator.

A print comic might not be able to practically include much of this information on a consistent basis. Think, for example, how much space it might take up to provide a complete set of character outlines for titles like *The Avengers* or *The Legion of Super-Heroes* with every issue. The effectively nonexistent cost for the web means that a creator can craft 5,000-word character studies for every character in their story, and still make them easily accessible to every reader, even if that reader won't discover the comic for another year. The paratexts remain as available as the primary text, both now and in the future.

While not necessarily critical for the development of a webcomic, they are widely seen as an industry best practice: "The About page, when organized and presented well, takes that moderately interested onlooker and prepares her to become a new reader. . . . It's as obligatory as the copyright on the bottom of the page" (Guigar, 2013a: 102). It is precisely this type of use of paratexts, when applied consistently throughout an entire webcomic, that allow any reader, regardless of their familiarity with the comic, to come to the comic at any point in its development—from the very first installment to the very last—and gain a solid sense of authorial intent directly from the source.

Additionally, individual installments of webcomics are frequently presented with meta-commentary from the creator, often via an associated blog running directly underneath the comic itself: "Beyond the comic itself, the most important tool you have in your community-building pursuit is your blog. It should appear as close to the comic as possible . . . all you have to do is *say* something" (111). While generally considerably shorter than the pages outlined earlier, these notes can provide readers with context more specific to an individual page or the time it was posted. Creators might provide an explanation for posting a strip earlier or later than usual, direct readers to new features or friends' comics, provide insight into creative decisions unique to that page, or simply make note of personal events going on at that time. While social media affords

print creators the ability to share the same type of information, even with the same level of detail, it is inherently presented via a different medium, thereby removing it from the context of the actual comic.

This last point is significant as it emphasizes how much of the context available for reading a webcomic is directly linked to the comic itself in the form of these paratexts. Print comics, if paratexts are desired by the reader, often need to be sought after in the form of certain editions. Further, not all paratexts are necessarily included in all editions, leading some readers to obtain multiple print editions of the same comic in order to peruse the varied paratexts that might be available. While a webcomic's paratexts are generally not included in print editions, the source webcomic itself will usually maintain these for the life of the comic, sometimes updating them as necessary to account for significant changes or updates to the comic itself. That might be adding new meta-content like the biography of a new colorist, or altering existing character descriptions to reflect changes to narrative continuity.

While paratexts are certainly not exclusive to webcomics, their frequent and ongoing attachment to the source material afford readers an ability to unilaterally take that material into consideration when examining a webcomic in a way that may not be possible with various forms of print comics. Ideally, a webcomic's paratexts should not be necessary to absorb and understand the webcomic itself, but the additional context can often provide a deeper appreciation of both the comic and the creators who developed it. That it is so readily available means that readers can enjoy the comic on its own merits or study it more in depth with equal aplomb based on their own preferences and desire to associate with the work.

APPENDIX: *SOLUTION SQUAD* LESSON PLAN

Jim McClain's work on *Solution Squad* highlights some of the additional work that goes in to webcomics beyond simply creating the comic. As part of the additional material he develops outside the comic itself, McClain also makes lesson plans that can accompany his stories to better facilitate and encourage use in the classroom by teachers. While this is not typical with regard to what a webcomic creator might work on as material that is ancillary to the comic narrative itself, it does point to the level of work involved beyond story development.

THE FUNDAMENTAL THEOREM OF ARITHMETIC

Common Core State Standards:

CCSS.MATH.CONTENT.4.OA.B.4
Find all factor pairs for a whole number in the range 1-100. Recognize that a whole number is a multiple of each of its factors. Determine whether a given whole number in the range 1-100 is a multiple of a given one-digit number. Determine whether a given whole number in the range 1-100 is prime or composite.

Indiana Academic Standards:

MA.7.NS.1: Find the prime factorization of whole numbers and write the results using exponents.

Note: *Although prime factorization is not a Common Core State Standard, it is extremely useful in simplifying fractions, which is also not a Common Core State Standard. It has been argued that simplifying fractions is not necessary and any mention of it has been buried in talking about equivalent fractions, but anyone who deals with polynomial fractions in the later grades is bound to disagree. Factored polynomial fractions and radical expressions must be simplified or they become unwieldy and useless. For this reason, prime factorization as a method of simplifying fractions gives students a concrete basis to learn a much more abstract concept in algebra.*

Introduction

At first, students are likely to look at this assignment and complain about how many problems it is. They'll see the last number and exclaim, "One hundred problems?!"

Not to worry. Once they are shown the methods for prime factorization, especially inverted division (see below), they'll see that many of their answers are already present. They can fill in the prime numbers fairly quickly from the list, and then if they look at the process that they are about to learn for more. Just looking at the factor tree for 90, for example, the prime factorizations for nine and 10 are already included. And if nine is 3^2, then 18, which is its double, is simply $2 \cdot 3^2$. Double that again, and 36 is revealed as $2^2 \cdot 3^2$. They can quickly fly through even numbers by increasing the powers of two for each double. Then they can do the same thing for triples, quintuples, and septuples, and all of a sudden, you're talking about prime numbers again! You don't have to deal with quadruples because they were already taken care of with the increasing powers of two! The circle is now complete.

FIGURE 7 *Jim McClain's lesson plans for* Solution Squad *include specific assignments and how they relate to required academic curricula.*

Source: *Solution Squad* by Jim McClain.

THE FUNDAMENTAL THEOREM OF ARITHMETIC

The fundamental theorem of arithmetic says that every natural number (except 1) is either a prime number or a unique product of prime numbers. One is the exception because it is the product of itself.

For example, $350 = 2 \cdot 5^2 \cdot 7$ is the only way you can break 350 into prime factors. Changing the order of the numbers is just an exercise of the **commutative property of multiplication**. You would still have to use the same factors regardless of order.

Prime factorization is useful to simplify large fractions as part of the Least Common Multiple (LCM) process and the Greatest Common Factor (GCF) algorithm. If you think this is a waste of time because you already know how to reduce fractions, be patient! Later, you will use the same concept to simplify polynomial fractions.

One way to find the prime factorization of numbers is to make a factor tree. You probably already know how to do this. Take 90 for example:

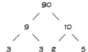

Once you put the factors in **ascending order** (least to greatest) and use exponents to express repeated factors, you write $90 = 2 \cdot 3^2 \cdot 5$. This works fine for small numbers or numbers that are easily divided.

Another way to do this is by using what we call **inverted division**. It's a great way to exercise your **mental math** skills! You will be dividing by the prime numbers in ascending order. You made a list of these **prime numbers** in the **Prime Number Sieve** activity.

- Start by checking to see if the first prime number divides evenly into the number for which you are trying to find the prime factorization.
 If that number divides in evenly, keep dividing by it until it no longer does. Put the quotient on the bottom of the "house" instead of on top.

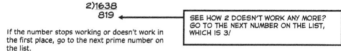

- If the number stops working or doesn't work in the first place, go to the next prime number on the list.
- If that prime number divides in evenly, keep dividing by it until it no longer goes in evenly. When it stops, go to the next number on the list.

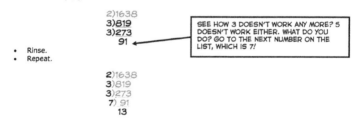

- Rinse.
- Repeat.

```
2)1638
3)819
3)273
7) 91
   13
```

When you end up with a prime number as a quotient, the number has been completely prime factored. Now look down along the left side of the divisions until you reach the bottom. The prime factors are already in order for you! So $1638 = 2 \cdot 3^2 \cdot 7 \cdot 13$!

TO BE CONTINUED...

FIGURE 8 *Jim McClain's lesson plans for* Solution Squad *include specific assignments and how they relate to required academic curricula.*
Source: *Solution Squad* by Jim McClain.

THE FUNDAMENTAL THEOREM OF ARITHMETIC

Write the unique prime factorization of each of the following numbers. You may use **factor trees** or **inverted division** as methods to find the prime factorizations. Each factorization should be written in ascending order with exponents, just to make it easier for your teacher (or classmates) to grade! If the number is prime, write "P" or "Prime."

2. ___PRIME___
3. ___PRIME___
4. ___2^2___
5. _____
6. _____
7. _____
8. _____
9. _____
10. _____
11. _____
12. _____
13. _____
14. _____
15. _____
16. _____
17. _____
18. _____
19. _____
20. _____
21. _____
22. _____
23. _____
24. _____
25. _____
26. _____
27. _____
28. _____
29. _____
30. _____
31. _____
32. _____
33. _____
34. _____
35. _____
36. _____
37. _____
38. _____
39. _____
40. _____
41. _____
42. _____
43. _____
44. _____
45. _____
46. _____
47. _____
48. _____
49. _____
50. _____

51. _____
52. _____
53. _____
54. _____
55. _____
56. _____
57. _____
58. _____
59. _____
60. _____
61. _____
62. _____
63. _____
64. _____
65. _____
66. _____
67. _____
68. _____
69. _____
70. _____
71. _____
72. _____
73. _____
74. _____
75. _____
76. _____
77. _____
78. _____
79. _____
80. _____
81. _____
82. _____
83. _____
84. _____
85. _____
86. _____
87. _____
88. _____
89. _____
90. ___$2 \cdot 3^2 \cdot 5$___
91. _____
92. _____
93. _____
94. _____
95. _____
96. _____
97. _____
98. _____
99. _____
100. _____

Inside speech bubble:
If you need a reminder, here are the primes you'll need:

2, 3, 5, 7, 11, 13, 17, 19, 23, 29, 31, 37, 41, 43, 47, 53, 59, 61, 67, 71, 73, 79, 83, 89, and 97.

Exercises like this will make you faster at mental multiplication and division!

FIGURE 9 *Jim McClain's lesson plans for* Solution Squad *include specific assignments and how they relate to required academic curricula.*
Source: *Solution Squad* by Jim McClain.

THE FUNDAMENTAL THEOREM OF ARITHMETIC ANSWERS

Write the unique prime factorization of each of the following numbers. You may use **factor trees** or **inverted division** as methods to find the prime factorizations. Each factorization should be written in ascending order with exponents, just to make it easier for your teacher (or classmates) to grade! If the number is prime, write "P" or "Prime."

2.	PRIME	51.	$3 \cdot 17$	
3.	PRIME	52.	$2^2 \cdot 13$	
4.	2^2	53.	PRIME	
5.	PRIME	54.	$2 \cdot 3^3$	
6.	$2 \cdot 3$	55.	$5 \cdot 11$	
7.	PRIME	56.	$2^3 \cdot 7$	
8.	2^3	57.	$3 \cdot 19$	
9.	3^2	58.	$2 \cdot 29$	
10.	$2 \cdot 5$	59.	PRIME	
11.	PRIME	60.	$2^2 \cdot 3 \cdot 5$	
12.	$2^2 \cdot 3$	61.	PRIME	
13.	PRIME	62.	$2 \cdot 31$	
14.	$2 \cdot 7$	63.	$3^2 \cdot 7$	
15.	$3 \cdot 5$	64.	2^6	
16.	2^4	65.	$5 \cdot 13$	
17.	PRIME	66.	$2 \cdot 3 \cdot 11$	
18.	$2 \cdot 3^2$	67.	PRIME	
19.	PRIME	68.	$2^2 \cdot 17$	
20.	$2^2 \cdot 5$	69.	$3 \cdot 23$	
21.	$3 \cdot 7$	70.	$2 \cdot 5 \cdot 7$	
22.	$2 \cdot 11$	71.	PRIME	
23.	PRIME	72.	$2^3 \cdot 3^2$	
24.	$2^3 \cdot 3$	73.	PRIME	
25.	5^2	74.	$2 \cdot 37$	
26.	$2 \cdot 13$	75.	$3 \cdot 5^2$	
27.	3^3	76.	$2^2 \cdot 19$	
28.	$2^2 \cdot 7$	77.	$7 \cdot 11$	
29.	PRIME	78.	$2 \cdot 3 \cdot 13$	
30.	$2 \cdot 3 \cdot 5$	79.	PRIME	
31.	PRIME	80.	$2^4 \cdot 5$	
32.	2^5	81.	3^4	
33.	$3 \cdot 11$	82.	$2 \cdot 41$	
34.	$2 \cdot 17$	83.	PRIME	
35.	$5 \cdot 7$	84.	$2^2 \cdot 3 \cdot 7$	
36.	$2^2 \cdot 3^2$	85.	$5 \cdot 17$	
37.	PRIME	86.	$2 \cdot 43$	
38.	$2 \cdot 19$	87.	$3 \cdot 29$	
39.	$3 \cdot 13$	88.	$2^3 \cdot 11$	
40.	$2^3 \cdot 5$	89.	PRIME	
41.	PRIME	90.	$2 \cdot 3^2 \cdot 5$	
42.	$2 \cdot 3 \cdot 7$	91.	$7 \cdot 13$	
43.	PRIME	92.	$2^2 \cdot 23$	
44.	$2^2 \cdot 11$	93.	$3 \cdot 31$	
45.	$3^2 \cdot 5$	94.	$2 \cdot 47$	
46.	$2 \cdot 23$	95.	$5 \cdot 19$	
47.	PRIME	96.	$2^5 \cdot 3$	
48.	$2^4 \cdot 3$	97.	PRIME	
49.	7^2	98.	$2 \cdot 7^2$	
50.	$2 \cdot 5^2$	99.	$3^2 \cdot 11$	
		100.	$2^2 \cdot 5^2$	

Within the speech bubble:

If you need a reminder, here are the primes you'll need:

2, 3, 5, 7, 11, 13, 17, 19, 23, 29, 31, 37, 41, 43, 47, 53, 59, 61, 67, 71, 73, 79, 83, 89, and 97.

Exercises like this will make you faster at mental multiplication and division!

FIGURE 10 *Jim McClain's lesson plans for* Solution Squad *include specific assignments and how they relate to required academic curricula.*

Source: *Solution Squad* by Jim McClain.

GLOSSARY

blog A shortened form of "weblog," a term coined by Jorn Barger in 1997 to identify a website that featured diary-style entries posted on a regular basis. The term was shortened to "blog" by Peter Merholz in 1999, and first used as a verb by Evan Williams.

Cintiq A series of electronic drawing tablets produced by Wacom. They allow artists to draw on the tablet's LCD surface using a stylus in a way that mimics traditional drawing tools, while creating digitally native art files.

CompuServe The first major commercial internet service provider in the United States; it predated the world wide web by several years. It began allowing file-sharing among their own users as early as 1981, although broader internet access did not begin until 1989.

crowd-funding A means of raising capital for a project by soliciting small amounts of money from a large number of people. The concept has been around for hundreds of years, but the internet has allowed for reaching a much wider base, not limited by geography. Several different crowdfunding platforms have been created on the web with unique variations on the basic model.

cycle animation A typically short animation in which the last frame leads seamlessly back to the first. This allows the animation to be played on an infinite loop without any visual breaks or cues that the sequence has started over.

DARPA (Defense Advanced Research Projects Agency) A division within the US Department of Defense that specializes in developing technologies to be used by the military. They often form partnerships with academic and industrial institutions, and some of the projects impact decidedly nonmilitary endeavors.

GEnie (General Electric Network for Information Exchange) An online service provider that was begun in 1985. The service struggled to adapt to widespread usage of the world wide web, and was closed entirely in 1999.

GIF (Graphics Interchange Format) An image file format originally developed by CompuServe. GIF images are able to use their own limited color palette, allowing for smaller file sizes but at the expense

of reproducing complex color mixes found in photographs or gradients.

Gopher A communications protocol developed at the University of Minnesota that was released in 1991 and can be considered a predecessor to the world wide web. Gopher services declined soon after the web's debut, in part, because the service required licensing fees and had a more rigid structure than the web's use of HTML.

Flash A multimedia software platform by Macromedia that allowed for vector-based animations on the web with the use of browser plug-ins. The software was purchased by Adobe in 2005 and as HTML5 was introduced, they began deprecating Flash's use, eventually terminating it entirely in 2020.

HTML (Hypertext Markup Language) The language used for documents to be displayed in a web browser. The language describes the structure of a web page semantically and, to a lesser extent, helps to define the appearance of the page, although this latter feature has largely been replaced with the use of Cascading Style Sheets that work in conjunction with HTML.

HTTP (Hypertext Transfer Protocol) The application protocol that serves as the foundation of the world wide web. It is a means in which one electronic device communicates to another to provide HTML and other types of documents.

hypertext Text displayed on a computer that links to other documents. This is conceptually the foundation of the world wide web, where any given web page can link to other web pages, which in turn link to other web pages. The term was coined by Ted Nelson in 1963, and a variety of interpretations in implementation of the idea were created well before the world wide web.

infinite canvas The theoretically limitless space comics can utilize on a single web page, allowing a creator to experiment with panel layouts and structures more than is possible in print. The term was first coined by Scott McCloud in 2000.

internet service provider (ISP) A company that provides individual users access to the internet. These are frequently thought of as commercial enterprises, but can include government and nonprofit organizations.

JavaScript A scripting language that is usable in conjunction with HTML to provide greater interactivity on web pages. Publicly introduced in late 1995, it allows for conditional variables to change how a web page might be viewed or used.

JPG (Joint Photographic Experts Group) An image file format that was designed primarily with an emphasis on file compression. Images can be compressed reasonably small with minimal loss in quality. The format is used extensively on the web, including most web comics.

meme Initially, any idea or behavior that spreads throughout a culture. With the rise of the web, the term is commonly used to refer specifically to widely shared images containing such an idea. Some webcomics inadvertently take this form. The term was first coined by Richard Dawkins in 1976.

micropayments Financial transactions, often made online, that involve a small amount of money. Precisely how small a transaction must be to be considered a micropayment is the subject of debate; Ted Nelson, who first considered the idea, limited the amount to no more than a few cents in American currency, while Visa in 2010 broadened their definition to anything under AU$20.

pixel The smallest component of a digital image. The word is a portmanteau of "picture" and "element" as first thought of by Frederic Billingsley in 1965. The term can be used to describe the number of elements in an image file, or the number of elements used by a display screen to render such an image. Webcomic artists typically focus on the former.

PNG (Portable Network Graphics) An image file format that was developed as an improvement over the GIF. The image quality of a PNG is generally superior to a GIF, but often at the expense of a GIF's smaller file sizes.

portal A website that is designed to present a variety of information from different sources in a coherent way. In the case of webcomics, a portal might allow readers to access a wide collection of different comics using different forms and formats in a single location.

Q-link An early internet service which was originally designed for Commodore 64 and 128 computers in 1985. Quantum Computer Services, which operated the service, expanded their base in 1989 and renamed themselves America Online.

ripping A process in which someone creates a website using the content from another by referring directly to it, utilizing the original content's source location. This puts a resource drain on the original content's servers without generating any additional traffic to the source site. A ripper could thereby present the source material but bypass any advertising and/or pay for the additional bandwidth. Although not technically illegal, it is often viewed as a form of stealing by the people creating the original content.

scraping A process in which a website's information is automatically extracted and then usually repackaged for use elsewhere. It is a similar concept to "ripping" however the content is being duplicated instead of simply referenced. While this does not carry the bandwidth concerns as ripping, it is still viewed as a form of stealing content.

TCP/IP (Transmission Control Protocol/Internet Protocol) The fundamental communications protocol used in computer networks like the internet. It identifies the basic way in which data should be broken up into smaller packets, how it should be sent and routed from one computer to another, and how those packets should be unpacked and recompiled once they reach their destination.

URL (Uniform Resource Locator) More commonly known as a web address. It acts as a series of instructions for a web browser to locate a specific file online.

Usenet A popular early distributed discussion forum on the internet. It was launched in 1980, and acted as a set of global message boards with users able to carry on threaded discussions under a wide variety of topic categories.

wiki A website of encyclopedic-style articles, contributed by a communal group of editors. Wikipedia is the most topically broad and well-known instance, although many others exist focusing on more niche topics. Some webcomics have their own wiki to help answer questions or provide summaries for newer readers.

WordPress A content management system popularly used for blogs and webcomics first launched in 2003. The system allows users to easily create and manage web content without having to develop actual web pages themselves. Using pre-built templates called themes, a creator can easily change the look of their entire website without having to touch the content itself. As of 2019, one-third of the top ten million websites run on WordPress.

World wide web The network of computers that serves hypertext documents via the internet. Its relative ease of use has allowed billions of people worldwide to access and take advantage of the internet.

RESOURCES

Aboraya, Abe (2010), "Eat Your Oatmeal," *Seattle Weekly*, 22 September. Available online: https://web.archive.org/web/20100927015217/ http://www.seattleweekly.com:80/2010-09-22/news/eat-your-oatmeal/3/ (accessed March 1, 2019).

"About" (2017), *Empathize This*. Available online: https://www.empathizethis.com/about/ (accessed February 27, 2019).

Adams, Scott (1994), "Dilbert Newsletter #1," *Dilbert*, May. Available online: https://web.archive.org/web/20081004094208/http://www.unitedmedia.com:80/comics/dilbert/dnrc/html/newsletter01.html (accessed March 2, 2019).

Allen, Todd W. (2014), *Economics of Digital Comics*, United States: Todd Allen.

"Alumni Profile Robert Khoo" (2008), University of Washington Foster. Available online: https://web.archive.org/web/20120217160819/http://www.foster.washington.edu/about/Pages/AlumniProfileRobertKhoo.aspx (accessed February 26, 2019).

Alvarez, James (2012), "6 Questions with Rebecca Cohen Creator of Gyno-Star," *Obscure Gentlemen*, 8 February. Available online: https://theobscuregentlemen.com/2012/02/08/6-questions-with-rebecca-cohen-creator-of-gyno-star/ (accessed February 28, 2019).

Alverson, Brigid (2012), "Mark Waid Reflects on the First Eight Months of Thrillbent," *Comic Book Resources*, 31 December. Available online: https://www.cbr.com/mark-waid-reflects-on-the-first-eight-months-of-thrillbent/ (accessed February 27, 2019).

Alverson, Brigid (2018), "Andrew Hussie on Bringing Wild Webcomic (?) Homestuck to Print," *B&N Sci-Fi & Fantasy Blog*, 7 May. Available online: https://www.barnesandnoble.com/blog/sci-fi-fantasy/andrew-hussie-on-bringing-wild-webcomic-homestuck-to-print/ (accessed February 27, 2019).

Arevalo-Downes, Lauren (2011), "Feature: PATV, Convergence and Comics," a.list, 3 February. Available online: https://www.alistdaily.com/strategy/feature-patv-convergence-and-comics/ (accessed February 26, 2019).

ArtistShare (2016), "About Us," ArtistShare. Available online: http://www.artistshare.com/about (accessed February 26, 2019).

"Baby Boomers and Seniors Fastest Growing Web Groups" (2000), The Big Picture Demographics, 4 April. Available online: https://web.archive.org/web/20000511182328/http://cyberatlas.internet.com/big_picture/demographics/article/0,1323,5901_334031,00.html (accessed March 1, 2019).

Baker, John (2008), "Origins of 'Blog' and 'Blogger'," Viral Blog Content, 20 April. Available online: https://web.archive.org/web/20141103083257/http://www.viralblogcontent.com/Origins_of__22Blog_22_and__22Blogger_22.pdf (accessed February 26, 2019).

Benjamin, Ryan (2018), "Fan Time," *Brothers Bond*, 8 November. Available online: https://www.webtoons.com/en/action/brothersbond/chapter-11-fan-time/viewer?title_no=1458&episode_no=12 (accessed February 27, 2019).

Berkenwald, Leah (2011), "Meet Rebecca Cohen and Gyno-Star, the World's First Explicitly Feminist Superhero," *Jewish Women's Archive*, 8 November. Available online: https://jwa.org/blog/meet-rebecca-cohen-creator-of-gyno-star-worlds-first-explicitly-feminist-superhero (accessed February 28, 2019).

Berners-Lee, Tim (1991a), "The Project," WWW. Available online: http://info.cern.ch/hypertext/WWW/TheProject.html (accessed February 26, 2019).

Berners-Lee, Tim (1991b), "WorldWideWeb—Summary," WWW. Available online: http://info.cern.ch/hypertext/WWW/Summary.html (accessed February 26, 2019).

Berners-Lee, Tim (1998), "The World Wide Web: A Very Short Personal History," W3. Available online: https://www.w3.org/People/Berners-Lee/ShortHistory.html (accessed February 26, 2019).

Berners-Lee, Tim (2001), "Answers for Young People," W3. Available online: https://www.w3.org/People/Berners-Lee/Kids.html (accessed February 26, 2019).

Berners-Lee, Tim (2002), "Frequently Asked Questions," W3. Available online: https://www.w3.org/People/Berners-Lee/FAQ.html (accessed February 26, 2019).

Bishop, Todd (2006), "'Woodstock for Gamers' grows by Leaps, Bounds," *Seattle Pi*, 23 August. Available online: https://www.seattlepi.com/business/article/Woodstock-for-gamers-grows-by-leaps-bounds-1212492.php (accessed February 26, 2019).

Bitmob (2011), "Interview: Penny Arcade's Robert Khoo on PAX, Child's Play, and Building an Empire," *Venture Beat*, 15 April. Available online: https://venturebeat.com/2011/04/15/talking-with-robert-khoo-about-pax-childs-play-and-other-great-things/ (accessed February 26, 2019).

Bjordahl, Hans (n.d.), "*Where the Buffalo Roam*—First Comic on the Internet," *Where the Buffalo Roam*. Available online: http://www. shadowculture.com/wtbr/site.html (accessed February 26, 2019).

Breeden, Jennie (2006), "Frequently Asked Questions," *The Devil's Panties*. Available online: https://web.archive.org/ web/20110716232445/http://thedevilspanties.com/extras/faq (accessed August 4, 2019).

Broadnax, Jamie (2015), "Comic Creator You Should Know: Olivia Stephens," *Black Girl Nerds*, 13 October. Available online: https:// blackgirlnerds.com/comic-creator-you-should-know-olivia-stephens/ (accessed February 27, 2019).

Brown, Joel (2008), "No Question, He's a Success," *Boston Globe*, 29 August.

Bughin, Jacques (2015), "Getting a Sharper Picture of Social Media's Influence," *McKinsey Quarterly*, July. Available online: https://www. mckinsey.com/business-functions/marketing-and-sales/our-insights/ getting-a-sharper-picture-of-social-medias-influence (accessed March 2, 2019).

Burlew, Rich (2012), "End of the Line—All Aboard!," Kickstarter, 21 February. Available online: https://www.kickstarter.com/ projects/599092525/the-order-of-the-stick-reprint-drive/posts/178261 (accessed March 1, 2019).

Campbell, John (2014), "Affluent People: Please Defend Your Desire for Affluence and Participation in Capitalism," *Sad Pictures for Children Kickstarter*, 27 February. Available online: https://www.kickstarter. com/projects/73258510/sad-pictures-for-children/posts/759318 (accessed February 26, 2019).

Campbell, T (2006), *A History of Webcomics*, San Antonio: Antarctic Press.

"Carlisle Robinson—Beyoutiful" (2015), [YouTube] USA, 27 June. Available online: https://www.youtube.com/watch?v=6-PZQV1p8XE (accessed February 27, 2019).

Caswell, Lucy Shelton and Jared Gardner (2017), *Drawing the Line: Comics Studies and INKS, 1994 to 1997*, Columbus: The Ohio State University Press.

Chin-Tanner, Tyler (2016), "High-Flying Fashion: An Interview with David Tischman about His Webcomic 'Heroine Chic'," *Broken Frontier*, 18 March. Available online: http://www.brokenfrontier.com/ david-tischman-heroine-chic-webcomic-audrey-mok-webtoons-comics/ (accessed February 27, 2019).

Clover, Juli (2017), "Apple Being Sued for 'Purposefully Slowing Down Older iPhone Models'," *MacRumors*, 21 December. Available online: https://www.macrumors.com/2017/12/21/apple-lawsuit-slowing-down-old-iphone-models/ (accessed March 2, 2019).

Cohen, Rebecca (2012), "About," *Adventures of Gyno-Star*. Available online: http://www.gynostar.com/about/ (accessed February 28, 2019).

Cohen, Rebecca (2013), "untitled," Rebecca Cohen Art, 5 October. Available online: http://rebeccacohenart.tumblr.com/post/63216486642/why-did-you-ignor-the-fact-that-there-are-feminist (accessed February 28, 2019).

Cohen, Rebecca (2014), "Rebecca Cohen Is Creating Snarky Feminist Comics and Podcasts," Patreon. Available online: https://www.patreon.com/gynostar (accessed February 28, 2019).

Cohen, Rebecca (2015), "You Could Work a Highly Stoned Cupcake Dress," *Adventures of Gyno-Star*, 2 June. Available online: http://www.gynostar.com/comic/you-could-work-a-highly-stoned-cupcake-dress (accessed February 28, 2019).

Cohen, Rebecca (2016a), "You Have the Right to Remain Silent," *Adventures of Gyno-Star*, 30 May. Available online: http://www.gynostar.com/comic/you-have-the-right-to-remain-silent/ (accessed February 28, 2019).

Cohen, Rebecca (2016b), "Working on New Gyno-Star Comics for You," *Adventures of Gyno-Star*, 7 December. Available online: http://www.gynostar.com/working-on-new-gyno-star-comics-for-you/ (accessed February 28, 2019).

Cohen, Rebecca (2018), "Hats for Brains," *Adventures of Gyno-Star*, 1 June. Available online: http://www.gynostar.com/comic/hats-for-brains/ (accessed February 28, 2019).

Coleman, Chris (2001), "An Interview with Illiad," O'Reilly ONLamp, 9 February. Available online: https://web.archive.org/web/20020105101131/http://www.onlamp.com/pub/a/onlamp/2001/02/09/illiad.html (accessed February 26, 2019).

"ConnectiCon Interview—*Dumbing of Age*" (2011), [YouTube] USA, 25 July. Available online: https://www.youtube.com/watch?v=Kcp87IfOkSg (accessed March 1, 2019).

Cook, Marcy (2014), "The Mary Sue Interview: Jeph Jacques Talks Mental Health, Sexuality, and Trans Characters in *Questionable Content*," *Mary Sue*, 12 December. Available online: https://www.themarysue.com/qc-jacques-interview/ (accessed February 28, 2019).

Cooper, Belle Beth (2016), "How Twitter's Expanded Images Increase Clicks, Retweets and Favorites [New Data]," Buffer, 27 April. Available online: https://buffer.com/resources/the-power-of-twitters-new-expanded-images-and-how-to-make-the-most-of-it (accessed March 1, 2019).

"Cost of Ad Blocking" (2015), PageFair and Adobe. Available online: https://downloads.pagefair.com/wp-content/uploads/2016/05/2015_report-the_cost_of_ad_blocking.pdf (accessed March 1, 2019).

Cravens, Greg (2016), "Creating the New Cartoonist," *Panel & Frame*, 21 January. Available online: https://medium.com/panel-frame/creating-the-new-cartoonist-5264a57b9658 (accessed March 2, 2019).

Crosbie, Vin (2002), "The 1 Percent Solution?" *ClickZ*, 8 October. Available online: https://www.clickz.com/the-1-percent-solution/77521/ (accessed March 1, 2019).

Curtis, George (2006), "Questionable Creator: George Curtis Interviews Jeph Jacques," Comix Talk, 9 March. Available online: http://comixtalk.com/questionable_creator_george_curtis_interviews_jeph_jacques/ (accessed February 28, 2019).

Curtis, Tom (2012), "*Homestuck* becomes the Third Highest Funded Game on Kickstarter," *Gamasutra*, 4 October. Available online: http://www.gamasutra.com/view/news/178865/Homestuck_becomes_the_third_highest_funded_game_on_Kickstarter.php (accessed February 27, 2019).

Dale, Brady (2015), "The Changing Internet through Webcomics," *Observer*, 18 November. Available online: https://observer.com/2015/11/webcomics-and-the-changing-web/ (accessed March 1, 2019).

Davis, Jim (2004), *Garfield at 25: In Dog Years I'd Be Dead*, New York: Ballantine Books.

Davis, Lauren (2014), "The Biggest Mistakes People Make When They Start A Webcomic," *Gizmodo*, 1 August. Available online: https://io9.gizmodo.com/the-biggest-mistakes-people-make-when-they-start-a-webc-1614779817 (accessed August 4, 2019).

Davison, Hallie (2015), "The Q&A: Perry Chen, Kickstarter," *Economist*, 28 May. Available online: https://web.archive.org/web/20150528181618/http://moreintelligentlife.com/blog/qa-perry-chen-kickstarter (accessed March 1, 2019).

Dawkins, Richard (1976), *The Selfish Gene*, New York: Oxford University Press.

Dealey, Samuel Isaac (2012), "Gutter Stars 4—GynoStar," *DeviantArt*, 22 January. Available online: https://www.deviantart.com/woohooligan/journal/Gutter-Stars-4-GynoStar-280772734 (accessed February 28, 2019).

Dean, Daniel (2009), "Andrew Hussie of *MS Paint Adventures*," *Comic Book Closet*, 22 March. Available online: https://wheals.github.io/interviews/comicscloset.htm (accessed February 27, 2019).

"Democratize Publishing" (n.d.), WordPress. Available online: https://wordpress.org/about/ (accessed February 26, 2019).

Dowdle, Max Miller (2018), "Interview With Minna Sundberg," *Artagem*, 7 May. Available online: https://www.artagem.com/interview-with-minna-sundberg/ (accessed February 28, 2019).

Dueben, Alex (2014), "Beranek & Crawford Look for 'Validation'," *Comic Book Resources*, 1 July. Available online: https://www.cbr.com/beranek-crawford-look-for-validation/ (accessed February 27, 2019).

Duffy, Damian (2017), "Teaching Hypercomics: Comics as Information Organization in Digital Pedagogy," *Inks: The Journal of the Comics Studies Society*, 1 (2): 205–25.

Edidin, Rachel (2013), "Comics Guys, Harassment, and Missing Stairs," *Postcards from Space*, 13 November. Available online: http://postcardsfromspace.tumblr.com/post/66907577520/comics-guys-harassment-and-missing-stairs (accessed February 28, 2019).

Eishtmo (2013), "What's Going on with *Sinfest*," *Wild Webcomic Review*, 9 August. Available online: http://wildwebcomicreview.blogspot.com/2013/08/whats-going-on-with-sinfest.html (accessed February 27, 2019).

Eisner, Will (1985), *Comics & Sequential Art*, Tamarac: Poorhouse Press.

Ekaitis, Joe (1994), "The Commodore Round Table," GEnie. Available online: http://cbmfiles.com/genie/geniefiles/Information/T.H.E.-FOX.TXT (accessed February 26, 2019).

Ellis, Keith (2017), personal communication, 14 February.

"*Empathize This* Is Creating Webcomics" (2014), Patreon. Available online: https://www.patreon.com/empathizethis (accessed February 27, 2019).

Eriksen, Travis (2017), "Child's Play Summer Faire and Table Tennis Tournament July 22nd," Child's Play, 3 May. Available online: https://www.childsplaycharity.org/news/post/childs-play-summer-faire-and-table-tennis-tournament (accessed February 26, 2019).

Fahlman, Scott (1982), "Original Board Thread in which :-) was Proposed," Carnegie Mellon University School of Computer Science, 19 September. Available online: http://www.cs.cmu.edu/~sef/Orig-Smiley.htm (accessed February 26, 2019).

Falck, Alex (2018), "An Interview with Author Sophie Labelle," *Intellectual Freedom Blog*, 17 December. Available online: https://www.oif.ala.org/oif/?p=16607 (accessed December 18, 2019).

Farley, David (1993), "New Cartoon—*Doctor Fun*," rec.arts.comics.strips, 24 September. Available online: https://groups.google.com/forum/?hl=en#!msg/rec.arts.comics.strips/aqV-98ZwKFU/e5FwR47LQtIJ (accessed February 26, 2019).

Farley, David (2002), "The Story of *Doctor Fun*, Volume 1," *Dr. Fun*. Available online: https://web.archive.org/web/20030622111849/http://www.ibiblio.org:80/Dave/faq.html (accessed February 26, 2019).

Farley, David (2005), "The Story of *Doctor Fun*, Volume 1," *Dr. Fun*. Available online: https://web.archive.org/web/20171130164847/http://www.ibiblio.org:80/Dave/oldfaq.html (accessed February 26, 2019).

Florido, Adrian (20015), "How Franklin, The Black 'Peanuts' Character, Was Born," *Morning Edition*, 6 November. Available online: https://www.npr.org/sections/codeswitch/2015/11/06/454930010/how-franklin-the-black-peanuts-character-was-born (accessed August 3, 2019).

Foglio, Kaja (2005), "Why Agatha Looks the Way She Does," *Kaja's Monster Table*, 1 November. Available online: https://web.archive.org/web/20170510184129/http://kajafoglio.livejournal.com/37481.html (accessed February 27, 2019).

Foglio, Kaja (2006), "Dirt, Collection Vol. 5, Furniture and Gaslamp Fantasy," *Diary of a Cartoon Girl*, 24 April. Available online: https://web.archive.org/web/20070313103808/http://kajafoglio.livejournal.com/60562.html (accessed February 27, 2019).

Foglio, Kaja (2013), "*Girl Genius* Volume 12 Printing and Reprint Frenzy!," Kickstarter. Available online: https://www.kickstarter.com/projects/girlgenius/girl-genius-volume-12-printing-and-reprint-frenzy/description (accessed February 28, 2019).

Foglio, Kaja (2018a), "Our New 'Kickstarter Backers' Contact Form' and Information Pages," *Girl Genius Backstage*, 4 February. Available online: https://girlgeniusbackstage.blogspot.com/2018/02/our-new-kickstarter-backers-contact.html (accessed February 28, 2019).

Foglio, Kaja (2018b), "Rambling about Kickstarter Fulfillment and Shipping," *Girl Genius Backstage*, 20 February. Available online: https://girlgeniusbackstage.blogspot.com/2018/02/rambling-about-kickstarter-fulfillment.html (accessed February 28, 2019).

Frazer, J. D. (n.d.), "FAQ," *User Friendly*. Available online: https://web.archive.org/web/19990202151833/http://www.userfriendly.org:80/faq/author/ (accessed February 26, 2019).

Frazer, J. D. (1999), "Copyright Questions," *User Friendly*. Available online: https://web.archive.org/web/19990202171447/http://www.userfriendly.org:80/faq/rights/ (accessed February 26, 2019).

Frazer, J. D. (2004), "Frequently Asked Questions," *User Friendly*. Available online: https://web.archive.org/web/20040611124901/http://www.userfriendly.org:80/faq/ (accessed February 26, 2019).

Frazer, J. D. (2006), "Frequently Asked Questions," *User Friendly*. Available online: http://www.userfriendly.org/faq/ (accessed February 26, 2019).

Freleng, Maggie (2013), "Miss Gendered: Cartoonist Satirizes Transphobic 'Feminists'," *Vitamin W*, 27 September. Available online: https://web.archive.org/web/20160527135158/http://vitaminw.co/culture-society/Miss-gendered-cartoonist-satirizes-transphobic-feminists (accessed February 28, 2019).

Gallo, Carmine (2013), "*Dilbert* Creator Scott Adams Reveals the Simple Formula That Will Double Your Odds of Success," *Forbes*, 23 October. Available online: https://www.forbes.com/sites/carminegallo/2013/10/23/dilbert-creator-scott-adams-reveals-the-simple-formula-that-will-double-your-odds-of-success (accessed March 2, 2019).

Gambrell, Dorothy (2013), "Cash Money 2012," *Cat and Girl*. Available online: https://web.archive.org/web/20130103050824/http://catandgirl.com:80/?page_id=2431 (accessed March 1, 2019).

Gambrell, Dorothy (2016), "Cash Money 2016," *Cat and Girl*. Available online: http://catandgirl.com/cash-money-2010/ (accessed March 1, 2019).

Gardner, Alan (2006), "*Diesel Sweetie* to Launch January 8," *Daily Cartoonist*, 14 December. Available online: http://www.dailycartoonist.com/index.php/2006/12/14/diesel-sweetie-to-launch-january-8/ (accessed March 2, 2019).

Gardner, Alan (2008), "Jim Davis Talks about 30 Years of *Garfield*," *Daily Cartoonist*, 12 June. Available online: http://www.dailycartoonist.com/index.php/2008/06/12/jim-davis-talks-about-30-years-of-garfield/ (accessed March 2, 2019).

Gardner, Alan (2010), "Julie Larson: Syndicates Are There for a Reason," *Daily Cartoonist*, 4 June. Available online: http://www.dailycartoonist.com/index.php/2010/06/04/julie-larson-syndicates-are-there-for-a-reason/ (accessed March 2, 2019).

Garrity, Shaenon (2012), "The Sisterhood of the Pimp Ninja Sluts," *Comics Journal*, 23 April. Available online: http://www.tcj.com/the-sisterhood-of-the-pimp-ninja-sluts/ (accessed February 27, 2019).

George, David and Tim Hatt (2017), "Global Mobile Trends 2017," *GSMA Intelligence*, September. Available online: https://www.gsmaintelligence.com/research/?file=3df1b7d57b1e63a0cbc3d585feb82dc2&download (accessed March 1, 2019).

Gianatasio, David (2015), "10 Visual Artists Who Are Changing the Way We See Advertising, and the World," *AdWeek*, 19 July. Available online: https://www.adweek.com/brand-marketing/10-visual-artists-who-are-changing-way-we-see-advertising-and-world-165988/ (accessed February 26, 2019).

Goodman, D. (2016), "Interview with Webcartoonist Brad Guigar," *Bam Smack Pow*, 4 April. Available online: https://bamsmackpow.com/2016/04/04/interview-with-webcartoonist-brad-guigar/ (accessed March 1, 2019).

Graham, Jefferson (2005), "Adobe Buys Macromedia in $3.4B Deal," *USA Today*, 18 April. Available online: https://usatoday30.usatoday.com/money/industries/technology/2005-04-18-adobe-macromedia_x.htm (accessed March 2, 2019).

Gromov, Gregory (1995), "Roads and Crossroads of the Internet History," NetValley. Available online: http://www.netvalley.com/cgi-bin/intval/net_history.pl?chapter=1 (accessed February 26, 2019).

Guigar, Brad (2011a), "Guide to Khoo Q&As," Webcomics.com, 15 March. Available online: https://webcomics.com/uncategorized/guide-to-khoo-qas/ (accessed February 26, 2019).

Guigar, Brad, Dave Kellett, Scott Kurtz, and Kris Straub (2011b), *How to Make Webcomics*, Berkley: Image Comics.

Guigar, Brad (2013a), *The Webcomics Handbook*, Philadelphia: Greystone Inn Comics.

Guigar, Brad (2013b), "What Do I Have to Lose?," Webcomics.com, 6 June. Available online: https://webcomics.com/articles/business/what-do-i-have-to-lose/ (accessed March 1, 2019).

Guigar, Brad (2015), "Ad Blocking Costs Web Publishers Big," Webcomics.com, 14 August. Available online: https://webcomics.com/articles/business/ad-blocking-costs-web-publishers-big/ (accessed March 1, 2019).

Guigar, Brad (2018), "Original Art and Patreon—A Perfect Match," Webcomics.com, 22 August. Available online: https://webcomics.com/articles/business/original-art-and-patreon-a-perfect-match/ (accessed March 1, 2019).

Harper, David (2015), "Is Gender a Determinant for How Much a Comic Artist Earns?," *SKTCHD*, 16 June. Available online: https://sktchd.com/longform/is-gender-a-determinant-for-how-much-a-comic-artist-earns/ (accessed August 4, 2019).

Hartman, Lisa (2017), "Canada: Canadian Human Rights Act and Criminal Code Amended to Include Gender Identity or Expression," *Mondaq*, 14 August. Available online: http://www.mondaq.com/canada/x/619694/Discrimination+Disability+Sexual+Harassment/Canadian+Human+Rights+Act+And+Criminal+Code+Amended+To+Include+Gender+Identity+Or+Expression (accessed February 27, 2019).

Harvey, Robert (1998), *Children of the Yellow Kid*, Seattle: University of Washington Press.

Heintjes, Tom, Dave Coverly, Jef Mallett, Hilary Price, and Stephen Pastis (2005), "Four of a Kind," *Hogan's Alley*, 1 (13): 46–55.

Heintjes, Tom and Stephen Pastis (2009), "The Stephen Pastis Interview," *Hogan's Alley*, 1 (16): 42–57.

Heylighen, Francis (1996), "Evolution of Memes on the Network: From Chain-Letters to the Global Brain," *Ars Electronica Catalogue*. Available online: http://pespmc1.vub.ac.be/Papers/Memesis.html (accessed March 1, 2019).

Holkins, Jerry (2004), "The Funny Papers," *Penny Arcade*, 7 January. Available online: https://www.penny-arcade.com/news/post/2004/01/07/the-funny-papers (accessed March 2, 2019).

Holkins, Jerry (2005), "And All of It True," *Penny Arcade*, 14 October. Available online: https://www.penny-arcade.com/news/post/2005/10/14/and-all-of-it-true (accessed February 26, 2019).

Holkins, Jerry and Mike Krahulik (2011), "Reprise," *Penny Arcade*, 15 June. Available online: https://www.penny-arcade.com/comic/2011/06/15 (accessed February 26, 2019).

Horton, Steve and Sam Romero (2008), *Webcomics 2.0*, Boston: Course Technology.

"ICT Data and Statistics (IDS)" (2008), International Telecommunication Union. Accessed online: http://www.itu.int/ITU-D/ict/statistics/ict/ (accessed February 26, 2019).

"ICT Facts and Figures 2017" (2017), International Telecommunication Union. Accessed online: https://www.itu.int/en/ITU-D/Statistics/Documents/facts/ICTFactsFigures2017.pdf (accessed March 1, 2019).

Ingraham, Christopher (2014), "Three Quarters of Whites Don't Have Any Non-white Friends," *Washington Post*, 25 August. Available online: https://www.washingtonpost.com/news/wonk/wp/2014/08/25/three-quarters-of-whites-dont-have-any-non-white-friends/ (accessed February 27, 2019).

Inman, Matthew (2012), "Tesla Response," *The Oatmeal*. Available online: https://theoatmeal.com/blog/tesla_response (accessed February 27, 2019).

Innes, Lora (n.d.), "A Word from the Author," The Dreamer. Available online: https://thedreamercomic.com/about/ (accessed February 27, 2019).

"Internet Usage Statistics" (2018), *Internet World Stats*, 30 June. Available online: https://www.internetworldstats.com/stats.htm (accessed March 1, 2019).

"Interview with Sophie Labelle" (2015), *Tomatrax*, 16 September. Available online: https://tomatrax.wordpress.com/2015/09/16/interview-with-sophie-labelle/ (accessed February 27, 2019).

Ishida, Tatsuya (2017), "Tatsuya Ishida Is Creating Comics," Patreon. Available online: https://www.patreon.com/sinfest (accessed February 27, 2019).

Ishida, Tatsuya (2018), "Community Guidelines," *Sinfest*, 3 July. Available online: http://www.sinfest.net/forum/viewtopic.php?p=33&highlight=#33 (accessed February 27, 2019).

Jacques, Jeph (2004a), "A QC Interview," *Questionable Content*. Available online: https://www.questionablecontent.net/interview.php (accessed February 28, 2019).

Jacques, Jeph (2004b), "untitled," *Questionable Content*, 24 August. Available online: https://www.questionablecontent.net/view.php?comic=174 (accessed February 28, 2019).

Jacques, Jeph (2009), "untitled," *Questionable Content*, 16 January. Available online: https://www.questionablecontent.net/view. php?comic=1319 (accessed February 28, 2019).

Jacques, Jeph (2012), *Questionable Content Vol. 3*, Easthampton: TopatoCo Books.

Jacques, Jeph (2017), Twitter, 28 November. Available online: https:// twitter.com/jephjacques/status/935555796309544960 (accessed February 28, 2019).

Jankowski, Lauren (2015), "Interview: Hanna-Pirita Lehkonen," *Asexual Artists*, 23 April. Available online: https://asexualartists. com/2015/04/23/interview-hanna-pirita-lehkonen/ (accessed February 27, 2019).

Jordan, Justin (2007), "Getting Smarter: Phil Foglio talks 'Girl Genius'," *Comic Book Resources*, 12 February. Available online: https:// www.cbr.com/getting-smarter-phil-foglio-talks-girl-genius/ (accessed February 27, 2019).

Kaszor, Daniel (2013), "Download Code: *Penny Arcade* Needs to Fix Its Krahulik Problem," *Financial Post*, 21 June. Available online: https:// business.financialpost.com/technology/gaming/download-code-penny-arcade-needs-to-fix-its-krahulik-problem (accessed February 26, 2019).

Khoo, Robert (2010), "Web vs Print," Webcomics.com, 2 March. Available online: https://webcomics.com/articles/business/robert-khoo-web-vs-print/ (accessed March 2, 2019).

Kingsley-Hughes, Adrian (2013), "Adobe's Creative Cloud Move Causes Outcry and Confusion," *Forbes*, 9 May. Available online: https://www. forbes.com/sites/adriankingsleyhughes/2013/05/09/adobes-creative-cloud-move-causes-outcry-and-confusion (accessed March 2, 2019).

Koster, Raph (2017), "The Online World Timeline," Raph Koster's Website. Available online: https://www.raphkoster.com/games/the-online-world-timeline/ (accessed February 26, 2019).

Krahulik, Mike (2014), "Resolutions," *Penny Arcade*, 1 January. Available online: https://www.penny-arcade.com/news/post/2014/01/01/ resolutions (accessed February 26, 2019).

Krehlmar (2015), "Ethnic and Racial Diversity in SSSS," *Stand Still Stay Silent. Fan Forum*, 23 May. Available online: https://ssssforum.com/ index.php?topic=453.0 (accessed February 28, 2019).

Kurtz, Scott (2004a), "SDCC 2004—Part Four," *PvPOnline*, 30 July. Available online: https://web.archive.org/web/20040814135954/http:// www.pvponline.com:80/rants_panel.php3 (accessed March 2, 2019).

Kurtz, Scott (2004b), "Wiley Takes a Swipe at Me?," *PvPOnline*, 14 December. Available online: https://web.archive.org/ web/20050205004633/http://www.pvponline.com:80/newspro/ archives/arc11-2004.html (accessed March 2, 2019).

Kurzweil, Ray (2001), "The Law of Accelerating Returns," *Kurzweil Accelerating Intelligence*, 7 March. Available online: http://www. kurzweilai.net/the-law-of-accelerating-returns (accessed February 27, 2019).

Labelle, Sophie (2015), "Sophie Labelle Is Creating *Assigned Male*, a Webcomic about Some Sarcastic Trans Teenagers," Patreon. Available online: https://www.patreon.com/assignedmale (February 27, 2019).

Labelle, Sophie (2017), "untitled," Facebook, 30 May. Available online: https://www.facebook.com/lasophielabelle/posts/1954885224791606 (accessed February 27, 2019).

Lee, Christopher (2008), "Where Have all the Gophers Gone? Why the Web Beat Gopher in the Battle for Protocol Mind Share," University of Michigan School of Information. Available online: https://ils.unc.edu/callee/gopherpaper.htm (accessed February 26, 2019).

Leiner, Barry M., Vinton G. Cerf, David D. Clark, Robert E. Kahn, Leonard Kleinrock, Daniel C. Lynch, Jon Postel, Larry G. Roberts, and Stephen Wolff (1997), "Brief History of the Internet," Internet Society. Available online: https://www.internetsociety.org/internet/history-internet/brief-history-internet/ (accessed February 26, 2019).

Lopez, Marco (2017), "You Should Be Reading ... *BOUNCE!*," *Monkeys Fighting Robots*, 23 June. Available online: https://www. monkeysfightingrobots.co/you-should-be-reading-bounce/ (accessed February 27, 2019).

MacDonald, Heidi (2017), "Breaking News: Only 30% of the News on Comics News Sites Is Actually about Comics," *The Beat*, 15 February. Available online: https://www.comicsbeat.com/breaking-news-only-30-of-the-news-on-comics-news-sites-is-actually-about-comics/ (accessed February 27, 2019).

Manley, Joey (2005), "Do Webcomics Have a Mainstream Already?" Webcomics, Hauppauge: Barron's Educational Series.

Markoff, John (1993), "Business Technology; A Free and Simple Computer Link," *New York Times*, 8 December. Available online: https://www.nytimes.com/1993/12/08/business/business-technology-a-free-and-simple-computer-link.html (accessed February 26, 2019).

Marshall, Rick (2008a), "Interview: Jeph Jacques on 'Questionable Content'," *ComicMix*, 17 July. Available online: https://www. comicmix.com/2008/07/17/interview-jeph-jacques-on-questionable-content/ (accessed February 28, 2019).

Marshall, Rick (2008b), "Interview: David Willis on 'Shortpacked'," *ComicMix*, 22 July. Available online: https://www.comicmix. com/2008/07/22/interview-david-willis-on-shortpacked/ (accessed March 1, 2019).

Martin, Tyler, John Bintz, Philip M. Hofer, and Danny Burleson (2010), "About," *ComicPress*. Available online: http://comicpress.org/about/ (accessed February 26, 2019).

Mautner, Chris (2015), "'I'm a Careful Person': An Interview with Kate Beaton," *Comics Journal*, 4 November. Available online: http://www.tcj.com/im-a-careful-person-an-interview-with-kate-beaton/ (accessed February 27, 2019).

McCloud, Scott (1993), *Understanding Comics*, Northampton: Kitchen Sink Press.

McCloud, Scott (2000), *Reinventing Comics*, New York: Paradox Press.

McCloud, Scott (2004), "Webcomics," ScottMcCloud.com. Available online: http://scottmccloud.com/1-webcomics/ (accessed February 26, 2019).

McDonald, Kel (2018), "Webcomic Ad History Lesson," *Sorcery 101*, 15 June. Available online: http://sorcery101.net/news/webcomic-ad-history-lesson/ (accessed March 1, 2019).

McElmurry, Todd (2014), "POTM Interview: Minna Sundberg of *Stand Still. Stay Silent*." Webcomic Alliance, 19 May. Available online: http://webcomicalliance.com/conversations/potm-interview-minna-sundberg-of-stand-still-stay-silent/ (accessed February 28, 2019).

Melançon, Isabelle (2018), personal communication, 29 November.

Milholland, R. K. (2003), "Defending Today's Comic ... and I Hate My Job," *Something Positive*, 8 January. Available online: https://web.archive.org/web/20030111094230/http://www.somethingpositive.net:80/sp01082003.html (accessed February 26, 2019).

Miller, John Jackson (2001), "February 2001 Comic Book Sales to Comics Shops," Comichron. Available online: https://www.comichron.com/monthlycomicssales/2001/2001-02.html (accessed February 27, 2019).

Miller, John Jackson (2002), "June 2002 Comic Book Sales to Comics Shops," Comichron. Available online: https://www.comichron.com/monthlycomicssales/2002/2002-06.html (accessed February 28, 2019).

Miller, John Jackson (2004), "November 2004 Comic Book Sales to Comics Shops," Comichron. Available online: https://www.comichron.com/monthlycomicssales/2004/2004-11.html (accessed February 28, 2019).

Miller, John Jackson (2005), "December 2004 Comic Book Sales to Comics Shops," Comichron. Available online: https://www.comichron.com/monthlycomicssales/2004/2004-12.html (accessed February 27, 2019).

Misao, Sue (2014), "Life's a Game—Leap of Faith Turns Comic Strip into Successful Gaming Company," *Asian Weekly*, 23 January. Available online: http://nwasianweekly.com/2014/01/lifes-game-leap-faith-turns-comic-strip-successful-gaming-company/ (accessed February 26, 2019).

Morreale, Herb (1992), "Daily Comic Strip Comming to alt.comics. buffalo-roam [sic]," alt.comics.buffalo-roam, 14 April. Available online: http://archive.li/744a2#selection-989.5-989.13 (accessed February 26, 2019).

Muniz, Jorge (2018), "About/Contact," Medcomic. Available online: https://medcomic.com/about/ (accessed February 27, 2019).

Murray, Noel (2004), "James Kochalka," AV Club, 28 July. Available online: https://www.avclub.com/james-kochalka-1798208366 (accessed August 25, 2019).

Musgrave, Shaun (2015), "RPG Reload File 051—'Penny Arcade's on The Rain-Slick Precipice of Darkness 3'," Touch Arcade, 13 August. Available online: https://toucharcade.com/2015/08/13/rpg-reload-file-051-penny-arcades-on-the-rain-slick-precipice-of-darkness-3/ (accessed February 26, 2019).

Nelson, Douglas L. Valerie S. Reed, and John R. Walling (1976), "Pictorial Superiority Effect," Journal of Experimental Psychology: Human Learning and Memory, 2 (5): 523–28.

Nelson, Noah J. (2012), "A Comics Crusader Takes on The Digital Future," All Things Considered, 7 August. Available online: https://www.npr.org/2012/08/07/158374174/a-comics-crusader-takes-on-the-digital-future (accessed February 27, 2019).

Nielsen, Jakob (2000), "End of Web Design," Nielsen Norman Group, 23 July. Available online: https://www.nngroup.com/articles/end-of-web-design/ (accessed March 2, 2019).

Nielsen, Jakob (2006), "The 90-9-1 Rule for Participation Inequality in Social Media and Online Communities," Nielsen Norman Group, 9 October. Available online: https://www.nngroup.com/articles/participation-inequality/ (accessed March 2, 2019).

"Not Crazy Reactions" (n.d.), Bad Webcomics Wiki. Available online: http://badwebcomicswiki.shoutwiki.com/wiki/Not_crazy_reactions (accessed February 28, 2019).

O'Malley, Bryan Lee (2012), "'Scott Pilgrim' Guy Interviews 'Homestuck' Guy: Bryan Lee O'Malley On Andrew Hussie," Comics Alliance, 2 October. Available online: http://comicsalliance.com/homestuck-interview-andrew-hussie-bryan-lee-omalley-ms-paint-adventures/ (accessed February 27, 2019).

Pagan, Luis (2007), "Pagan Pedagogics—David Willis Interview," Silver Bullet Comics, 23 February. Available online: https://web.archive.org/web/20070927234557/http://www.silverbulletcomics.com/news/story.php?a=4056 (accessed March 1, 2019).

Page, Frank (2012), personal communication, 17 July.

Page, Frank (2013), personal communication, 16 September.

Parker, Charley (2018), Argon Zark!, 18 May. Available online: http://www.zark.com/ (accessed February 26, 2019).

Perrin, Andrew (2015), "Social Media Usage: 2005–2015," *Pew Research Center*, 8 October. Available online: http://www.pewinternet. org/2015/10/08/social-networking-usage-2005-2015/ (accessed March 1, 2019).

Peterson, Kim (2004), "*Penny Arcade* Takes Tazor-Sharp Jabs at Video-Game Industry," *Seattle Times*, 25 August. Available online: http://old.seattletimes.com/html/businesstechnology/2002014618_ pennyarcade25.html (accessed February 26, 2019).

Petkus, Shelby Clark (2014), "'Trans Girl Next Door' Documents Artist's Transition," *Pride Source*, 30 October. Available online: https://pridesource.com/article/68731-2/ (accessed February 27, 2019).

"The Phil and Kaja Foglio Interview" (2008), [Podcast] Biblio File, 27 January. Available online: https://web.archive.org/ web/20110720203728/http://recordings.talkshoe.com/TC-7022/TS-86385.mp3 (accessed February 27, 2019).

Pickles, Matt (2016), "New Research Networks to Study Comics," *University of Oxford Arts Blog*, 11 July. Available online: http:// www.ox.ac.uk/news/arts-blog/new-research-networks-study-comics (accessed February 27, 2019).

Pinantoan, Andrianes (2015), "How to Massively Boost Your Blog Traffic with These 5 Awesome Image Stats," *Buzzsumo*, 20 May. Available online: https://buzzsumo.com/blog/how-to-massively-boost-your-blog-traffic-with-these-5-awesome-image-stats/ (accessed March 1, 2019).

Pittman, Taylor (2015), "These Comics Absolutely Nail Why We Still Need Feminism," *Huffington Post*, 2 July. Available online: https:// www.huffingtonpost.com/2015/07/02/rebecca-cohen-feminist-illustrations_n_7713378.html (accessed February 28, 2019).

Powell, Lewis (2007), "WCCAs," *Wax Intellectual*, 20 January. Available online: https://web.archive.org/web/20180820131405/http:// waxintellectual.com/blog/archives/archive_2007-m01.php (accessed February 26, 2019).

"Q&A-ing with 'Garfield' Cartoonist and His Syndicate" (2008), *Editor & Publisher*, 11 June. Available online: https://www.questia.com/ magazine/1G1-180283015/q-a-ing-with-garfield-cartoonist-and-his-syndicate (accessed March 2, 2019).

Rall, Ted (2006), *Attitude 3: The New Subversive Online Cartoonists*, New York: NBM.

Rall, Ted (2009), "TCJ 300 Conversations: Ted Rall & Matt Bors," *Comics Journal*, 23 December. Available online: http://classic.tcj.com/ tcj-300/tcj-300-conversations-ted-rall-matt-bors/6/ (accessed March 2, 2019).

Roussel, Gilles (n.d.), "F.A.Q.," *Bouletcorp*. Available online: http:// english.bouletcorp.com/#mail (accessed February 27, 2019).

Rozakis, Charles (2003), "An In-Depth Look at the Business Viability of Webcomics," AB diss., Princeton University, Princeton.

Sands, Austin and Vince Tseng (2009), "1 in 3 Laptops Fail over 3 Years," *SquareTrade*, 16 November. Available online: https://www.squaretrade.com/htm/pdf/SquareTrade_laptop_reliability_1109.pdf (accessed March 2, 2019).

Scheff, Meredith (2008), "Meredith Scheff Interviews Phil Foglio," *Steampunk Workshop*, 10 March. Available online: http://steampunkworkshop.com/phil-foglio-shtml/ (accessed February 27, 2019).

Schelly, Bill (1999), *The Golden Age of Comic Fandom*, Rev. edn, Seattle: Hamster Press.

Shafer, Jack (2019), "The End Times of the Political Cartoon," *Politico*, 1 July. Available online: https://www.politico.com/magazine/story/2019/07/01/the-end-times-of-the-political-cartoon-227259 (accessed August 25, 2019).

Shapiro, Walter (1982), "LIVES: The Cat That Rots the Intellect," *Washington Post*, 12 December. Available online: https://www.washingtonpost.com/archive/opinions/1982/12/12/lives-the-cat-that-rots-the-intellect/d6ed28c6-bee3-41ad-81f2-1839b34b87b1/ (accessed March 2, 2019).

"Share Your Story" (2017), *Empathize This*. Available online: https://www.empathizethis.com/share-your-story/ (accessed February 27, 2019).

Shifman, Limor (2013), "Memes in a Digital World: Reconciling with a Conceptual Troublemaker," *Journal of Computer-Mediated Communication*, 26 March. Available online: https://onlinelibrary.wiley.com/doi/full/10.1111/jcc4.12013 (accessed March 1, 2019).

Singer, Marc (2019), *Breaking the Frames: Populism and Prestige in Comics Studies*, Austin: University of Texas Press.

Smith, Zack (2011), "Wide World of Webcomics: Hugo Award Winning GIRL GENIUS," *Newsarama*, 27 June. Available online: https://www.newsarama.com/7884-wide-world-of-webcomics-hugo-award-winning-girl-genius.html (accessed February 28, 2019).

Smith, Zack (2012), "Stephan Pastis Talks *Pearls Before Swine* and the Future of Newspaper Comic Strips," *Indy Week*, 7 October. Available online: https://indyweek.com/culture/archives/stephan-pastis-talks-pearls-swine-future-newspaper-comic-strips/ (accessed March 2, 2019).

Snyder, Steven James (2010), "The 50 Best Inventions of 2010," *Time*, 11 November. Available online: http://content.time.com/time/specials/packages/article/0,28804,2029497_2030652_2029823,00.html (accessed March 1, 2019).

Solon, Olivia (2013), "Richard Dawkins on the Internet's Hijacking of the Word 'Meme'," *Wired*. Available online: https://www.wired.co.uk/article/richard-dawkins-memes (accessed March 1, 2019).

Spurgeon, Tom (2011), "CR Holiday Interview #4—Matt Bors," *The Comics Reporter*, 10 January. Available online: http://www.comicsreporter.com/index.php/resources/interviews/30630/ (accessed August 25, 2019).

Sundberg, Minna (2012), "untitled," *A Redtail's Dream*, 3 July. Available online: http://www.minnasundberg.fi/comic/page146.php (accessed February 28, 2019).

Sundberg, Minna (2013), "Some 'Final' Words About Artd," *Stand Still. Stay Silent.*, 29 October. Available online: http://www.sssscomic.com/journal.php?entry=6 (accessed February 28, 2019).

Sundberg, Minna (2014a), "*Stand Still. Stay Silent.*—Book 1," *IndieGoGo*. Available online: https://www.indiegogo.com/projects/stand-still-stay-silent-book-1#/ (accessed February 28, 2019).

Sundberg, Minna (2014b), "*Stand Still. Stay Silent.*—Webcomic, Page 99," *SSSScomic Disqus*, 24 April. Available online: https://disqus.com/home/discussion/sssscomic/stand_still_stay_silent_webcomic_page_99 (accessed February 28, 2019).

Sundberg, Minna (2014c), "*Stand Still. Stay Silent.*—Webcomic, Page 115," *SSSScomic Disqus*, 26 May. Available online: https://disqus.com/home/discussion/sssscomic/stand_still_stay_silent_webcomic_page_115 (accessed February 28, 2019).

Sundberg, Minna (2016a), "untitled," *Stand Still. Stay Silent.*, 26 May. Available online: http://www.sssscomic.com/comic.php?page=527 (accessed February 28, 2019).

Sundberg, Minna (2016b), "untitled," *Stand Still. Stay Silent.*, 24 June. Available online: http://www.sssscomic.com/comic.php?page=550 (accessed February 28, 2019).

Sundberg, Minna (2016c), "Schedule Change and Side Project Start.," *Stand Still. Stay Silent.*, 19 November. Available online: http://www.sssscomic.com/journal.php?entry=25 (accessed February 28, 2019).

Sundberg, Minna (2017a), Twitter, 9 March. Available online: https://twitter.com/SSSScomic/status/839973102742306816 (accessed February 28, 2019).

Sundberg, Minna (2017b), "untitled," *Stand Still. Stay Silent.*, 6 June. Available online: http://www.sssscomic.com/comic.php?page=730 (accessed February 28, 2019).

Sundberg, Minna (2017c), "untitled," *Stand Still. Stay Silent.*, 14 December. Available online: http://www.sssscomic.com/comic.php?page=830 (accessed February 28, 2019).

Sundberg, Minna (2018), "Still Water," *DeviantArt*, 2 September. Available online: https://www.deviantart.com/minnasundberg/art/Still-Water-762274195 (accessed February 28, 2019).

Tak, ed. (2014), "I Have Asperger's and I Read Your Comments Too," *Empathize This*, 15 https://www.empathizethis.com/stories/aspergers-read-comments/ (accessed March 2, 2019).

Tak (2019a), personal communication, 15 January.

Tak (2019b), personal communication, 17 January.

Tarter, Steve (2009), "On the Air: Internet Not Helping Cartoonists," *Peoria Journal Star*, 22 November. Available online: https://www.pjstar.com/x511160397/On-the-Air-Internet-not-helping-cartoonists (accessed March 2, 2019).

Thomas, Guy (2014), "Interview with Kevin Budnik," *Panel Patter*, 14 October. Available online: http://www.panelpatter.com/2014/10/interview-with-kevin-budnik.html (accessed August 25, 2019).

Thompson, Steve (2011), "Introduction," *Pogo Through the Wild Blue Yonder*, Seattle: Fantagraphics Books.

Torheim, Maria Gilje (2017), "Do We Read Differently on Paper than on a Screen?," *Phys.org*, 21 September. Available online: https://phys.org/news/2017-09-differently-paper-screen.html (accessed February 27, 2019).

Townsend, Alex (2015), "Webcomic Spotlight: An Interview with David Willis, Creator of *Dumbing of Age* and *Shortpacked*," *Mary Sue*, 4 November. Available online: https://www.themarysue.com/interview-with-david-willis/ (accessed March 1, 2019).

Trotman, C. Spike (2013a), "untitled," Twitter, 20 January. Available online: https://twitter.com/Iron_Spike/status/293037207021834242 (accessed March 2, 2019).

Trotman, C. Spike (2013b), *This Is Everything I Know*, Chicago: Iron Circus Comics.

"Wake Me Up Before You IndieGoGo: Interview with Slava Rubin" (2010), *Film Threat*, 5 October. Available online: http://filmthreat.com/uncategorized/wake-me-up-before-you-indiegogo-interview-with-slava-rubin/ (accessed February 26, 2019).

Walker, Rob (2011), "The Trivialities and Transcendence of Kickstarter," *New York Times*, 5 August. Available online: https://www.nytimes.com/2011/08/07/magazine/the-trivialities-and-transcendence-of-kickstarter.html?pagewanted=all (accessed March 1, 2019).

Warshow, Robert (1954), "Paul, the Horror Comics, and Dr. Wertham," *Commentary*, 1 (17): 596–604.

"Welcome to the Bad Webcomic Wiki" (n.d.), *Bad Webcomics Wiki*. Available online: http://badwebcomicswiki.shoutwiki.com/wiki/Main_Page (accessed February 28, 2019).

"What Is Pax?" (2016), PaxEast. Available online: https://web.archive.org/web/20160301014352/http://east.paxsite.com/what-is-pax (accessed February 26, 2019).

"What's New!" (1993), *Mosaic Communications*, 30 September. Available online: http://home.mcom.com/home/whatsnew/whats_new:0993.html (accessed March 1, 2019).

Willis, David M. (n.d.), "About," *Dumbing of Age*. Available online: http://www.dumbingofage.com/about/ (accessed March 1, 2019).

Willis, David M. (2013), "untitled," *This Is So Babies*, 20 April. Available online: http://web.archive.org/web/20130420180140/http://itswalky.tumblr.com/post/44925990876/whats-your-opinion-of-danny-your-comments-on-the (accessed March 1, 2019).

Willis, David M. (2015), "… Take a Message Back from Me," *This Is Totally Babies*, 18 November. Available online: http://itswalky.tumblr.com/post/133473860727/dumbingofage-dumbing-of-age-take-a-message (accessed March 1, 2019).

Withrow, Steven and John Barber (2005), *Webcomics*, Hauppauge: Barron's Educational Series.

Wolf, Clint (2017), "A Penny's Worth of Thoughts," *Zombie Ranch*, 17 May. Available online: http://www.zombieranchcomic.com/2017/05/17/a-pennys-worth-of-thoughts/ (accessed February 26, 2019).

Woods, Ben (2014), "Kickstarter opens up to Projects from Denmark, Norway, Sweden and Ireland," *Next Web*, 15 September. Available online: https://thenextweb.com/eu/2014/09/15/kickstarter-opens-projects-denmark-norway-sweden-ireland/ (accessed February 28, 2019).

"Worldcon 74 Interview: Kaja Foglio" (2016), [YouTube], USA, 11 September. Available online: https://www.youtube.com/watch?v=hUFZIs6Hwsw (accessed February 28, 2019).

"Writing Excuses Episode 28: Writing for Webcomics with Phil and Kaja Foglio" (2008), [Podcast] USA, 18 August. Available online: https://writingexcuses.com/2008/08/18/writing-excuses-episode-28-writing-for-comics-and-graphic-novels/ (accessed February 27, 2019).

Xerexes, Xaviar (2007), "Biggie Panda: Old Skool Webcomics," *Comix Talk*, 28 January. Available online: http://comixtalk.com/biggie_panda_old_skool_webcomics/ (accessed February 26, 2019).

Yoshimickster (2014), "The 'What the Hell has Happened to *Sinfest*' Thread!," *Halforums*, 2 January. Available online: https://www.halforums.com/threads/the-what-the-hell-has-happened-to-sinfest-thread.30047/ (accessed February 27, 2019).

Zabel, Joe, T Campbell, Alexander Danner, Shaenon Garrity, William G., Bob Stevenson, and Noel Von Flue (2004), "The Future of Webcomics," *The Webcomics Examiner*. Available online: https://web.archive.org/web/20050224025349/http://webcomicsreview.com/examiner/issue041213/future3.html (accessed February 26, 2019).

Zero, Mr. (2016), "Rebecca Cohen—Fighting the Patriarchy One Comic at a Time," *Kiwi Farms*, 6 November. Available online: https://kiwifarms.net/threads/rebecca-cohen.25589/ (accessed February 28, 2019).

INDEX